THE ART OF RICHARD HUGHES

A STUDY OF THE NOVELS

THE ART OF RICHARD HUGHES

*A Study
of
the Novels*

PAUL MORGAN

CARDIFF
UNIVERSITY OF WALES PRESS
1993

© Paul Morgan, 1993

British Library Cataloguing-in-Publication Data.
A catalogue record for this book is available from
the British Library.

ISBN 0–7083–1192–X

Cover design by Design Principle, Cardiff.
Typeset by Mackreth Media Services, Hemel Hempstead.
Printed in Great Britain by WBC, Bridgend.

To
Caroline

Contents

Abbreviations

Page numbers for the novels are given in parentheses within the text, using the following abbreviations. These refer to the first British editions as described in the Bibliography.

HW *A High Wind in Jamaica*

IH *In Hazard*

FA *The Human Predicament*: Volume One: *The Fox in the Attic*

WS *The Human Predicament*: Volume Two: *The Wooden Shepherdess*

Introduction

In half a century as a writer, Richard Hughes produced just three novels. As well as being best-sellers, *A High Wind in Jamaica*, *In Hazard*, and *The Human Predicament* were all critically acclaimed. Walter Allen termed *A High Wind in Jamaica* 'one of the classic novels of childhood', and *The Human Predicament* 'the great English novel of the sixties'.[1] Yet Hughes occupies a curious, liminal position in English studies. Despite the praise received by his novels on publication, critics, then and since, have evidently felt uncomfortable with him. There has been persistent difficulty in finding methods of approaching the novels, which do not fit conveniently into orthodox perceptions of the form. Paid the lip-service of recognition as a significant author, he is in practice hardly written upon, hardly taught at universities, and has never been subjected to that intense critical embrace received by his contemporaries. It must be said that, notwithstanding his formal reputation, Hughes exists in a critical limbo.

Why should this be so? I believe the answer lies in the contradictory, unsettling nature of the texts themselves. Despite the commonly acknowledged brilliance of their writing, all three have seemed oddly 'unfinished' (literally so in the case of *The Human Predicament*); generic and narrative expectations are raised, then unfulfilled; characters are carefully built up to arouse interest, then unaccountably ignored for long periods; the narrative voices veer without warning between apparent objectivity, cruelty, tenderness and even puzzlement in their attitudes to the novels' characters, and, above all, each work is dominated by a profoundly ambiguous protagonist. In short, every page offers a challenge, a quandary, a trap, in face of which the reader has a simple choice: first, to ignore this complexity as 'noise', as others have

done, and even to dismiss it as flawed writing; or alternatively, to take up the challenge, acknowledge this 'difficulty' not as a problem but, on the contrary, as a locus of meaning – not a dead end, but a place to start.

My purpose in this study is to demonstrate incontestably and, it is hoped, enjoyably, what a truly remarkable set of novels was written by Hughes, by revealing in them an unsuspected richness, a sophistication, and a coherence – by which this anomalous, 'incomplete' aspect can be recognized as a positive and integral part of how the texts function. This in turn must change how the corpus as a whole is viewed, not as the intermittent, varied outpourings of a somewhat old-fashioned figure, but as an exciting series of highly original works, the audacity and achievement of which enable a reassessment of Hughes's place in English literature – as a major novelist of the twentieth century, whose concerns, and the techniques used to explore them, demand our attention.

Before outlining the argument of this study, it will be helpful to give a brief summary of the novelist's life and career.[2] Richard Arthur Warren Hughes was born in 1900. Following the early death of his father (who worked at the Public Record Office) and of his sister, he was brought up alone by his mother, and, aided by scholarships, was able to attend Charterhouse. A brief period in the Army (fully expecting to be posted to France, and to die), was brought to an end by the Armistice, and he went on to study at Oxford. Here, he began to write and publish in earnest: reviews, essays, poems and short stories appeared on both sides of the Atlantic. A play, *The Sisters' Tragedy*, was staged in the West End by Sybil Thorndike as part of her *Grand Guignol* series. On graduating, Hughes seemed set at first for a dramatic career: more plays were produced, he was closely involved in efforts to develop a Welsh National Theatre and, in January 1924, he wrote the first original drama for radio, *A Comedy of Danger*, broadcast by 2LO, the BBC's first radio station. He was editor of *Oxford Poetry 1921*, and produced an edition of Skelton's poetry. In the 1920s, too, Hughes began to travel widely, working on sailing ships and setting out for the wilder parts of Europe, Canada and north Africa. Behind this restlessness, however, his private intention was always clear: to be a novelist.

Soon after leaving Oxford, he had accepted a contract with Chatto & Windus for a first novel, but was adamant that he would not be ready to begin until he was twenty-five. As this age approached, collected editions of his poetry (*Confessio Juvenis*), plays (*The Sisters' Tragedy*), and stories (*A Moment of Time*) were prepared and sent to the press – putting those forms behind him – and in his twenty-fifth year, Hughes began

work. Interrupted by a mental breakdown and by frequent travelling (the novel was written in various locations in Wales, England, Italy and the United States), *A High Wind in Jamaica* was finally published in 1929. The immediate success of the novel made Hughes a household name; it also enabled him to buy a house in Tangier to escape this attention, and to provide a base for his travels in Morocco.

During the 1930s, he was much in demand as a columnist and reviewer, writing regularly for the *Spectator, Time and Tide*, and the *New Statesman*. After several years' work, he abandoned one novel to begin another, *In Hazard*, which appeared in 1938. This was largely written in a tower of Laugharne Castle (on which he had taken a long lease some years earlier). Since schooldays, Hughes had regarded himself as an adoptive Welshman (though his family had not lived in the country for centuries), and from this time on, Wales was to be his permanent home. This was the busiest and – one suspects – the happiest period in Hughes's life. In 1932 he had married Frances Bazley; the travelling and sailing continued, and there was much pleasurable tinkering with the design of Laugharne Castle House, and of a cottage kept in north Wales, near his friends, the Williams-Ellises. (Amabel Williams-Ellis was a close friend from student days, when she was Literary Editor of the *Spectator*, and Clough Williams-Ellis naturally advised on the 'tinkering'.) Dylan Thomas also became a close friend at this time, and it was the Hugheses' ever-hospitable presence which played a large part in drawing the poet back again and again to Laugharne, until his name became more closely associated with it than anyone's.

The year 1939 brought the Laugharne period to an end, and Hughes spent the war years at the Admiralty in Bath, working on weapons procurement. Although he did not see active naval service as he had wished, the responsibility of his position and the realities of warfare (experienced at first hand during the 'Baedeker Raids' on Bath) made a profound impression on him, and – as he later confirmed – *The Human Predicament* was conceived at this time. The long, exhausting years as an administrator seem to have numbed Hughes's nerves as a novelist, however. The novel was left to incubate while a new, more practical home was found (a solid, stone house, just across the water from Portmeirion), and a variety of other, more remunerative tasks were taken on, including acting as an official war historian, and script-writing for Ealing Studios. At Gresham College in the mid-1950s, Hughes gave a series of lectures on the art of fiction, which seemed to crystallize his ideas, and work was begun on the final novel. The next

twenty years of Hughes's life, until his death in 1976, were taken up by *The Human Predicament*; one volume, *The Fox in the Attic*, appeared in 1961, and another, *The Wooden Shepherdess*, in 1973. Unlike his publisher, and many critics, Hughes viewed the 'incompletion' of this last, ambitious work with equanimity. As the years went by, he often joked about a race between the printer and the undertaker! It is surely certain that Hughes knew the novel would never be 'completed' in the ordinary sense, and would remain an open-ended construction – as, it can be strongly argued, he came to design it during composition. The solution to *The Human Predicament* lies in comprehending this problem of incompletion, and this in turn requires a radical re-evaluation of the two preceding novels.

An unmistakable fault-line lies between the early poems, plays and stories, and the three novels which are of a wholly different order. Despite his precocious success in other literary forms, it is on the three mature works that Hughes's reputation must finally be judged. It is to these, therefore, that this study is devoted. It might be said that Hughes was a victim of his own success. *A High Wind in Jamaica* was praised almost universally (by Cyril Connolly, L. P. Hartley and V. S. Pritchett, among others) for being a marvellous story, a vivid evocation of a tropical island, and a brilliantly unsentimental portrayal of childhood. These things are true, as far as they go, yet that narrative is continually subverted and played with by the author, the vivid picture of Jamaica occupies only a tiny portion of the novel, and Hughes expressed surprise that his view of children was anything out of the ordinary at all. These most obvious aspects of the book, however, were what encouraged such high sales, and gave it its reputation. *A High Wind in Jamaica*'s status as a best-seller and the most talked-about novel of 1929 led to Hughes becoming pigeon-holed as a masterful storyteller, with a gift for description. The publication of *In Hazard* saw the same thing happen. It, too, was damned with the praise of being called a good yarn, or an allegory of the coming war, and its subtler operations and concerns were largely uncommented upon. The novelist despaired at this concentration on the most superficial aspect of his work in an essay of 1938:

> Perhaps one of the worst misfortunes which can befall a book is a sudden wide success: because that success is often due to something more or less irrelevant which comes to cause the main theme of the book to escape notice. This happened with my first book, *A High Wind in Jamaica*: and it

seems to have happened again with *In Hazard*. For, so far as I can judge, the latter has been successful because the description of the storm is said to be vivid and the story to be exciting.[3]

There was something horribly ironic about the way in which popular and critical success was conjoined with such wholesale misinterpretation. It was too late, though. The reputation had stuck, so that when a new Hughes novel appeared, reception of it was conditioned by what was now expected of him.

This was proven when *The Human Predicament* began to appear, twenty-three years after *In Hazard*. Hughes was now seen as a somewhat old-fashioned, pre-war figure, and the work's setting led to it being read by critics as very much an orthodox, naturalistic, historical novel. There was, once again, the familiar combination of praise for his storytelling and descriptive passages, with the old puzzlement, even disappointment, that 'legitimate' expectations remained unfulfilled. This was regarded as a degree of failure on Hughes's part, a judgement expressed more harshly on the appearance of the second, still inconclusive volume after a gap of twelve years. With his death, this estimation was conventionalized, and has persisted ever since.

In this study I intend to argue a very different view of the novels of Richard Hughes. Read afresh, and with an understanding of the normative bias introduced by their critical reception, the novels are revealed for the remarkable works they are. In this way, the puzzling, contradictory elements in their overt plots are recognized not as a problem, but as necessary parts of a covert plotting – in which the reader is deliberately inveigled into participating. Hughes repeatedly places his reader in a predicament by beginning within the confines of a genre, by setting the narrative in motion, and then increasingly exploiting generic conventions and intervening in the narrative mechanism. This authorial strategy is not simply disruptive, but has the positive intent of jolting the reader into contributing to, and helping create, a deeper meaning from the material of the text. Thus, each work can be seen not as a static artefact with a manifest narrative conclusion; rather, each is a dynamic process, in which the interrelation of all parts of the text, and of the text with the reader, is what fulfils it as a work of art. A key part of how each operates is the presence of numerous subtle patterns of allusion and metaphor arrayed around the protagonists: complex tropological systems, the exploration of which generates previously unguessed-at meanings.

This essential importance to Hughes's art of dialectical elements (the positive, dynamic quality he perceives in paradox, contradiction and incompletion), and of rhetoric (by the involvement of the reader's response as an integral part of each work), can be seen from Hughes's writings on fiction, which form a consistent and deeply thoughtful body of writing on his art. It is only detailed examination and consideration of the novels themselves, though, which can demonstrate this convincingly, as we shall see.

So it is that, while *A High Wind in Jamaica* was acknowledged as revolving around ten-year-old Emily's discovery of her 'self' while captured by pirates, the overt narrative's withholding of adequate explanation of this (or of her actions, including murder) can now be seen not as a flaw, but as a deliberate tactic of the novelist – provoking the reader to go beyond the plot, and investigate the more complex patterning of phrase and image which enrich the enigmatic meaning of Emily. *In Hazard* contains even more contradictory and incomplete elements than its predecessor. The young hero is far more ambiguous in his motives and actions than at first appears. Having concentrated the narrative on the fate of the steamship *Archimedes* in a hurricane, and brought this to a pitch of tension, Hughes puts it aside to give a long, relaxed digression on the home life of one of the Chinese crewmen. The crew's heroic efforts to save the ship prove irrelevant, and, finally, the fate of many characters (some facing ruin, and even execution) is left unknown on the final page. All of these elements, too, can be shown as functional rather than accidental, and directed towards exposition of *In Hazard*'s essential theme: the necessity of humans to accommodate themselves to the ineluctable conditions of existence in a physical universe.

With *The Human Predicament*, expectations of the work as an orthodox, historical novel, together with the extraordinary manner of its publication (written over a twenty-year period, published in two volumes twelve years apart, and left notoriously 'incomplete'), conspired even more to produce misreading. Here, it can also be seen that these problematic aspects are integral to how it works – and an understanding of this is essential to approach the central Hobbesian theme: how individual humankind can possibly exist in society with similar beings. Hughes's final novel, then, was a culmination of his experiment with novelistic technique. It is argued, indeed, that the 'unfinished' state of the work was foreseen and accepted by the novelist, who ensured that the extant published text – however he left

it – could be read as a coherent whole, and that this is entirely consistent with how the two previous novels operated. Consistent, too, is the theme of human consciousness: explored first in dealing with its self-discovery, and the responsibility this brings; then, in coming to terms with existence within the finite conditions of space and time; and finally the most complex condition of all in relation to other beings of a similar nature, within human society.

Richard Hughes is not only a far more ambitious writer than has hitherto been suspected, he is also, admittedly, a demanding one for his reader. But this is deliberate, for to him a novel was indeed a process not an artefact alone: something which acquired meaning insofar as its audience participated in it imaginatively. It is hoped that this study will not only show this convincingly, but also demonstrate that the effort is more than worthwhile – justifying the belief that Hughes is one of the most rewarding, as well as one of the most original, masters of the novel in the twentieth century.

Chapter 1

The Reader's Predicament:
Richard Hughes and the Dynamics of Fiction

> When I set myself to the composition of some sort of explanatory
> introduction I found it exceedingly difficult: I felt like the Russian dancer
> who was asked what it all Meant, and replied 'If I could tell you, do you
> think I would put myself to the infinite pains of dancing it?'[1]

Whenever questioned about how he wrote, Richard Hughes always
insisted that the process could not be planned. He commented on the
composition of *The Human Predicament*: 'I wrote no synopsis: I just
cannot write that way. If you ask what will happen next, I cannot tell
you. All the same, nothing I write is haphazard: the planning goes on
all right, in minute detail – but out of sight somewhere, under the
"threshold": it only surfaces into consciousness with the pen in my
hand.'[2] He was, nevertheless, fascinated by this process of artistic
creation and throughout his life maintained a steady output of writings
on the art of fiction. This lifelong dialogue with himself – in essays,
reviews, broadcasts, lectures and letters – functioned not only 'to get
the rust off my pen',[3] but also to hone his own craft, helping to put
ideas in order before launching himself at a new work. These discursive
writings, then, should not be regarded as a prescription on how to read
the novels, but as a useful and fascinating insight into their author's
creative processes, 'under the threshold'.

One of the most noticeable things about Hughes's writings is their
dialectical cast: the tendency to apprehend and explain things in terms
of inherent contradiction. 'It is when Truth meets Truth that there
comes the tug-of-war', as he wrote in an early essay.[4] This is not just a
technical habit for Hughes, but a conviction that the essential nature of
consciousness, of 'reality', is dialectical and therefore can be

understood only if approached in this way. Whether describing a book, a character or a situation he instinctively does so by revealing inherently contradictory elements within the subject as the most effective way of vivifying it, dramatizing its essential nature.

What exactly do we mean by 'dialectic', though, and more importantly, what did Hughes mean by it? The *OED* describes it as 'the process by which . . . contradictions are seen to merge themselves in a higher truth that comprehends them'. This modern, English understanding derives from the philosopher G. W. Hegel's term describing triadic logic, in which any proposition (the thesis) may be countered by a contradictory statement (the antithesis), and it is only by means of a third proposition (the synthesis) that the subject in dispute may be fully understood. The ultimate triadic synthesis, according to Hegel, is that in which 'Being' and 'Not-Being' come together in 'Becoming' – the constant, ever-changing renewal of existence. Richard Hughes's use of the dialectic is not necessarily derived straight from Hegel nor is it in any way dogmatic; it is simply an intuitive, pragmatic response to the material before him. The philosopher quoted in support of his view is far more ancient than Hegel (and may not even have existed as a particular individual): Lao Tse, putative author of the *Tao Te Ching*, composed in China during the third century BC. Hughes's early play, *A Comedy of Good and Evil*, bears an epitaph ascribed to Lao Tse: 'For one must always be careful of distinctions !',[5] and the introductory note to another drama, *The Man Born to Be Hanged*, refers to the dialectical aspect of the *Tao* in describing the title-role, who is asleep throughout the play:

> Or take the case of the title-role, the 'Man' himself, Mr Lenora. He neither acts nor speaks from one end of the play to the other; but yet, as the Chinese say, 'acting by inaction', he goes through a fairly considerable series of vicissitudes.[6]

In his review of *Mrs Dalloway*, Hughes also adduces the *Tao* in his contention that all knowledge is necessarily dialectical and subjective. He writes:

> The human mind is itself not a microcosm (as men used to think) but the macrocosm: it cannot 'find out' anything about the universe because the terms both of the question and answer are terms purely relative to itself: that even the keywords, being and not-being, bear no relation to anything except the mind which formulates them.[7]

The 'keywords' quoted bring the Hegelian dialectical model to mind, as does the use of the word 'synthesis', in the same review, to characterize the completed aesthetic effect of a work of art. There is no way of knowing whether Hughes used these terms in a deliberately Hegelian sense, though, and it is just as likely that he chose the most apt words, which coincide with the usual English rendering of Hegel. The Taoist connection with Hughes's writings has been recognized by Peter Thomas:

> That Hughes had been deeply influenced by his reading of the *Tao* is evidenced by his use of the principle of action-by-inaction in the character of Lenora. His belief in the contrariness of things found support in the dialectical and paradoxical manner of the *Tao*.
> A cosmos in which good and evil were understood as the eternal interaction of opposing forces, yin and yang, accords closely with the implied metaphysical scheme of *A High Wind in Jamaica*.[8]

Whether Hughes was actually 'deeply influenced' by the *Tao Te Ching* (of which an English translation by W. G. Old was in print during the early decades of the century), or whether he simply found it an interesting source of ideas sympathetic to his own is also moot. What is indisputable is the extent to which this dialectical mode informs Hughes's writings, not just in moral terms (as Thomas states), but in discussing all aspects of existence. As far as Hughes is concerned, too, this is how art works.

 He described this view of art in the 1948 essay, 'The writer's duty', which discusses the conflicting demands of art and propaganda. It is a valid part of a propagandist's duty to advocate solutions, he writes, but continues:

> Wherein then lies the core of the writer's duty – what is it that he has to communicate? Is it new answers to old riddles? No, that is the politician's business, the propagandist's. Rather it lies in the framing of new riddles, posing new questions.[9]

A work of art, for Hughes, works like Nabokov's imaginary biography of Sebastian Knight: 'Two modes of his life question each other and the answer is his life itself, and that is the nearest one can approach a human truth.'[10] His definition of the writer's duty is not simply an avowal of liberal values, but goes beyond that to assert the primacy of aesthetic value, *within a work of art*, over all other criteria. Contrasting

his view with that of an overtly didactic novelist, Hughes writes: 'if I were to introduce political ideas into a novel, my intention would be the opposite of his: the politics would be the means, the novel the end. I would introduce them merely because they were material necessary to the story I had to tell. That is a totally different kettle of fish.'[11] Even the humanistic values and moral force commonly discerned in Hughes's fiction are but grist to his mill; they are present, as he says, only to be exploited for artistic effect. This is not to deny them their value, but to subsume them to the author's overall aesthetic considerations, the artist's colder eye.

For Hughes, this way of writing simply reflected how he saw the world. The writer and the text were, for him, a corollary of God and Creation. There are persistent allusions in his writings to this relationship. The 'Preface to his poetry' he terms 'some sort of Athanasian creed'.[12] Of the scientist's recourse to verbal rather than purely mathematical communication, he writes: 'When they wish to use words, they are forced – just as Jesus Christ was forced, when he would say the unsayable – into the use of parables.'[13] He agreed with an interviewer that his novels were indeed eidetic – creations of his mind alone, over which he had absolute control.[14] But as well as this metaphorical function, there is another more metaphysical aspect to Hughes's aesthetic concept. This is the near-mystical function of a work of art – the novel in particular – which allows the audience an opportunity to transcend the subjectivity of phenomenal experience, the solipsism of human existence. For Hughes, 'the Universe is divided between myself and all the others, and if Mankind is to survive it has somehow to be conscious that one's fellow beings have also their own identities.'[15] For Hughes it was through art, and quintessentially the novel, that this could be achieved:

> Socially we live more and more like cells in one big organism, semantically and cybernetically we invent more and more means of intellectual conference: yet in our consciousness we remain incommunicable islands . . . Even in married love we can't become self-conscious with the other partner's own 'I-ness': we are still each in solitary confinement, only tapping out messages on the dividing wall. Only when reading novels (or watching plays and films, to the extent that these too are forms of fiction) do we repeatedly adopt someone else's 'I am' for our own, are let out of our solitary cells, think what the other man thinks even when he is thinking it, 'identify' with him and feel what he feels.[16]

He goes on to compare the experience of fiction explicitly with religious experience itself, as though two versions of the same process:

> Indeed I know of only one place to look for anything comparable with Fiction, and that is in the field of religious experience. But here the roles are reversed, for this is the man-in-the-novel become aware of the Novelist! . . . Still, mystics are few, and for most of us Fiction in one form or another offers our only way of experiencing the identity of others.[17]

How is this actually effected through fiction? Hughes himself answers the question in a passage already quoted: 'it lies in the framing of new riddles, posing new questions. In that too he works in imitation of his Maker, Whose every word to man is – not an answer, but a question.'[18] This dialectical mode of creation demands not only that readers have to make their own connections, supply their own answers, but also be responsible for these interpretations (rational, moral, aesthetic or whatever). Of this individual responsibility Hughes writes, 'every person who accepts [the author's] power does so of his own free will. Every single one! None is compelled. In that he is copying God rather than the princes of the world.'[19] It might be said, therefore, that for Hughes each reader opens one of his works in a 'prelapsarian' state and is thereafter individually responsible for all judgements: the 'human predicaments' of which he writes are made – in each particular reading of a work – the reader's predicament.

The dialectical mode can be seen, then, as a dynamic element within Hughes's creations: each works by the setting up, exploitation, and (with the reader's participation) resolution of contradictory elements within the work. There is, indeed, even a creative tension between what is present in the work and what is not, as Hughes explains:

> In the first place the material of a book consists of two parts. There is the part which the reader knows about, the part, that is to say, which the writer puts into his book. But there is another part equally important which most readers do not realize to exist: the part, I mean, which he leaves out. That part consists of everything else the writer knows or has experienced.[20]

As well as this Taoist-sounding concept, Hughes stresses the value of using absolutely contradictory elements within a single work. In the 'Preface' he writes: 'Truth is the only effective weapon against itself. No wholly false theory ever did damage to a true one: it is when Truth meets Truth that there comes the tug-of-war. It is a curious, but

inevitable quality of the Universe that when two truths meet they almost invariably fight as fiercely as two Kilkenny cats.'[21] The value of such paradox is described in *A High Wind in Jamaica*: 'often the only way of attempting to express the truth is to build it up, like a card-house, of a pack of lies.'[22] This striking metaphor recurs in a letter written to his daughter Penelope over twenty years later: 'Truth is a bit like a card-house, which topples over if you put up the opposing cards first one and then the other, instead of putting them both on together.'[23] The power of such perception-through-contradiction is vividly illustrated in Hughes's reaction to the 1941 'Baedeker Raid' on Bath, where he watched the bombing of the city from his vantage as fire-watcher on the roof of the Empire Hotel:

> I had a perfect view of the whole thing. I can't help it; it is a most beautiful and magnificent sight. Up high like that you know nothing of humanity, except a shout or so: this city laid out under you in moonlight and suddenly huge fires full of majesty and compounded of strange colour mounting around you. The twinkle of AA fire high up. They were dive-bombing, swooping down almost as low as I was, and then as they rose again firing from their rear guns downwards like a stream of golden rain.[24]

This mysterious and paradoxical experience – in which events of horrific murder and destruction have an undeniable visionary beauty – may well have contributed to germination of *The Human Predicament*, which Hughes had determined to write by the middle of the war. To supply any explicit moral 'point' to his works would, as we have seen, reduce their validity as art in his own estimation: supplying answers not 'new riddles'. Harold Rosenburg, the art critic, has written: 'Every art has its own moral principle, without which its creations are mere stimulants of sensation.'[25] The moral principle of Hughes's art is also inherent in its aesthetic principle: a dialectical formulation, dependent upon the reader's response for its eventual synthesis. Of her own fiction, Angela Carter writes that 'it retains a singular moral function – that of provoking unease'.[26] Hughes's works are similarly designed, in that any conclusions must be made individually by the reader, basing them upon subjective reactions (of unease, wonder, horror or whatever). It is this active, heuristic participation by the reader which completes each work and makes it real as the author alone cannot do. This way of writing, then, not only makes use of the ability of the reader's mind, it actively encourages it. In one of his lectures as

Gresham Professor of Rhetoric in the 1950s, Hughes characterized this as 'wisdom' as opposed to 'knowledge':

> A little while ago I distinguished between 'knowledge' and 'wisdom'. I would say that 'wisdom', as an activity of the mind, lies in the polyphonic faculty of connecting of which I have spoken. The novel, then, does not only provide an additional storehouse of knowledge, it enables the mind itself to grow. [27]

This necessary participation of the reader in constructing the meaning of a novel also received extended attention from Hughes in his critical writings. They reveal a deep conviction of the communicative function of all art, a recognition of how verbal art differs in its reception from plastic art, and an awareness of the special opportunities afforded the artist in the novel – whose reception is a unique and far subtler business. For Hughes, the novel was conceived, and could only be comprehended, as a dynamic process.

Hughes called this involvement of his audience, 'rhetoric'. He uses the term in distinguishing between two understandings of 'meaning' in art: in poetry, for example, there was the meaning invested by the poet in the poem, and '"meaning" in the sense of what passes from the poem into the reader, which I term "rhetoric"'.[28] As a classical scholar, he was familiar with Aristotle's crisp definition in the *Ars Rhetorica* – 'Rhetoric may be defined as the faculty of observing in any given case the available means of persuasion'[29] – and invoked the philosopher in constructing his own understanding, as applied to art:

> I would vary Aristotle's πολιτικὸν ζῷον by calling Man a Communicative Animal. To say that he has a natural impulse towards self-expression is inadequate, and has led to a good many heresies: for one cannot express oneself *in vacuo*: one has to express something to someone else. Expression must be intelligible to others beside the artist: and a poem which is only intelligible to its poet is not merely regrettable from the point of view of the rest of the world, it is inadequate from the author's own point of view: it would simply be a farce to call it self-expression. If it should be argued that this communicative instinct, which although it differentiates man from brute with greater truth than Aristotle's political instinct, is not sufficiently fundamental to merit exaltation into a definition, I would reply that it is a foundation of all knowledge and all art: that Knowledge is the receptive aspect of communicativeness, and art the productive, the inside and outside of the jacket.[30]

Using Aristotle as a touchstone, Hughes argues here that art without consideration of its reception is not art but a solipsistic 'farce'. The passage is worth quoting at length, allowing Hughes to demonstrate the force with which he held this conviction, brought to bear so powerfully and subtly in the novels. In making this point, he deliberately counters the Essentialist argument, that the reception of a work of art is irrelevant and extrinsic to the work itself. This is a view expressed by Walter Benjamin for example: 'art . . . posits man's physical and spiritual existence, but in none of its works is it concerned with his response. No poem is intended for the reader, no picture for the beholder, no symphony for the listener.'[31] For Hughes, the poem, picture, or symphony is incomplete and without meaning if taken *in vacuo*, without reference to an audience. This he makes clear in 'The writer's duty':

> But if he [the writer] were creating something for his own sole delight, why should he bother to put it into words; why not be content with easy reverie? Why use words, the very stuff of communication (and awkward stuff to handle at that)? Again, if utmost communication were not the very essence of his calling, why should he use the written word? Writing is a device to bottle knowledge and feeling, so that they can be transmitted across distances of space and down the ages.[32]

In discussing the rhetoric of art, Hughes reveals a fine awareness of how it operates in written forms, especially the novel, compared with other media. The 'Preface', for example, identifies the subtler opportunities allowed to the literary artist. Quoting a 'ridiculously simple example', he writes:

> The first problem to the poet, then, is vivid expression, and in this he has to remember that the reader is not his friend, but his enemy. The normal mind does not allow itself to be excited or to receive suggestions if it can help it. The poet has to outwit the reader and throw him off his guard. The attack must not come from the direction from which it is expected. To take an instance: if I were to turn suddenly to you and say 'blue!', it conjures up in your mind only a faint impression of the colour; but if instead I said, 'Fields of cornflowers! Chests of sapphires! Italian skies!' in each case I think you will admit that the effect is far more vivid.[33]

The novel in particular, for Hughes, is characterized and shaped by the manner of its reception: because of its extended length and because

the audience is typically a single, silent reader. The most cogent account of this view is found in a Gresham Lecture passage: 'A work of literature has an added dimension', he writes, 'the dimension of time.'[34] Because of the period of time necessary to read a book, he continues, it is given a fourth dimension, to the three of a work of plastic art. This element of duration is more important in an extended work like a novel because it is impossible to hold the total work in the mind at once. The experience of reading a novel replicates the experience of life, as each page retreats into memory: 'a present moment, moving always from a partially-remembered past towards a partially-foreseeable future'.[35] Essentially important too, he writes, is the sequence of these moments: 'It is the order in which these effects are presented to the reader, even more than the power of the effects themselves, which prostrates resistance. It is as a linked succession of experiences that they have meaning.'[36] As well as the importance of this sequence within the duration of the work – its ability to reshuffle space and time – Hughes shows equal awareness of the importance of what is omitted from it. This recalls his early enthusiasm for Taoist philosophy, by which the silent, or absent, has as much significance as that which is present: offering to the reader, '"connections" of a kind absolutely impossible to physical experience'.[37]

For Richard Hughes, then, the total effect of a novel is peculiarly influenced by the sequence, position and elision of elements within the set duration of the text. This effect on the reader – the 'novel behind his eyes' as Hughes calls it – is quite distinct from the presentation of the parts; it is the essence of the whole work, distilled by the mind. 'And when you come to the end', he asks, 'when you actually close the book, what really remains in your mind? What "organic unity" whose value is greater than the value of the sum of its parts?'[38] This is why, he argues, even authors may not recognize their own work from an account which simply lists what happens. Hughes uses this distinction in his review of *Mrs Dalloway* where, he writes, London seems to be re-created in art. For the reader, 'it emerges, shining like crystal, out of the fog in which all the merely material universe is ordinarily enveloped in his mind.'[39] He then continues, 'to come to the matter of chronicle . . .', and gives a brief account of what happens in the novel, its plot, but concludes with these words: 'Chronicle is an ass; this is an unusually coherent, lucid, and enthralling book, whatever he may suggest to the contrary.'[40] This sentence is peculiarly pertinent to Hughes's own fiction since it was, ironically, by their 'chronicling' that his novels were classified and

judged when they appeared, a fact he recognized in 1938, writing that both *A High Wind in Jamaica* and *In Hazard* achieved popular success for what they appeared to be 'about', what they chronicle (a children's adventure, a tropical storm), rather than their true themes. Of the latter he wrote, 'because I gave the theme no more weight than what is natural, some readers, it seems, have never noticed what the book is about!'[41]

The importance accorded by Richard Hughes to the individual apprehension of written art by 'silent, private reading'[42] makes great demands upon his readers; it also shows an equally great respect for them, and for their receptive imagination. The intensity which characterizes this relationship between writer and reader is well described by Walter Benjamin:

> A man listening to a story is in the company of the storyteller; even a man reading one shares this companionship. The reader of a novel, however, is isolated, more so than any other reader. (For even the reader of a poem is ready to utter the words, for the benefit of the listener.) In this solitude of his, the reader of a novel seizes upon his material more jealously than anyone else. He is ready to make it completely his own, to devour it, as it were. Indeed, he destroys, he swallows up the material as the fire devours logs in the fireplace. The suspense which permeates the novel is very much like the draft which stimulates the flame in the fireplace and enlivens its play.[43]

An important consequence of the intimacy of the novel form, Hughes recognizes, is an intensification of this individual imaginative response. He ascribes part of Shakespeare's popular appeal to a comparable recognition and exploitation within the dramatic medium:

> The continued popularity of Shakespeare doesn't mean that everybody in the audience is seeing at all the same play: it's quite a false assumption that there's some kind of common denominator which everybody likes in a Shakespeare play. *Hamlet*, for instance. One boy sees a nice lot of stabbings and murders, royalty stomping about, grand clothes; Viennese professors see a subtle psychological dilemma; somebody else hears beautiful language beautifully spoken. And yet they're all watching the same play, *Hamlet*.[44]

This polyphony of response, necessarily intensified in the novel, was something that Hughes welcomed. In an introductory essay to *In Hazard*, published in 1966, he makes a clear distinction between a

single, consciously intended interpretation of a text (which he refers to as mere allegorization) and the manifold interpretations beyond an author's control. *In Hazard*, he admits, is capable of being read in ways he never considered while writing it, yet these are wholly valid and valuable readings. The distinction is reminiscent of that made more dogmatically by Umberto Eco in *The Role of the Reader*, between closed and open texts.[45] As Eco writes elsewhere, these ideas were certainly not original when he set them down.[46] Indeed, in 1938 R. G. Collingwood stressed this phenomenal aspect in *The Principles of Art* where he terms the audience the artist's collaborator (as Eco calls the reader, 'an accomplice').[47] For an artist, Collingwood writes:

> The audience is perpetually present to him as a factor in his artistic labour; not as an anti-aesthetic factor, corrupting the sincerity of his work by considerations of reputation and reward, but as an aesthetic factor, defining what the problem is which as an artist he is trying to solve – what emotions he is trying to express – and what constitutes a solution of it. The audience which the artist thus feels as collaborating with himself may be a large one or a small one, but it is never absent.[48]

By having to work and discover their own unique interpretations of the text, readers thus enact the themes they find within it, participating in the creation of the work as a whole. In her review of Hughes's first volume, Amabel Williams-Ellis wrote: 'Mr Hughes seems to have a prodigious idea of the intellect of his readers; indeed, he possesses as much respect for them as Mr Arnold Bennett has contempt.'[49] It is this 'prodigious respect' which makes his work so demanding and equally so rewarding.

Chapter 2

A High Wind in Jamaica

Richard Hughes's first novel, *A High Wind in Jamaica*, was published in 1929 and immediately established his reputation as a writer. Its plot is simply told. The work is set in the mid-nineteenth century, in Jamaica, London, and primarily on a pirate ship ranging through the Caribbean. Emily Thornton, ten years old, lives with her shabby-genteel family on a broken-down estate in the Jamaican hills. After a hurricane destroys their house, Frederic and Alice Thornton decide to send their children to England where they will be safer, and their surroundings more civilized. Soon after leaving the island, however, the children's ship is attacked by pirates, they are abandoned to their unwilling captors, and what happens next forms the bulk of the novel. Taken to the pirates' lair, Emily's brother John dies in an accident; another captured young girl, Margaret Fernandez, becomes the mate's mistress and falls pregnant; a merchantman carrying circus animals is waylaid, and its Dutch captain left tied up with Emily who – frightened and confused – stabs him fatally. From being a group of terrified children, the young Thorntons and Fernandezes come to rule the ship like a pack of demons, and the crew are glad to transfer them by subterfuge to a passenger ship on its way to England. Emily, who had come to have a strange emotional relationship with Jonsen, the pirate captain, suddenly turns against him, and her 'betrayal' and testimony in court lead to the crew's eventual execution (thought to be particularly deserved because of the supposed murder of John and the Dutchman). A coda shows the children reunited with their parents in London, and Emily one of a pack of ordinary English schoolgirls, from whom the narrator challenges the reader to distinguish her.

This curious tale made Hughes author of the most talked-about book

of the season. High sales were matched by superlative praise from the critics. 'Wide and instant success seemed to fall on it out of the blue', Hughes later wrote.[1] To a great degree, this initial response – in both popular and critical perception – cast the die for later attitudes to his work, contributing to the misapprehension which has since distorted readings of *In Hazard* and *The Human Predicament*, as well as *A High Wind in Jamaica* itself. For this reason the appearance of Hughes's first novel in 1929 is of particular interest, and it is worthwhile briefly examining its circumstances before turning to the text itself.

A High Wind in Jamaica was written between 1925 and 1928, although he had been contracted for a novel as early as 1922:

> Not long after I left Oxford, a London publisher offered me a small fixed income provided he could have my first novel whenever it appeared. Then I fell ill, and wasn't able to work for some time: so actually that first novel was *A High Wind in Jamaica*, which he didn't get until seven or eight years later. But he was quite calm and happy about it, and I'm glad to think it paid him in the end.[2]

Ideas for the novel, as well as its likely subject, had been with Hughes for some years but as he later explained, 'I had forbidden myself to attempt a novel till I was at least twenty-five'.[3] Sure enough, in his twenty-fifth year, work was begun: intermittently at first, as he also saw his collected poems and short stories to the press in this period, there was a nervous collapse which almost stopped him writing for twelve months, and there was, of course, much research into the literature of piracy and the Caribbean. After being worked on at Garreg Fawr (Hughes's home in north Wales), in London, Capodistria, and finally in Connecticut, *A High Wind in Jamaica* was completed by the end of 1928.

The first British edition was published by Chatto & Windus on 26 September 1929.[4] The dust-wrapper predicted of Hughes that the novel 'should win for him a public as wide as it is already distinguished'. This was also, coincidentally, the date on which Hughes set sail from New York after his latest visit to North America. On arrival in Britain, he found himself author of a best-seller, writing to Henry Leach on 9 October:

> Curiously enough, my novel seems to be getting the kind of success that it missed in America. At any rate, the first impression of 11,000 was sold out in a little over a week, which I must confess seems to me a little odd.[5]

Odd or not, this figure is substantially correct. According to the publisher's printing schedule, a first impression of 10,000 copies had to be supplemented within days, and a further 20,000 copies were printed before the end of 1929 alone. As well as this evident popular success, the novel enjoyed considerable praise from critics. The book's reception, though, reveals a curious pattern of insight and misunderstanding, and this is particularly interesting for it was here that the 'mould' of Hughes's novelistic reputation was cast, and fundamental misapprehensions may be seen set into it from the very beginning.

It should be emphasized that, with very few exceptions, reviewers immediately recognized *A High Wind in Jamaica* as an important novel. What sort of novel they considered it, however, is of equal importance. Lyn Irvine's review in the *Nation* suggests the enthusiasm provoked by the book:

> Most serious novel-readers must have felt during the past ten or twelve months that if fire and brimstone descended upon the race of novelists and destroyed them, the world would gain rather than lose. But a novel has just been published by Mr Richard Hughes which explains and justifies the clemency of heaven.[6]

From amongst the general praise (of which Irvine's, it must be said, is the gushiest), two broad responses are detectable. There were, firstly, those full of praise for the author's descriptive powers, yet found themselves confused over what the work was actually about. The second group also praised the evocative language of the novel, but were decided that its subject was the mind of the child. Typical of the first response was J. E. S. Arrowsmith, in the *London Mercury*, who predicted success for the novel, for its powers of evocation alone:

> Everyone will read it. Mr Hughes's descriptions of the earthquake which preceded that high wind and of the high wind and torrential rain that followed will ensure that. Such a beginning would be cause enough for the author to get away with anything.[7]

The novel as a whole, though, seems to bewilder Arrowsmith in the end: the children he finds 'not as other children are'. Sudden intrusions of death and violence into the narrative are regarded as unrealistic, and Hughes's handling of them found inexplicable. He sees no metaphorical connotation in the title, calling it 'almost pointless' and

suggesting 'Captured by Pirates!' as more apt.[8] *John O'London's Weekly* also enthused over the fine writing in the rest of the novel, but confessed that 'Mr Hughes's purpose in *A High Wind in Jamaica* is not very plain'.[9]

The second type of response concentrated on the idea that the novel was principally about children. Cyril Connolly (in the *New Statesman*) began with a straightforward, 'This is an admirable novel', but went on to assert:

> Though anybody would enjoy *A High Wind in Jamaica* as fiction unless they disliked pirates, children, animals, satire and travellers' tales reinforced by modern sensibility, the inner significance will only exist to those who have been baffled by the child mind . . . the heartlessness, egotism, and animal grace of children not sophisticated by all the promises of the catechism.[10]

The same line is taken by *The Times Literary Supplement* review, by L. P. Hartley in the *Saturday Review*, and by V. S. Pritchett in the *Spectator*; the last-named calling it, 'a most profound study of child character'.[11] Such praise for the novel as an almost clinical study of juvenile psychology was again accompanied, though, by puzzlement at its more exotic episodes, and the idiosyncratic manner of its telling. Hartley, for instance, curiously accuses Hughes of 'exaggeration', and Pritchett confesses to finding Emily's murder of the Dutchman (a central act in the novel) inexplicable. The matter of *A High Wind in Jamaica* and how it is written were equally misinterpreted, then, as these contemporary reviews indicate. While the descriptive power is acknowledged, there is no recognition of the extreme sophistication with which the narrative is presented to the reader; of the duplicitous complexity with which Hughes uses the storyteller to pose an elaborate riddle for his audience. For some reviewers, it even seems (despite all evidence to the contrary) that the narrator is Richard Hughes himself, telling a story. For one, it is Hughes who has 'never . . . visited the island since 1860' rather than the mercurial narrator.[12] L. P. Hartley's description of the novel as 'essentially a "tall" story . . . flouting verisimilitude' is indeed accurate. The work undoubtedly contains exaggerated and inaccurate details;[13] however, he solemnly regards these as mistakes and 'grounds for criticism', rather than as a deliberate and integral part of a fictional narrator's storytelling.

The book's subject, too, was represented in an over-simple and misleading manner. Reading it as being 'about' pirates or children,

critics failed to recognize, let alone call, Hughes's bluff in the riddling game he plays with his reader. As with many other literary works which have happened to become best-sellers, great popular success seems to have contributed to a misconception of it. *A High Wind in Jamaica* was thus labelled a book about 'the difficulty of understanding children'[14] – a gross simplification encouraged by the inter-war fad for simplistic psychology, and by the current fashion for an 'understanding' indulgence towards children (an attitude satirized by Hughes in a story from this period, 'Telephone Travel').

The author himself was aghast at how his work was commonly regarded. Its instant popular success was chiefly attributable, in his view, to the fact that 'it gave people something to argue about'.[15] The reputation which *A High Wind in Jamaica* rapidly acquired was a genuine shock to Hughes:

> I myself was entirely astonished at the controversy my innocent tale aroused. I had not set out to change anybody's ideas about anything. I had a story to tell. My story chanced to be about children . . . [16]

He was not merely surprised at this reception, but deeply disappointed at the ironical effect of the work's popular appeal, when he wrote in 1938:

> Perhaps one of the worst misfortunes which can befall a book is a sudden wide success: because that success is often due to something more or less irrelevant which comes to cause the main theme of the book to escape notice. This happened with my first book, *A High Wind in Jamaica*.[17]

It is not only Hughes's own words which encourage a reassessment of the novel, but the irresistible evidence of the text itself. *A High Wind in Jamaica* has a very different tale to tell than has hitherto been realized: more difficult and rewarding; more complex, and far more rich.

To understand *A High Wind in Jamaica*, it is necessary to understand Emily; to understand Emily, it is first necessary to understand the voice which tells us her story. The narrator of the novel begins by seeming to hover over Jamaica, considering the island's history and geography; moving nearer, it focuses on the Thornton family, and then on its younger members. Soon it concentrates almost entirely on the enigmatic figure of Emily, whose eleventh year is covered exactly by

the duration of the narrative. As the story progresses, we close in so near that her image fills the screen, as it were, provoking horror and wonder in the reader. And then here, at the threshold of her mind, the narrator seems to pause and withdraw – leaving the reader to consider and decide upon her mysterious nature. This accomplished use of narrative depends not upon a single, simple narrator, but on a complex narrative structure employing a range of voices, and, within this range, a principal narrator who plays a variety of games and tricks on the reader.

There is, then, not just one anthropomorphic narrator. Rather, there exists a whole rhetorical assembly of voices which contradict one another, change tone, attitude and even identity – Proteus-like – according to the needs of the text. The use of this mercurial narrator noticeably evokes the practice of oral storytelling, about which Hughes was so enthusiastic himself. (During the 1920s he regularly broadcast stories on BBC children's radio, making them up as he went along, prompted by objects suggested by listeners.) As for a traditional storyteller, the narrative persona in *A High Wind in Jamaica* actually acts out the story and invokes the audience's participation in the fulfilment of the work: mimicking characters, assuming omniscience, pretending ignorance – all with the covert intention of manipulating the audience's response.

A High Wind in Jamaica teems with voices, products of the narrator's sly ventriloquism. To begin with, the very number of different languages used in the novel is noticeable: apart from English, there is Jamaican patois, Spanish, French, German, Italian, Greek and even a little Welsh. The murdered captain's last words are said in Dutch, and when Jonsen attempts to run an auction in Cuba he does so in Danish! The narrator also dissembles in how he quotes foreign languages, sometimes giving the original words, sometimes an English translation. This mêlée of languages not only reflects the polylingual nature of the Caribbean (especially during this colonial period), it also indicates, by suggestion, Emily's new circumstances on the pirate ship. The unstable, dangerous world into which she is precipitated is reflected in this instability of the novel's language: a verbal equivalent of the earthquake which shakes her confidence in the unchanging nature of life. The shifting languages also hint at the mercurial duplicity of the narrative itself, and the multiplicity of voices used by the narrator.

A number of voices in the novel are explicitly labelled. There are, for

example, the pirate cook's gallows speech (reproduced verbatim from *The Times*), and the three letters to Mr and Mrs Thornton: from Emily, John and Captain Marpole. These give interestingly different accounts of what happened on board the *Clorinda* after the vessel left Jamaica. Emily's is short and dutiful, saying nothing of herself and mainly describing the cargo of turtles. John's, which follows, is even shorter and tells proudly how he and his sister have learnt to hang from the rigging by their heels. Emily's silence on this hazardous game is an early hint of how much less innocent than her brother she is. Both letters, too, indicate how quickly new acquaintance and experience seem to have displaced parents and home from their minds. These letters are written on the same day that they left Jamaica, it later transpires, though they take weeks to arrive. By remaining with the lonely parents after they receive this mail (rather than rejoining the children), the narrative makes these light-hearted letters very poignant, inspiring the reader to share the Thorntons' fears: 'That was the last news they could expect for many months. The *Clorinda* was not touching anywhere else. It gave Mrs Thornton a cold feeling in the stomach to measure just how long.' (HW,57) These fears then seem justified by Captain Marpole's letter which arrives some weeks later. This third first-person voice – also reproduced without the narrative returning to the children – brings the parents' worries to life in the most nightmarish way, for it seems to tell of their children's death.

The captain's letter reveals the man better than any exposition. It is, in fact, a work of art in its own right. The letter begins by giving a set of nautical bearings for the voyage. The straightforward 'log book' tone of these reflects Mrs Thornton's impression of him as a no-nonsense sea-dog with 'clear blue eyes of a translucent trustworthiness' whom she believes 'too good to be true'. (HW,51) As soon becomes clear, however, this fussy exactitude about their course is a way of avoiding the point – that he believes all their children murdered. His story of the ship's capture by pirates then moves from truth to half-truth (as the actual account which follows in the novel makes plain). The action he describes is one of high drama and violence, an episode from the adventures of Captain Kidd or Bluebeard: a dozen disguised gun-ports are suddenly unmasked, 'fifty or seventy ruffians of the worst Spanish type, armed with knives and cutlasses' come on board and use 'every possible threat which villainy could devise' to make him reveal where the money on board was hidden. (HW,59) Marpole's voice here betrays his deceit (for he actually abandoned the children). The melodramatic

choice of phrase suggests an origin in half-remembered story-books rather than memory.

When he finally comes to the point Marpole shifts from half-truth to plain lies, in claiming that all the children were butchered before his eyes and their bodies cast into the sea. As the reader quickly learns, he flees the scene as soon as he is able, without a thought for Emily and the others. Even Marpole, however, confesses he can imagine no reason for their murder, and puts it down to 'sheer, infamous wantonness'. (HW,60) He finishes with a flourish of mendacity (having got into the swing of things, as it were) by stating that 'considering the sex of some of the poor innocents . . . I am glad to say [they were] done to death immediately . . . There was no time for what you might fear to have occurred'. (HW,61) By this clumsy attempt to assuage fears of rape, he manages only to make things even worse by bringing it to mind. The Thorntons, however, have no reason to doubt Marpole, and take his words utterly at face value. As we see from the example of these letters, then, the novel contains several explicit voices which deceive and dispute one another in interesting ways, alerting the reader to how artful and deceptive the narrative as a whole can be. By setting up these differing, even contradictory voices, Hughes disallows any calm reception of the story and forces the reader constantly to suspect and re-evaluate what is being said. As he wrote a few years earlier, the writer

> has to remember that the reader is not his friend, but his enemy. The normal mind does not allow itself to be excited or receive suggestions if it can help it. The poet has to outwit the reader and throw him off his guard. The attack must not come from the direction from which it is expected.[18]

This continual, subtle shifting of tones, even within the main storyteller's narration, is a crucial tactic within Hughes's rhetorical strategy of changing 'direction' and challenging the reader's wits.

What now can we say of this main storytelling persona in *A High Wind in Jamaica*? The novel begins with a rambling anecdotal account of the island's Derby Hill Estate (where the ex-slaves had taken over and established tyranny over their former owners). This place actually plays no further part in the story, but the colourful account serves to establish immediately the narrator's character as witty and avuncular – someone to listen to. Events in the novel take place around 1860. This, the narrator states, 'is a long time ago now' (HW,4) when he had

business at Derby Hill. At the same time, a number of contemporary references are made which together insist that the story is being narrated in the 1920s. A comic scene at the pirates' refuge on Cuba is described 'just as if the cinema had been invented', (HW,110) which places it well within the twentieth century. It is also said that the child-mind of Laura 'lived in the midst of familiar relics of the baby-mind, like a fascist in Rome', (HW,159) which further places the narrative well after the rise of Fascism in Italy in 1919. The identification of viewpoint between storyteller and contemporary reader here unequivocally places the narrative in the 1920s. Apart from concluding that Hughes chose to invent an extraordinarily aged narrator, then, we must accept that this is simply an appropriate mask to wear for opening the novel, and that others will similarly be put on and cast aside, according to the demands of the text. The storyteller is far from being a passive, objective observer, then. As will be seen, he is continually manipulating how things are seen and how the reader reacts to them: sympathy is extended then withdrawn; at one moment he appears omniscient, and at the next pleads ignorance or even withholds information for a while; perspectives on characters, too, are changed abruptly to dislocate the reader's attitude to them.

This modulation of the narrative is even slyly signposted from within the novel itself. For example, when the Jamaican earthquake occurs, Emily's reaction is to practise telling the story of it in different ways, testing their effect:

> First she held an actual performance of the earthquake, went over it direct, as if it was again happening. Then she put it into Oratio Recta, told it as a story, beginning with that magic phrase, 'Once I was in an Earthquake'. But before long the dramatic element reappeared – this time, the awed comments of her imaginary English audience. When that was done, she put it into the Historical – a Voice, declaring that a girl called Emily was once in an Earthquake. And so on, right through the whole thing a third time. (HW,35–6)

The auction of the *Clorinda* loot in Cuba also prompts the following comment:

> But auctioneering is an art: it is as easy to write a sonnet in a foreign tongue as to conduct a successful auction. One must have at one's command eloquence without a hitch: the facility of kindling an audience, amusing them, castigating them, converting them, till they rattle out increments as a camp-meeting rattles out Amens. (HW,97–8)

In both of these passages, the narrator is also describing how his own narrative works. These allusions to the rhetorical art of the storyteller and auctioneer hint to readers the stratagems actually being applied to them!

One of the most obvious is an abrupt switch of tone, to another seemingly at odds with the first. This occurs when the relaxed, idiosyncratic voice of the main storyteller (he uses words like 'energeticalness') makes way for one which is brisk and factual, describing something with great attention to detail, before reverting to the familiar accent again. This first happens with the initial evocation of Jamaica, when the process of sugar production is described, with careful accounts of how the machinery is arranged, what happens at each stage of production, and so on. The practical effect of this is to make the reader work harder, to bring the visual and logical imagination into play. One cannot skim over the description of an industrial process, as one might with the evocation of a tropical landscape. A quite different order of apprehension is required here from the usual reading of a narrative. A similar change occurs when the *Clorinda* begins her voyage, and the narrative breaks off to give an intricate account of the reefs. The abrupt demand made upon the reader to imagine this topographically – to reconstruct it mentally – is repaid later when we learn that the pirates' lair is hidden away behind these treacherous reefs. On two further occasions, this matter-of-fact voice breaks into the story, describing (with the addition of a footnote) exactly how the shark bites, and giving a historical digression on Cuba. Here we see plainly that the narrative voice in *A High Wind in Jamaica* is a strictly pragmatic rhetorical device; where Hughes wants a particular effect, the necessary voice is adapted accordingly (like the right implement drawn from a toolbox). The naturalistic consistency of the storyteller's persona, for its own sake, is simply not regarded as important. It might be said that the narrative's consistency lies only in its own protean, opportunistic inconsistency.

A further use of opposition is that between the supposed omniscience and the ignorance of the storyteller. At times, he professes to a god-like insight into the minds of the characters. The most spectacular instance of this is when Emily (slowly changing from a child to an adult) 'suddenly realized who she was'. (HW,134) When she climbs to the mast-head in order to muse on this in peace, the narrator is able to follow each stage of her thought. By the time she descends to the deck again, the storyteller confides, Emily has decided 'it was much better to

keep her godhead up her sleeve for the present'. (HW,139) Can a narrator privy to such intimate thoughts be ignorant of anything? Apparently so. While the inmost reflections of the characters are open to him, he seems unsure of quite mundane facts. How many pirates actually captured the *Clorinda*? He does not know, but thinks it 'cannot have been more than eight or nine'. (HW,71) From whose plate does Margaret Fernandez eat when she shares the cabin with Jonsen and Otto? 'Probably she used the mate's when he had finished'. (HW,163) The narrative is shot through with such professions of ignorance. Qualifying expressions such as 'probably', 'I believe' and 'I suppose' occur again and again. After Emily's murder of Captain Vandervoort, her mind too becomes closed to the narrator: 'I can no longer read Emily's deeper thoughts or handle their cords. Henceforth we must be content to surmise.' (HW, 276) By playing in this way with the narrator's omniscience, Hughes first of all lends him an air of anecdotal veracity (when it suits), making him appear genuinely unsure, like anyone remembering a tale from the past. It also functions as a way of deliberately puzzling the reader. If the narrator were consistently omniscient or consistently unsure, then the reader would feel secure about how to react to the text. By switching from one mode to another, however, the narrative forces the reader to evaluate and consider every statement individually. Having become accustomed to an all-knowing voice, the reader is frustrated by these confessions of ignorance and is thus encouraged to fill in the 'gaps'.

A subtler variation in voice occurs where it actually takes on the tones of a character. This temporary modification is quietly done: it is neither marked off by quotation marks nor overtly stated which character is influencing the narrative. These very localized changes (sometimes lasting just a few words) are easily missed therefore, but to do so is to lose a whole dimension of how the story is told. Most often it is Emily's reactions one is secretly invited to share in this way. A brief but telling example is when little Harry Fernandez mentions sniffing clothes to tell their owner. Emily says nothing, but a few lines later occurs the phrase, 'it showed what sort of people Creoles were, to talk about Smell in that open way'. (HW, 26) This is not the voice of author or storyteller; the narrative here has taken on the colouring of Emily's view of things, reflecting the girl's inherited snobbery towards the Creoles.

Another significant use of this device occurs in the passage where the frightened Emily stabs the Dutch captain to death. While the crew and

other children transfer to the captured *Thelma* to see the circus animals
set upon one another, Emily, with her hurt leg, is left in Jonsen's cabin
with Captain Vandervoort tied up on the floor. The cruel goading of the
sea-sick lion and tiger to fight is intercut with scenes of Emily and
Vandervoort. The latter's agony is implicitly compared with that of the
animals: while the beasts lie 'growling (or groaning) slightly',
(HW,173) the Dutchman 'lay still and groaned'. (HW,175) It is only at
the very end of this scene that the narrator's sympathy is fully extended
to him. All the while he is begging the child to help him, but his words
are in Dutch and neither does the girl understand him nor is the reader
given a translation. Only when he has been stabbed, and is about to
die, are the man's words given in English: '"But, Gentlemen, I have a
wife and children!"' (HW,177) Before this poignant vista into
Vandervoort's feelings, it is Emily's perception of events which is
implicitly presented: 'there is something much more frightening about a
man who is tied up than a man who is not tied up'. (HW,173) On how
the bound man feels, the narrative is silent. The reader is then reminded
that 'the terrible Dutchman' is physically unpleasant: 'Remember that
he had no neck, and the cigar reek'. (HW,174) As he reaches for the
knife to free himself, 'the veins on his forehead stood out . . . His
fingers were groping'. (HW,175) The narrative presents him not as a
helpless victim, but as an object which inspires fear, almost a monster
(who, moreover, smells nauseatingly of cigar smoke). It seems almost
natural, then, when the child lunges from the bunk and stabs the man to
stop his groaning and groping to untie himself. Even here, it is Emily's
'pain and terror' (HW,176) which are referred to, not her victim's. The
adoption by the narrative of Emily's perspective, here and elsewhere,
seduces the reader into sharing this viewpoint – only to have it rudely
undermined, by Vandervoort's pitiful dying words, for example.
Confirmation of this trick – of the narrative reflecting the 'colouring' of
a character – was made by Hughes in an interview given in 1967. In *A
High Wind in Jamaica*, he says, he describes a scene, 'at second hand
in a way. I describe it as it appeared to the last person who spoke,
though not in his words'.[19] This is almost exactly what happens in those
scenes referred to above.

 As well as mimicry, other devices such as scripted dialogue and
ellipsis are also brought into play. Dialogue is used to convey unspoken
thoughts effectively and economically, a facility well shown on the
children's first night in the hold of the pirate ship. This scene is
presented almost entirely through speech, laid out as in a dramatic

script. While the little ones bicker, Margaret Fernandez is heard to be sobbing quietly, yet refuses to say why:

> RACHEL. I believe she's frightened! (Chants tauntingly) Marghie's got the bogies, the bogies!
>
> MARGARET (sobbing out loud). Oh you little fools!
>
> JOHN. Well, what's the matter with you then?
>
> MARGARET (after a pause). I'm older than any of you.
>
> HARRY. Well, that's a funny reason to be frightened!
>
> MARGARET. It isn't.
>
> HARRY. It is!
>
> MARGARET (warming to the argument). It isn't, I tell you!
>
> HARRY. It is!
>
> MARGARET (smugly). That's simply because you're all too young to know . . . (HW,88)

Margaret is thirteen and very aware of her difference from the other children. As the *Clorinda* leaves Montego Bay she regrets this age-gap: 'They were all younger than she was: which was a pity', and also notices 'How handsome Mr Thornton looked'. (HW,54) Awareness that she is no longer quite a child means she is also aware of the possibility of rape by the pirates. This is, however, only implied by her words, and the incomprehension of the others only makes her situation seem all the more lonely and frightening. Margaret's 'smugness' about her vulnerable position is also interesting. Though genuinely frightened, this fear becomes something to be proud of as it distinguishes her from the others, makes her feel special. Her smug response to Harry, then, hints at a more 'adult' realization of her own sexuality, something which takes place in the extraordinary circumstances of a pirate ship. This is later confirmed when she begins to follow the mate Otto around like a lovestruck teenager, and eventually moves into his cabin.

Another characteristic of the narrative is the use of ellipsis. Key

examples of this are Margaret's sexual relationship with Otto, and John Thornton's death. Margaret is certainly said to have begun sleeping in the mate's cabin, and then – in London – there are two oblique references to her 'condition'. These facts are understated, however, and it is left to the reader to realize what is happening: that a thirteen-year-old child spends her nights with the captain and Otto, is having sexual relations with the latter, and becomes pregnant. The handling of John's death also shows the narrator making a point by what he deliberately omits. Immediately after John's fatal fall, it is said that Emily misses him, but thereafter it is as though he had never existed: 'his disappearance was strictly taboo between them'. (HW,193) One thing after another happens without mention of him: the capture of the *Thelma*, the circus animals' 'fight', the Dutchman's murder, Jonsen's scheme to pass the children on to the steamship. When, finally, John suddenly comes into the captain's mind, 'something he had completely forgotten about till then', (HW,243) it is quite possible that the reader – led on by the storyteller – has forgotten the boy's existence too. In this way, the reader is also implicated in the children's apparently callous forgetfulness.

The whole way in which the teller narrates the novel seems to leave it deliberately 'incomplete' in a number of ways, then. This 'incompletion', though – the lacunae of viewpoint, plot, moral perspective, and the problem of Emily's identity – do not mean that the work is unbalanced, or strained, or amoral. Instead, by requiring the reader's active, imaginative participation to fill in these 'gaps', *A High Wind in Jamaica* contains an even greater potential of meaning and insight. This is only realized, however, by engagement with the demands of the text and its covert patterns of imagery, hidden beyond what Hughes termed the 'ass' of chronicle, of the apparent story being told. An understanding of the novel must be actually assembled by the reader: taking these disparate voices and other elements of the work, and completing it by relation of these parts.

It is particularly apt that Hughes's first novel should exploit so fully the shifting identity of its mercurial narrator, for a principal theme within the book is the puzzle of identity, of who is Emily. The major challenge set the reader is to comprehend the mystery of what lies within her mind. The whole narrative gradually but inexorably homes in on this problem, until all we can see is Emily's enigmatic face: 'that inhuman, stony, basilisk look' (HW,276) which can outstare an alligator. The closer he approaches, however, the less the narrator tells

of her. The reader can only gain such intimate knowledge by seeking it out from the clues available. In the closing lines of the novel, the narrator confesses that he cannot distinguish this extraordinary being from the crowd of ordinary schoolgirls who surround her: 'perhaps God could have picked out which among them was Emily: but I am sure that I could not'. (HW,284) These parting words form a direct challenge to consider what distinguishes her, and how extraordinary or not she actually is. In mastering the maze of the narrative, with all its traps for the unwary, the reader is then able to discern other patterns of metaphor and allusion within the novel, weaving a variety of shapes but all – like the narrative structure itself – ultimately revolving around the mystery of Emily.

Almost every sentence, every image, in *A High Wind in Jamaica* ultimately reflects back on Emily, and the contents of the novel only achieve coherence when her central importance is recognized: not as a conventional naturalistic protagonist, but as the focusing consciousness of the text. The increasing opacity of her mind to the reader only makes this all the more important to understand. To investigate this progress of Emily, the conditions which surround her – the alembic into which she is plunged by Hughes – will now be examined. The development of her mind itself is then traced as far as possible, until it becomes obscured and lost to view. This 'incompletion' of the novel's narrative component is countered, however, by its non-linear content, the many patterns of metaphor and allusion inlaid into the text, each of which circles around Emily and contributes a further dimension to our understanding of her, and so of the whole novel.

The world described in the novel was not new to Hughes. A passionate sailor, he had even served on a vessel similar to the pirate schooner. Jamaica, too, was familiar to him, albeit at second hand. His mother had lived there as a child, and recounted her vivid memories of it to him. There were also two documentary sources which he made use of. These described the incident of the *Zephyr*, a merchantman with some children on board, which was captured by pirates off Jamaica in 1822. The first of these was a short manuscript memoir (shown to Hughes by a friend) written by an old lady who had been a child on the brig, describing the kindness of the pirates, who had taken her onto their ship for a while and fed her on crystallized fruit. It can easily be imagined how the incongruous juxtaposition in the story appealed to

Hughes, and this brief memoir was evidently rich enough in possibilities to provoke Hughes into beginning his first novel.[20] The second account of the incident was written by the *Zephyr's* mate, Aaron Smith, who published it in 1824 as *The Atrocities of the Pirates*.[21] According to Smith, the pirates kidnapped him to work for them, and he was taken to Cuba, and there escaped to Havana where he was arrested for piracy himself. Put on trial in London, he was acquitted, and his book was probably a bid to make some money from public interest in the case.

Smith's book was of use to Hughes in two ways. Firstly for practical details of the everyday life of pirates, and also for its tone. The mate of the *Zephyr* writes in a voice of strident, almost hysterical, self-justification which makes one suspect that he 'protests too much', that he had been an accomplice of the pirates after all. This is detectable in the very title of his book, worth quoting in its entirety: *The Atrocities of the Pirates: Being a Faithful narrative of the Unparalleled Sufferings Endured by the Author During His Captivity Among the Pirates of the Island of Cuba: With an Account of The Excesses and Barbarities of Those Inhuman Freebooters*. His overblown self-dramatizing style is noticeably reminiscent of how Captain Marpole writes in the novel. Marpole's deceitfulness leads him to a peculiar, melodramatic form of expression, which almost betrays him by its excess. Hughes may well have suspected a similar reason for Smith's style, and it certainly seems to have influenced the tone of Marpole's letter.

In a 1931 interview, Hughes detailed the other practical research he had done, reading old navigation and travel books, and 'every reference in *The Times* to the West Indies over a period of fifteen years, and every reference to piracy in the first half of the last century. Having done all this reading, I gave myself six months to digest it, and, more important still, to forget it.'[22] Examination of *Palmer's Index to The Times* (a primary source which Hughes will have used in his reading at the British Museum) confirms the novel's assertion that piracy in the Caribbean 'had long since ceased to pay' (HW,95) by mid-century, and was already an anachronism. Between 1850 and 1860, for example, only two or three reports per year are listed under 'Piracy', and these are generally concerned with events in the Mediterranean or Pacific regions. A generation earlier, however, dozens of occurrences appear every year, in which West Indian pirates have disrupted shipping, in particular those from Cuba (where Jonsen and his crew have their base).

By selecting from these sources and transforming them imaginatively, Hughes creates a physical, social and psychological context for Emily's development within the novel. Despite the apparently relaxed, conversational tone of much of the narrative, this context is very carefully prepared in terms of period, of place, and especially of her family, the microcosm of society in which she is placed. All of these, we see, provide parallels to Emily's experience of growing up, an agony ruthlessly magnified and sustained by the author for the purposes of his art.

To begin with, Jamaica itself is said to be in a 'transition period' after the emancipation of the slaves. (HW,3) This transition undergone by the island in mid-century was profound. The old economic order, based on sugar plantations and slavery, had been brought to an end by the emancipation of 1834 (referred to in the very first words of the novel), and by the Sugar Equalization Act of 1848 which removed protective duty from the island's main export. The result was a severe economic depression, and the years around 1860 were also notable for earthquakes, droughts and outbreaks of cholera and smallpox. As Clinton Black writes in his *History of Jamaica*, 'the year 1860 ushered in one of the unhappiest periods in Jamaica's history', a period which culminated in the Morant Bay Rebellion of 1865.[23] Hughes conveys this situation in terms of imagery rather than exposition, allowing extended descriptions of the ruined Derby Hill and Ferndale estates to speak for themselves. Jamaica is also notable for its curious mixture of tropical landscape with English-sounding place-names. Thus remote rainforest settlements are called Islington, Grantham or Ipswich, for example. This strange juxtaposition obviously appealed to Hughes, who uses unmistakably English names like Exeter and Derby Hill in the novel – exaggerating the sense of an alien, colonial society attempting to live 'normally' on a tropical island, as though still in the Home Counties.[24]

The 'high wind' of the title is also an indicator of the confusion and change experienced by Emily. Having blown through the island, it renders it another place completely:

> You could hardly tell, geographically speaking, where you were. It is vegetation which gives the character to a tropic landscape, not the shape of the ground: and all the vegetation, for miles, was now pulp. The ground itself had been ploughed up by instantaneous rivers, biting deep into the red earth. The only living thing in sight was a cow: and she had lost both her horns. (HW,40)

This unearthly storm is echoed by the recurrent use of a hurricane as a metaphor. The 'high wind' occurs not only in the opening chapters of *A High Wind in Jamaica*, but blows throughout the entire book. Emily's conscience is said to rage around her soul 'like a whirlwind'. (HW,156) The ship's black pig, so loved by the children, is called 'Thunder'. (HW,161) When Jonsen slides onto the deck, he lands 'like a thunderbolt'. (HW,214) Rachel later attacks him with 'a tornado of punches'. (HW,198) Finally, when Emily breaks down in court and describes Vandervoort's bloody body, the defending counsel has to sit down 'thunderstruck'. (HW,281) This pattern of allusions, then, reminds the reader of the instability and capacity for dramatic change in everything within the novel, from someone's simple physical appearance to a child's capacity for murder. Although the narrative soon moves on from Jamaica and the hurricane, both linger in the reader's mind, setting the tropical, overheated tone of the whole story.

Emily is carefully placed within her family – the smallest unit of society – to emphasize her state of flux. This is done in two ways: with regard to the other children, and with regard to her parents. The children form a spectrum of ages, illustrating the passage from babyhood to adulthood. As Patrick Swinden has noted, they form a continuum with the account of Jamaica's flora and fauna: 'We have moved away from a description of landscape and animals to a description of human beings and how their minds work, what they are like inside. But the move has not been as abrupt as may be supposed at first glance.'[25] The transition is marked in steps of two or three years: Laura at three still a baby and therefore, 'not human', (HW,158) Rachel, five, Edward and Harry, seven, John, twelve, and then Margaret who, at thirteen, considers herself practically grown-up. Emily is to be found at the very centre of this spectrum: not quite a child, nor yet quite an adult. It is the day after her tenth birthday that she travels to Exeter and experiences the earthquake which marks the beginning of her metamorphosis; at the novel's end she is eleven and an utterly different person. In the midst of her captivity, we are told, 'she, like Laura, had one foot each side of a threshold . . . she was ten and a half'. (HW,186,187) Hughes catches Emily at this vulnerable, transitional phase of her development and – by his plot – magnifies its drama and extends it over long months. His evolutionary metaphor, then, has led the reader from the inanimate to the animate, the vertebrate, the child, and finally – with Emily – to the very point where matter, it might be said, becomes aware of itself, able to take responsibility for its actions.

Emily also encapsulates the tension between her parents. The difference between the two is marked, and both have left an impress on their eldest daughter's mind. Alice Thornton is sentimental and self-absorbed, has no idea what her children are like, and is also a snob. This snobbery is clear in relation to the Fernandez family. Mrs Thornton is unsure about the children visiting 'lest they should learn bad ways'; the Fernandez children are described as Creoles and said to go barefoot, 'which is a very important point in a place like Jamaica where the whites have to keep up appearances', and finally they have a governess 'whose blood was possibly not pure'. (HW,15) Apart from being offensive, a number of these remarks are simply untrue or misleading. Criticizing the children of so-called 'whites' going barefoot is quite absurd for Mrs Thornton, considering her own children's wild existence, often going naked, and their feet infested with jiggers. The Fernandezes' un-English name, and repeated references to their being Creoles, also tempt the reader to accept a subtle racial prejudice against them. As the narrative also explains though, 'Creole' simply means 'families who have been in the West Indies for more than one generation' (HW,15) regardless of origin. With her petty snobbery, arrogance and cultivated vagueness, Alice Thornton plays no small part in her daughter's estrangement from those around her.

Frederic is a rather different character. To begin with, he 'had every accomplishment, except two: that of primogeniture, and that of making a living'. (HW,44) These words, which might be the opening of a Jane Austen novel, say much about their subject. His social accomplishments, and the implication of a wealthier, elder brother, immediately suggest that Frederic is the younger son of a well-to-do family. The inconsistent use of 'Thornton' and 'Bas-Thornton' throughout the novel also draws attention to the petty snobbery often associated with assumption of a hyphenated name. His two occupations, as shopkeeper in a remote Jamaican town and as dramatic critic for various colonial newspapers, also suggest that he has distant, or not very powerful, connections in the Colonial Service. His failure to make a proper living is compounded towards the end of the novel by his nightly drinking sessions after returning from the theatre. Frederic Thornton is obviously on the way down. His refusal to take up one of the professions (traditional refuge for younger sons) does suggest a certain independence of mind, however. The unconventional, bohemian way in which he allows his children to live, at Hammersmith Terrace as well as at Ferndale, also hints at a more sympathetic attitude to them

than that of his wife. This superiority of imagination is proven when he watches Emily sleep, shortly before the trial, and perceives the awesome complex of thoughts and emotions within her:

> To his fantastic mind, the little chit seemed the stage of a great tragedy: and while his bowels of compassion yearned towards the child of his loins, his intellect was delighted at the beautiful, the subtle combination of contending forces which he read into the situation. He was like a powerless stalled audience, which pities unbearably, but would not on any account have missed the play.
> But as he stood watching her, his sensitive eyes communicated to him an emotion which was not pity and was not delight: he realized, with a sudden painful shock, that he was afraid of her! (HW,275)

It is through Frederic's perception that the most telling description of Emily is thus articulated, in contrast with Alice's which is the most inaccurate. As her parents' daughter, as in so many circumstances in the novel, Emily is placed in a state of tension, and the influence of both may be seen in her: the mother's prejudice towards others; the father's sensitivity and over-active imagination.

In a range of ways, then, Emily is trapped between worlds, and almost driven mad while so held, for the reader to observe her reactions. As she approaches Exeter where her ordeal properly begins (with the earthquake), the sunset is said to appear threatening, and the distant house is 'a sort of ultimate mouse-trap'. (HW,17) Having entered this 'trap', Emily does not emerge from it until a year later, after the trial. This set of conditions, this laboratory alembic in which she is placed by Hughes, helps to expose her nature. To discover more of this, we must now look closer at Emily herself, and then too at that web of metaphors and allusions spun subtly around her.

Emily is not only surrounded by a flux of circumstances, she is in a state of transition herself, on the very point of leaving childhood behind. Hughes conveys this by inciting two contradictory reactions to her: of sympathy and revulsion. By regularly allowing the narrative to take her viewpoint, he invites the reader to see things through her eyes. At the same time, this sympathy is undercut by sudden changes of perspective which show how callous she has been. After being the subject from whose perspective the story is told, she becomes an object of the narrative: a creature who increasingly inspires fear in others.

The narrative then offers a choice of solution to her increasing opacity: that she on the one hand is a helpless victim of circumstance

or, alternatively, a murderous monster of almost supernatural proportion. It could be argued, however, that by making Emily's mind obscure to the reader and then offering these options, Hughes lays a double trap. Not only do these alternatives cheat the reader of a conclusive insight into her mind, the offer of a choice is also misleading. For there is actually no need to choose at all. We need only recognize that both perspectives are valid simultaneously. To conclude that Emily is a monstrous, basilisk-like figure (as the latter pages of the novel suggest) is to fall into the very mode of thinking of which she is accused: that of ignoring others' ways of seeing and feeling, and of treating them as objects. Equally, to regard her solely as an innocent victim is to deny her any individual will and awareness of responsibility, both of which are undeniable, and provide a motive power for the character of Emily and for the novel itself. Rather than choose just one viewpoint, then, it is possible to hold both in mind as equally valuable in estimating Emily. The principle of necessary contradiction, so important to Hughes, is thus seen at the very heart of his first novel. Emily is revealed as both innocent and terribly responsible, pitiful and awesome, at the same time. By capturing her at this particular moment of transition, the rich complexity of a human mind is shown at one of its most revealing stages: as it becomes aware of itself.

Once this is understood, it is possible to plot the development of her mind more accurately, to that point where she becomes a mystery to the narrator, and the spoor disappears. It is here that the importance of the non-narrational element in the novel becomes evident. Inlaid within the text are a very high number of metaphors and allusions which form an integral pattern within the work, complementing those deliberately incomplete and puzzling aspects of the narrational element.

Emily's experiences in *A High Wind in Jamaica* take place within the space of twelve months, from her tenth birthday until she is eleven in the following autumn. Even in its objective chronology, therefore, the narrative is very much determined by Emily. Within this crucial year there are three distinct periods, in which physical locale corresponds to the development of Emily's mind: firstly her life on Jamaica and the *Clorinda* (when she is seen as still a child, the stirrings of adulthood glimpsed *in potentia*); secondly the period on the pirate ship (when the mental changes of puberty are magnified), and finally her return to 'civilized' society on the steamer and in London (when she learns to hide her inner thoughts and promptings, even from herself). These periods are clearly marked off from one another, and

distinguished by the increasing opacity of her mind to the narrator. This in turn subverts the apparently satisfying symmetry of the narrative, leaving the reader with an obscure sense that it has somehow lost sight of Emily. Let us follow her then, as far as we can, until the track peters out, before trying to make out more of her meaning through those elusive, allusive patterns within the text.

It is in the initial, Jamaican stage that the first signs of something strange about to happen to Emily are seen. When the earthquake occurs, she feels more than the ordinary excitement experienced by others: 'She was too completely possessed to be able to see anything, or realize that anyone else pretended to even a self-delusive fiction of existence'. (HW,28) The combination of great sensitivity to her own feelings, with an incapacity to imagine those of others, is what makes Emily distinct, and proves to make her so dangerous.

This aspect of Emily is indicated in her reaction to the runaway slaves' village which she discovers on her birthday. Following a stream into the jungle, she goes beyond the frangipani tree full of humming-birds which marks the usual limit of the children's exploration – 'somehow the celestial vividness of this barrier generally arrested them' (HW,12) – as she also begins now to move beyond the boundaries of childhood. She soon comes across Liberty Hill, a settlement of runaway slaves established years before. As soon as she sees the dark-skinned children, she begins to walk 'with dignity' to assert her superiority:

> Encouraged by the comfortable feeling of inspiring fright she advanced . . . And then, that her cup of happiness might be full, some of the bolder children crept out and respectfully offered her flowers – really to get a better look at her pallid face. Her heart bubbled up in her, she swelled with glory: and taking leave with the greatest condescension she trod all the long way home on veritable air. (HW,14)

Nowhere in the novel is Emily more like her mother than in this scene; inherited snobbery is compounded by a particular sensitivity to her own position, and insensitivity to that of others.

When the children board the ship for England, there is a final hint of what lies within her, in the sly comparison with the vessel's figurehead,

> the big white wooden lady (Clorinda herself), bearing the whole vessel so lightly on her back. Her knees in the hubble-bubble, her cracks almost filled up with so much painting, vaster than any living lady. (HW,64)

When Emily is described a few paragraphs later, it might be that wooden figure again: her face is 'almost expressionless'; her eyes shine intensely (like over-painted ones), and her beautiful lips look 'almost as if they were sculptured'. (HW,65) By regarding others as mere objects, she seems to make herself an insensate thing too. Before this description of Emily and her siblings, the narrator comments, 'they were living creatures just the same, full of promise'. (HW,65) When the eerie comparison of Emily and the wooden lady is recognized, this remark gains an extra dimension of irony: her 'promise' encompasses a whole range of human behaviour, including deceit, utter ruthlessness, and bloody murder.

This promise is fulfilled in the central, shipboard part of Emily's development, that voyaging phase when she becomes conscious of herself. Realizing for the first time that she is a unique individual, she soon comes to wonder what God created 'this particular one, this Emily'. (HW,136) With philosophical rigour she comes to the conclusion that she herself willed it. She, therefore, must be God, and so capable of any act, good or bad. Thus she becomes aware of a capacity for evil – understood in an entirely pragmatic way as something willed arbitrarily, knowing it would harm another. (One of the first things she now imagines, for example, is turning Margaret blind.) This awakening of conscience evokes one of the most powerful images in the novel:

> she never knew when she might offend this inner harpy, Conscience, unwittingly: and lived in terror of those brazen claws, should she ever let it be hatched from the egg. When she felt its latent strength stir in its pre-natal sleep, she forced her mind to other things, and would not even let herself recognize her fear of it. (HW,156)

This image of a terrible, clawed figure emerging from an egg recurs later when Emily (who has since slept with a pet alligator, an oviferous creature) is compared with a basilisk. This fabulous reptile was hatched by a serpent from a cock's egg, and even its look was fatal. This might be a double-sided emblem for the novel: on one side representing a maleficent symbol of Emily's capacity for harm; on the other, a powerful image of Conscience, implacably pursuing her like Nemesis. (The importance invested in this paradoxical image is suggested by Hughes's original title for the novel, 'A Girl in the Egg'.) Like 'wickedness', 'conscience' to Emily is understood in a very pragmatic way, not as an abstract ethical concept, but as a frightening suspicion

that others do not see things as she does, that her actions might actually have consequences beyond herself. Emily is not such a solipsistic creature after all then. 'Conscience', as she imagines it, is an embodiment of the fear that she is not omnipotent, and that others are as much active, sentient individuals as herself.

It is the conflict between her will and this 'conscience' which then leads her to conclude that she is not divine after all:

> Gone, alas, was any shred of confidence that she was God. That particular, supreme career was closed to her. But the conviction that she was the wickedest person who had ever been born, this would not die for much longer . . . Had she not already committed the most awful of crimes . . . the most awful of crimes, though, that was not murder, that was the mysterious crime against the Holy Ghost, which dwarfed even murder . . . had she, unwittingly, at some time, committed this too? (HW,188)

What can this 'mysterious crime' be, which is not the murder of Vandervoort, and which even its perpetrator 'did not know what it was'? (HW,188) Surely it must be Pride (the first 'Crime') – thinking herself the equal, or even the person, of God. Emily's tense mental state at this time can be inferred by her increasingly maniacal behaviour. She declares, for instance, that she is going to kill Rachel, and the five-year-old recognizes the almost insane ruthlessness of her sister:

> Emily was so huge, so strong, so old (as good as grown up), so cunning! Emily was the cleverest, the most powerful person in the world! The muscles of a giant, the ancient experience of a serpent! – And now, her terrible eyes, with no hint in them of pretence. (HW,204)

This new, self-knowing capacity for cruelty (she pursues her sister even when she recognizes her panic) is, in origin, a measure to protect herself: a consequence of her magnified sense of vulnerability. By the end of the pirate voyage, indeed, she lives in terror that someone will discover 'how defenceless she was', and 'feared and hated everybody'. (HW,225) She even considers pushing Margaret into the sea, to prevent her from telling what really happened to Vandervoort.

The final phase of Emily's development is soon dealt with, for it really only poses a question: the enigma of her true nature. This third part of her metamorphosis from child to adult – arrested for so long – commences as soon as she is on the steamer. The bodily change she experiences is a sign of this: 'suddenly something seemed to snap in

her heart' (HW,234) and she has a sort of fit, after which she relaxes for the first time in many months. This new Emily impresses everyone on the steamer with her calm and friendly character: 'She was a nice child: and being a little less shy than formerly, was soon the most popular of them all . . . At least, any one could see that Emily had infinitely more sense.' (HW,244)

By the time of the pirates' trial, the narrator has to confess: 'What was in her mind now? I can no longer read Emily's deeper thoughts, or handle their cords. Henceforth we must be content to surmise'. (HW,276) In fact, long before this he has ceased to give any consistent account of her thoughts. It is as though she becomes opaque to the narrator's gaze. This is, at least, a conceit he allows himself to dramatize her position. 'No one, in point of fact', he writes, 'knew much what Emily was thinking about anything', and the reader too is placed in this situation. (HW,261) Faced with such obscurity, we are presented with a dilemma in any surmise about her. There is the view of Emily held by the court and most of those who meet her, that she is a helpless victim of cruel pirates. This melodramatic conception of events is, however, consistently mocked and undermined by the narrative. The other view, inferred by the narrator (and suspected by her father) is that Emily is a heartless monster. Mr Thornton is actually frightened by her 'inhuman, stony, basilisk look'. (HW,276) This invitation to see the girl as a murderous fiend is the narrator's last bluff, however. To perceive Emily unsympathetically in this way is to regard her exactly as she attempts to regard others, as objects. At the very end of the book, then, the reader is tempted to share Emily's own way of seeing and be implicated in the very 'crime' for which she is condemned! In fact, both views are shown to be valid.

On the one hand, if Emily were so straightforwardly heartless, she could have faced the memory of what she had done with equanimity. She imagines it all too well, however, and this is the reason for that 'subtle combination of contending forces' in her. (HW,275) By the time the trial is over – and Emily has made what seems a condemnation, but is actually a confession – she does achieve a way of balancing these forces, essentially by acquiring an adult's mind. She does this by mastering a capacity for self-deception, a quality which her story argues is almost a necessity to live among others. Thornton wonders, 'Was it conceivable she was such an idiot as really not to know what it was all about? Could she possibly not know what she had done?' (HW,282) Emily is far from being an idiot, and her childish

innocence (suggested by the child's-eye description of the court) is assumed, a way of walling off part of herself from the conscious mind. So it is that in the last scene of the novel, the narrator cannot distinguish Emily from among a 'gentle, happy throng' of English schoolgirls. (HW,284)

This last scene, then, puts for a final time that question posed by the paradoxical presentation of Emily: whether she is truly a monstrous will, capable of anything, or an amiable schoolgirl? It is for the reader to construct the most satisfactory answer: that both statements are true; that any child at that stage in life, placed in those circumstances, would display her capacity for pitiless self-interest. And beyond this lies another question, the enigma which sits at the very kernel of *A High Wind in Jamaica*: the question of how to live, knowing oneself to be in possession of a will to act which is capable of almost anything. This is the dizzying problem with which ten-year-old Emily, and ultimately the reader too, is presented.

We are encouraged to pursue Emily, however, only to have a cloud drawn around her as the narrative approaches a close. This deliberate incompletion is so frustrating, it encourages a more active, creative reading of the novel – to supply our own meanings from elsewhere in the text. Predominantly, this means the very high concentration of metaphors and allusions it contains – like fragments of answers which only make sense when gathered and pieced together by the reader (and pieced together in different ways by different readers, of course!). Far more than either of the novels which followed, *A High Wind in Jamaica* teems with beautiful and striking tropes. Set in the tropical zone, and focused on the luxuriant imagination of a pubescent child, it is appropriate that the novel should be so rich in exotic imagery. These metaphors and allusions are not simply atmospheric, however, but form a series of patterns ranged around Emily, sometimes shadowing the plot, sometimes forming quite discrete shapes. Not only is the narrative enriched in this way, therefore, but extra dimensions of meaning are also added independently from the chronicle of the plot. Many different patterns can be picked out, of references to animals, classical mythology, the theatre, literature (especially the Gothic tradition), and two which particularly reward attention and will be focused on here: sexuality and philosophy.

The pattern of sexual allusions in *A High Wind in Jamaica* is surprisingly extensive and varied. They are unemphatic individually, but together combine to form a real presence in the novel, with several

dimensions. The first of these uses Emily's growing sexualization to trace the growth of her 'adult' individuality. For example, the moment when she discovers her 'self' is described in particularly sensual terms:

> She slipped a shoulder out of the top of her frock: and having peeped in to make sure she really was continuous under her clothes, she shrugged it up to touch her cheek. The contact of her face and the warm bare hollow of her shoulder gave her a comfortable thrill, as if it was the caress of some kind friend. But whether the feeling came to her through her cheek or her shoulder, which was the caresser and which the caressed, that no analysis could tell her. (HW,135–6)

Here the realization of her own body as an object of conscious physical pleasure expresses what is going on in Emily's mind; for the first time she understands the distinction between herself and everything else – the viewer and the viewed. It is paradoxically by imagining herself in both positions – as 'caresser' and 'caressed' – that she comes to understand this.

A second, more disturbing aspect of sexuality in the novel is the discreet presentation of Emily as an erotic object. The most overt occasion of this occurs when the drunken pirates descend to the hold one evening, and Captain Jonsen begins to caress Emily, his voice strangely different with 'a sort of suppressed excitement in it'. (HW,142) Without understanding his purpose, she is nevertheless afraid and bites his thumb till it bleeds. This is later called his 'bandaged member'. (HW,143) The choice of this term (rather than 'thumb' or 'finger') is surely not accidental, providing a phallic suggestion and a reminder of Jonsen's intentions. The young pet alligator which Emily takes to bed on the steamer, and which bites her finger, also has a phallic connotation: it is said to be 'about six inches long', moves jerkily, and has a 'tongueless mouth'. (HW,237) On being caressed by Emily, the creature 'wormed its way' (HW,239) under her nightdress and burrowed down. In the context of sexual allusion in the novel as a whole, the erotic overtone of this second passage too seems undeniable. In both cases, the connotation lends a strange, disturbing power to these moments when Emily's will reveals itself. She does not appear conscious of this aspect of her behaviour, finding 'unaccountable' (HW,144) Jonsen's shame after their encounter, for example. Whether conscious or not, however, sexuality informs more and more of her dealings with others. By the time Emily leaves the ship, she has begun to flirt with Jonsen in a very dangerous manner –

wriggling her body against the captain and calling him a darling – implying that she too might soon end up in Margaret's position.

Presentation of Emily as an object of sexual attention (including the unconscious recognition of it herself) is emphasized by further allusions, in which she seems more literally like an object. We have already noted the implicit comparison of her to the wooden figurehead of the *Clorinda*: this description as an impressive yet inanimate figure can also be recognized as very sexual:

> Emily, with her huge palm-leaf hat, and colourless cotton frock tight over her minute impish erect body: her thin, almost expressionless face: her dark grey eyes contracted to escape the blaze, yet shining as it were in spite of themselves: and her really beautiful lips, that looked almost as if they were sculptured. (HW,65)

The taut body pressing against colourless material, the shining eyes and 'really beautiful lips' combine to make this child's body disturbingly attractive. It is disturbing for two reasons. Firstly, to find it sexually attractive (as the reader is covertly invited to do) is to approach, imaginatively, being an accomplice in Jonsen's attempted child-rape. The second reason is that it identifies an object of sexual desire as literally an object (rather than a person) to the desirer. This is reinforced by the strange, repeated image of Emily upside-down, her dress over her head. When her mother insists she wear a night-gown to swim (for decency), the garment fills with air and tips her upside-down, leaving her naked lower half helplessly exposed. This posture is repeated on the *Clorinda* when Emily swings from the rigging, as her brother writes: 'I hang from the ratlines by my heels which the sailors say is very brave, but they don't like Emily doing it, funny'. (HW,56) The sailors' embarrassment at her position confirms their perception of it as sexually provoking too. On another occasion Emily is said to be so confused, she did not know 'whether she was on her head or her heels'. (HW,229) The presentation of the human body in bizarre, undignified poses is a characteristic of pornographic iconography. In *A High Wind in Jamaica*, Hughes places Emily in the most unnatural position of all for a human, by completely inverting her. In this way, as with a pornographic image intended to arouse sexual excitement, Emily's body is presented as an object – not only to the other characters but also to the reader. Hughes's intention, of course, is not to excite the reader, but to allow a glimpse of her in this way, and then to exploit the disturbed response.

A final aspect of sexuality in the novel is the broader matter of gender. When the children are living in Jamaica they use old bottles as dolls: 'The bottles with square shoulders they called He-beasties, and the bottles with round shoulders they called She-beasties'. (HW,257) As Emily grows up on the pirate vessel, she feels increasingly as though the whole world is divided into 'He-beasties' and 'She-beasties'. Her increasing attraction towards, and fear of, males approaches a crescendo by the end of the voyage, when she dreams of fighting her way in panic through hordes of hairy sailors. At the same time, however, Emily thinks: 'But she loved Jonsen and Otto: how could she bear to part with them?' (HW,229) Then, on the passenger steamer, her relief expresses itself as an escape from one gender's company to another:

> Men! It was perfectly true that for months and months she had seen nothing but men. To be at last back among other women was heavenly. When the kind stewardess bent over her to kiss her, she caught tight hold of her, and buried her face in the warm, soft, yielding flesh, as if to sink herself in it. Lord! How unlike the firm, muscular bodies of Jonsen and Otto! (HW,235–6)

Even the two vessels participate in this primal division of Emily's world. The steamer seems a particularly female ship, dominated by the huge warm stewardess who puts her to bed. The woman's breasts fascinate her:

> Was it conceivable that she would herself ever grow breasts like that – beautiful, mountainous breasts, that had to be cased in a sort of cornucopia? Or even firm little apples, like Margaret's? (HW,236)

Once the children have left the pirate ship, that in turn takes on a particularly male air:

> Jonsen could feel the difference at once: and it seemed almost as if the schooner could. A schooner, after all, is a place for men . . . The lean masculine schooner shivered and plunged in the freshening evening breeze. (HW,239,240)

There is more to this distinction than the fact that Emily is becoming sexually aware. By representing so much around her in terms of gender – the most fundamental distinction between beings of the same

species – Hughes uses sexual difference to show how Emily's whole apprehension of herself and others has changed; an apprehension exaggerated, of course, by the extraordinary position in which the plot places her.

By becoming aware of femality as part of her personal identity, the 'masculinity' of shipboard life comes to represent for Emily the external world, 'that-which-is-not-I'. Thus, in the end, sexuality in *A High Wind in Jamaica* goes beyond its behavioural aspect to encompass that whole relationship between what is 'self' and what is 'other': between the subjects and objects of apprehension. Emily's discovery of her identity, in this context of sexual difference, thus makes her fearfully aware that there are two utterly different modes of dealing with experience, complementary yet also quite strange and alien to one another.

The second major group of allusions and metaphors in *A High Wind in Jamaica* draws on philosophy, especially from the Christian tradition. A cumulative general effect of these references is to challenge the reader to take an intellectually critical attitude to events in the novel. As well as references to an alligator's 'Socratic forehead' (HW,237) and Hobbes's materialist concept of sensation, the narrative also takes on a discursive, philosophical tone at times. Emily's thoughts on 'discovering' herself, for example, are laid out in question-and-answer form as by the Socratic method. When the Thornton children leave Jamaica, their parents' concern about the voyage is expressed in this way: 'Philosophically speaking, a ship in its port of departure is just as much in its port of arrival: two point-events differing in time and place, but not in degree of reality.' (HW,57) This invocation of the Monist viewpoint (like that of the pre-Socratic, Parmenides) by which every thing and event *is*, without the possibility of movement or change, invites the reader to take a similarly playful intellectual attitude to events in the narrative. At the same time, the passage suggests that the worried parents are indulging in sophistry to comfort themselves: it may also be seen, then, as a warning against the deceptive, and self-deceptive, uses to which language and logic can be turned.

There are a number of references to Cartesianism in the novel (as in Hughes's other works): these form a consistent argument against the anthropocentricity and intellectual arrogance associated with that position. The most striking parallel is the key moment when Emily discovers her unique self. By choosing to set this on a ship, and by rendering it in the form of a philosophical disquisition, Hughes invokes

a famous passage from Descartes's *Meditations* where the metaphor of
a person on a ship is used to define identity. This is the summation of
his concept of the mind as a noumenal centre of consciousness, distinct
from, yet aware of, the phenomenal material existence of the body:

> I am not only lodged in my body as a pilot in a vessel, but . . . am very
> closely united to it . . . For if that were not the case, when my body is hurt,
> I, who am merely a thinking thing, should not feel pain, for I should
> perceive this wound by the understanding only, just as the sailor perceives
> by sight when something is damaged in his vessel . . . For all these
> sensations of hunger, thirst, pain, etc. are in truth none other than certain
> confused modes of thought which are produced by the union and apparent
> intermingling of mind and body.[26]

This parallel, then, provides a useful point of reference in under-
standing the philosophical aspect of the novel, which implicitly
contradicts the Cartesian position by seeing as one Emily's sensual and
intellectual growth.

Allusions to Christian tradition number over two dozen in *A High
Wind in Jamaica*. Regarded as a whole, they provide an almost biblical
allegory for Emily's adventures: her Jamaican existence is 'a kind of
paradise', (HW,6) but into this breaks the 'Hell's pandemonium'
(HW,33) of the hurricane. In Santa Lucia there is a nativity play, and
one of the sailors stands as though transfigured. Emily sees 'a violent
road, leading to Hell' before her. (HW,191) Once safe on the steamer,
however, and offered the pet alligator, 'Emily was translated into
Heaven'. (HW,238) Even the pirates' trial has an ecclesiastical mood:

> A criminal court is a very curious place. The seat of a ritual quite as
> elaborate as any religious one, it lacks in itself any impressiveness or
> symbolism of architecture. A robed judge in court looks like a Catholic
> bishop would if he were to celebrate mass in some municipal bath-house.
> (HW,278)

A general effect of these references is to provide an alternative
perspective on the narrative, in contrast with the usually sardonic view
of the storyteller. This forms a useful reminder of how the children
themselves see events. Religion plays a surprisingly important part in
their lives: Emily is able to pray and give thanks to God quite unself-
consciously (before deciding that she herself is the Supreme Being, of
course), and for a time she attempts being a sort of missionary to the

Ferndale servants. 'Onward Christian Soldiers' is sung by John, and again later by Rachel in the 'service' she holds on board ship. While her incantation of '"Gabble-gabble, Brethren, gabble-gabble"' shocks Jonsen as sacrilegious, she herself takes it all quite seriously, telling him, '"You're a wicked pirate! You'll go to Hell!"' (HW,198)

The irony of these allusions, however, immediately deflates any possible allegorical interpretation. In the Jamaican 'paradise', many islanders live in miserable settlements like Liberty Hill, and great cruelties are inflicted on animals by the children. The scene of the Cuban nativity play, a celebration of birth, is actually where John is killed. When José is said to be transfigured, this is not from any spiritual revelation but at the sight of a sumptuous Santa Lucian banquet. When Rachel plays at being a preacher, the mate joins in by pretending to be a crucifix: 'Otto entered into the thing at once, rolled up his eyes and spread out his arms, cross-wise, against the wheel-house at his back.' (HW,197) This is particularly ironic, for Otto will indeed be executed within the year, as a consequence of the children's testimony. The comparison of his trial with the mass is almost as ironic as Rachel's service. The presence of death, of a capital sentence, is described as 'the Real Presence' (HW,278): this is actually a term in Catholic liturgy referring to the presence of Christ in the Eucharist.

By this pragmatic use of philosophical allusion, then, Hughes deflates the rationalistic Cartesian attitude, while at the same time subverting the traditional, Christian, moral perspective on the narrative. In this typical use of paradox, Hughes enlists two contradictory words, 'devil' and 'innocence'. Both appear almost a dozen times: 'devil', 'imp', or 'fiend' applied to the pirates as well as their captives; and 'innocence' applied mainly to the children, principally Emily. Her 'beautiful, innocent grey eyes' (HW,186) and 'innocent little face' (HW,282) are ironically stressed previous to the pirate cook's declaration (after being sentenced to death on her word) that he would rather die now, innocent, than later, guilty of some terrible crime. This paradoxical presentation of Emily and her companions has a neat corollary in the image of 'a poor innocent little devil of a pirate craft' (HW,123) described by Otto, in which both attributes are present.

This ambiguous use of 'innocence' encourages us to seek a wider understanding of the term than the moral sense, one which suggests the growth of knowledge through experience. Just as Margaret 'loses her innocence' in a physical sense on the pirate voyage, Emily loses hers in a mental sense. This happens not because she commits a 'bad' act, but

because she becomes capable of knowing what is harmful to others and what is not: the moment when the 'inner harpy, Conscience' with 'those brazen claws' (HW,156) makes itself known to her. In the end, then, despite the irony with which allusions from Christianity are used, the implicit comparison between Emily's growth from child to adult and the original Lapse remains valid: gaining of the knowledge of Good and Evil changes things utterly. In becoming aware of herself as a discrete being, and thus conscious for the first time of the responsibility she bears for her actions, Emily inevitably loses her childhood innocence (in which she was able to torture birds, unable to imagine another creature's suffering). By 'growing up' in such extraordinary circumstances, she demonstrates how becoming an adult does not involve being a 'better' or 'worse' person, but does mean living with a strange new responsibility, that of being an independent being able to do good or harm, in a world full of similar beings.

A High Wind in Jamaica, then, is a remarkable novel, in which Richard Hughes explores the nature and implications of human consciousness, as revealed in Emily's passage from childhood to self-conscious early adulthood. Yet the work is recognizably a first novel too, by its very exuberance. Hughes uses every possible trick he can to dazzle his audience. In later works, he cut down more and more on what Amabel Williams-Ellis termed an inclination for 'jumping out at you from behind a door armed with a fire-cracker'.[27] Indeed, one reason for the ever longer periods his novels took to write was a determination to eliminate anything which even hinted at being over-written. In this first novel, however, the density and richness of the prose actually correspond to the tropical atmosphere and overheated Gothic ambience of the tale, and contribute significantly to its success as a work of art. When *In Hazard* appeared nine years later, it too took a high wind and a dangerous Caribbean voyage for its subject. As will be seen though, both in its execution and in the themes examined, it was a quite different work.

Chapter 3

In Hazard

In Hazard was published in July 1938, and was an immediate and popular success. Like its predecessor, the new novel was set on a ship in the Caribbean. This time though, the story was set in modern times, and concerned a merchant ship caught in a hurricane of fearsome and unprecedented force. The reactions and behaviour of the officers and crew during the week-long ordeal are told, and the vessel is finally seen towed safely towards an American port. The extraordinary, almost supernatural, experiences of the SS *Archimedes* are seen through the eyes of several on board, but particularly of two young men: Dick Watchett, junior officer, and Ao Ling, a fireman in the boiler-room. While the happy ending lends a superficial conclusion to *In Hazard*, the novel teems with unanswered questions and teasing contradictions, which enable deeper exploration of its true theme: how to come to terms with the perplexity of physical existence, which whirls around us like the storm around the *Archimedes*.

Graham Greene's review in the *Spectator* sums up the favourable response this second novel received:

> It is nine years since Mr Richard Hughes published his former – and first – novel, *A High Wind in Jamaica*. Nine years is a long time: suppose only a mouse had emerged from the enormous gestation. A friendly critic opens the second novel – nervously. A first paragraph puts his mind at rest. Here is the old simplicity, surprise, outrageous humour.[1]

Greene's review is entitled 'A High Wind in the Caribbean', reflecting how natural it seemed that Hughes would again deal with a tropical storm, the Caribbean Sea, a group of disparate characters on a ship. The

general reception of *In Hazard*, indeed, was as a familiar adventure story, a plainly told tale, and this was also encouraged by the marketing of the book (a process in which its author enthusiastically participated). The misleading critical reaction to *A High Wind in Jamaica* was perpetuated, then, in the view of the new work as a sub-Conradian 'Books for Boys' adventure, to use Hughes's own term.[2] Once again, the circumstances of the book's publication are worth examining, to see how they have affected its interpretation.

It was by no means a matter of course that Hughes's second novel would again deal with 'a high wind in the Caribbean'. A novel called 'Quella Famiglia' was started on Capodistria in 1927, while *A High Wind in Jamaica* was still being written.[3] This was to have dealt with the life of an Italian family, 'destitute to the point of starvation, completely incapable of work, by no means picturesque, and always merry'.[4] It was abandoned in 1933, however, when Hughes learnt of an astonishingly powerful hurricane which had swept through the Caribbean the previous November, and of a British merchant ship which had somehow survived the worst of it, without the loss of a single life. Over thirty years later he described the challenge this story seemed to give him:

> I was already in the throes of another novel which this new project would have to elbow into limbo. The book moreover would be utterly unlike anything else I had written or expected to write – or indeed, was fitted by experience to write, for I had never been to sea in steam (any more than, before writing *A High Wind in Jamaica*, I had ever been a little girl). The work involved would be immense. Why, then, this interest in an alien and merely true event so compulsive that I felt under the Muse's explicit orders to drop everything else and write it?[5]

It was only in this 1966 introduction to an American edition of the novel that Hughes confessed the factual origins of his tale, kept strenuously hidden when it first appeared. He made himself utterly acquainted with the experiences of the real-life crew so that, as he later wrote, 'I knew more about the total effects of that wind than any one of them separately knew'.[6] Only then could the real writing begin, in which 'actual material incidents' could be reworked to his artistic purposes, and the ship peopled with an imaginary crew. To have reproduced the crew's reactions as well as the hurricane, would have been to write history, not art. As Hughes himself put it, 'there are no human portraits here, for this would neither have been decent behaviour

to the men themselves nor would it have served my purposes as a novelist.'[7] In the short term, the first reason was evidently important, but it is the second which shows Hughes's distinction between recording 'merely true events' and writing a work of art.

Completed early in 1938, the novel took another troublesome six months before it was ready for publication. There were problems with a recalcitrant printer (who insisted on changing punctuation), and at the last minute Hughes inserted running titles giving the days of the action – acknowledging that the reader might have difficulty with the work's 'difficult time-table'.[8]

The title also caused trouble. Hughes at first preferred the mundane, 'A Sea Story'. When this was understandably rejected, he came up with a whole list of alternatives: 'Force 10', 'No Small Tempest', 'Tempest', 'The Winds Return', 'White Night' and – perhaps whimsically – 'Archimedes Unscrewed'. 'In Hazard' was agreed upon at last, however, and this was accepted with 'A Sea Story' as subtitle. He argued for it thus:

> It is the correct term for danger to a ship at sea (especially where possible blame attaches to the commander): and 'In hazard' is a very fair description of the subject of the book without giving too much away. It is a better description of the book than 'Tempest', because it tends to more include the human element.[9]

By the time it appeared in bookshops, *In Hazard* was *Daily Mail* Book of the Year and the Book Society Recommendation for July. Hughes enthusiastically publicized the novel by writing articles and broadcasting on the subject of hurricanes, and he also made several timely television appearances on the infant BBC service.[10] In the next six years, over 100,000 copies were printed, an extremely high figure which suggests the particular allegorical appeal this tale of a lone British steamer surviving a storm must have held during the wartime period. Chatto & Windus astutely realized that *In Hazard* had the popular appeal which would justify newspaper serialization (the sort of treatment received in later years by writers such as Frederick Forsyth or John Le Carré), and a deal was soon arranged with the *News Chronicle*. This serialization appeared daily between 25 July and 24 August 1938. It must have been a curious experience for Hughes to see his novel published every morning in such a mass medium, with an instant readership of one and a half million. During the serialization a competition was run inviting readers' comments, and a selection of

these was published in the final week as 'They Think *In Hazard* Great'.[11] (It was also reported that Laugharne Carnival had included a float carrying a tableau of the *Archimedes*.)

Critical response was wide-ranging as well as enthusiastic, reflecting the novel's popular appeal, and over eighty notices and reviews are preserved in the Chatto & Windus publicity files. Two broad opinions can be observed in these reviews. The first gives special praise to the evocation of the storm, but finds the stories of the crew over-long and obtrusive (especially in the case of Ao Ling). Glyn Jones, in *Life and Letters Today*, found the hurricane itself excellent, but the crew neuters and the biographical material extraneous, concluding his review, 'I wish Hughes had cut out a good proportion of the non-hurricane matter.'[12] Marie Scott-James, in the *London Mercury*, noted that Hughes seemed indifferent to character but brought the novel to life in describing the tempest. At the beginning, she writes:

> he is writing a straightforward report as banal yet as insidiously exciting as a seedsman's catalogue. Then the hurricane breaks. The poetic observation which Mr Hughes has kept in reserve is here brought into full play.[13]

Edwin Muir's *Listener* review admired the work as a 'meteorological romance', but again found the style more suitable to describing the weather than the crew: 'Mr Hughes's imagination has a touch of inhumanity; we feel that he stands in somewhat the same relation to the characters as to the winds.'[14] The other broad opinion took a contrary view, praising the human element of *In Hazard*. For David Garnett in the *New Statesman*, and Charles Marriott in the *Manchester Guardian*, the novel's chief merit was the handling of the crew's emotions. To James Grant, in *Queen*, it was 'an unforgettable tale of human endurance'.[15] And unlike Glyn Jones, Edith Shackleton, in *Time and Tide*, found the characters far from neuters:

> Mr Hughes's Captain and crew are not stylised figures, but individuals each with their own queer patterns of thought. Even the Chinese hands become individual and comprehensible and the whole life of one of them is shown in some half-delirious twirls of his memory.[16]

This fractured response to *In Hazard* recalls the comparable reception of *A High Wind in Jamaica*, in which critics were divided between those who saw the narrative and descriptive elements respectively as paramount. In both cases there was a failure to

recognize that these elements were equally important, and had to be viewed integrally for the works to be understood properly. *In Hazard*, even more so than its predecessor, is a wholly unified work. It cannot be read as a sort of 'lucky bag' from which some parts (description of engine-room, account of storm) can be kept, and others (Ao Ling's childhood, for example) discarded. All are necessary and interrelated, and it is essential to recognize this in order fully to understand any of them individually. In an essay written soon after the novel appeared, Hughes himself noted this tendency to take a one-sided view of his work. The main theme of *A High Wind in Jamaica* escaped notice, he writes, and goes on: 'it seems to have happened again with *In Hazard*. For, so far as I can judge, the latter has been successful because the description of the storm is said to be vivid and the story to be exciting.'[17] The reasons for this misapprehension are varied. Undoubtedly a part was played by expectations of what sort of writer Hughes was, based on assumptions about his previous writings. Presentation of the work as an adventure story – a view encouraged, for good commercial reasons, by the marketing of the novel – is also part of the game Hughes plays with his reader, yet this bluff remained uncalled at the time. It must be said, too, that there was a continuing misjudgement of his sophistication as a novelist: that the virtuosity and metaphorical power of descriptions, the artful handling of plot, the sly exploitation of narrative personae and other devices for inveigling the reader's participation, all need to be appreciated as they work together towards a single artistic aim.

Detailed examination of *In Hazard* shows that there is indeed more to it than the sum of those parts discerned on its first appearance, and far more than 'a plain sea story about men in a storm', as Hughes wryly termed it.[18]

To approach *In Hazard*, we must first recognize that the storyteller is, in fact, a whole polyphony of voices, modulating continually as Hughes adapts the voice to the changing needs of the text. Without any overt signal to the reader, it becomes – sometimes briefly, sometimes for extended periods – the voice of a series of characters in turn. The whole colouring of the narrative thus changes – chameleon-like – to reflect the crew member under observation: vocabulary, syntax, and even the sentiments expressed become temporarily those of a character. Such changes not only make the narration more vivid, they also serve as

devices to challenge the reader's imaginative response. We can see, too, that the conventional aspect of the narrative – concerned with relaying the plot, the chronicle of the novel – contains a number of contradictory, unsatisfactory or incomplete elements which form a challenge to the reader. In puzzling these out, the narrative structure reveals other aspects, independent of the linear unfolding of the plot: in particular, the complementary biographies of Dick and Ling which stand apart from the main story. By relating this extra-chronological aspect of *In Hazard* to the remainder of the work, a reading can be assembled which justifies the presence of its many disparate, even contradictory parts: in this way it is the reader who brings together and completes the novel, by answering those puzzles and questions framed in the text as a whole.

It is the viewpoint of Dick Watchett, the junior officer, which is assumed most often, reflecting his apparent function as hero of the novel, when this is regarded as a straightforward adventure story. This function is, however, consistently undermined by the irony with which he is presented, suggesting his youthful naïvety and self-dramatization. Dick also serves to contrast with the Chinese crewman, Ao Ling, in the events of his life, his reactions to them, and in his dreams. By doing so, he participates in the novel's submerged dialectic between a series of opposites: conventional occidental and oriental attitudes, action and passivity, empiricism and intuition, factual and imaginative truth. This latter aspect of Dick is left implicit, however. In *A High Wind in Jamaica*, the narrator confesses that Emily's mind is finally beyond him, challenging the reader to fill in the unfinished picture. In *In Hazard* a similar challenge is issued regarding Dick; this time though, the narrator confesses he may have said too much about the character – implying in this way that the picture is still incomplete, so that the reader may discover the full meaning of Dick's actions, thoughts and dreams.

As well as these modulations by character, the principal storyteller has his own very definite set of attributes. Furthermore, this persona is not just undermined by the narrative in a simple, ironic fashion, but undergoes a series of changes in response to the course of the storm. The storyteller himself, then, is a dynamic element within *In Hazard*. His presence is forcefully established in the opening pages – of eighteen uses of the first person pronoun in the novel, half occur in the first twenty pages. As in the opening to *A High Wind in Jamaica*, the narrative does not begin with the actual events of the plot, but starts

conversationally, remarking that the chief engineer is not only called Ramsay MacDonald, he actually looks like him – using something incidental but curious to ensnare the reader's attention before leading into the narrative proper. (MacDonald, of course, was a major contemporary political figure between the wars, being Prime Minister during the events of the novel and until a few years before its publication.) On the first page, too, the narrator remarks that the ship was 'purely a cargo vessel (unless you refuse to class as cargo the Moslem pilgrims she occasionally carried)'. (IH,3) The treatment of non-Europeans as less than human is a theme which recurs in the novel, and this announcement of it in an offensive remark by the narrator, marks him off unmistakably from his author.

The immediate impression, then, is of a bluff, plain-speaking, possibly racist narrator; he might be an engineer connected with shipping, for example. This impression is compounded when he describes the engine-room and other parts of the ship. 'What else shall I tell you, to describe to you *Archimedes*?', he asks, continuing:

> I say nothing of her brilliant paintwork, or the beauty of her lines: for I want you to know her, not as a lover knows a woman, but rather as a medical student does. (The lover's part can come later.) (IH,9)

The strangeness of the ship's world is conveyed by consistently homely or otherwise familiar comparisons. Thus the furnace firing-rod is held in 'a container such as you might stand an umbrella in', (IH,7) and the advent of the hurricane is compared to 'a rapidly spinning top [which] only creeps across the nursery floor'. (IH,31) Such domestic metaphors allow the reader to build up a vivid impression of the *Archimedes* and its extraordinary experiences by a cumulation of familiar but transposed images.

As well as carefully explaining the workings of the ship and weather in familiar, understandable terms, the narrator also makes use of technical footnotes and parentheses. Soon, however, the insistence and even redundancy of these comments become irritating to the reader: does one need to be told that the after-castle is at the ship's stern? And after Navassa Island, the ship is said to be forty-eight hours from 'the Panama Canal (where Mr Rabb was to join his own ship)'. (IH,27) This is surely a supernumerary comment about the supernumerary officer; it is only eight pages since Rabb's destination was carefully explained. Such redundant expressions, together with the tone of excessive

assurance noticed by Edwin Muir, combine to show the storyteller as over-confident, even arrogant, at first. In his eulogy of the ship's strength, there is something dismissive about his treatment of the elements, in a way which dangerously overestimates the power of human artifice against the rest of non-human existence. The narrator's hubris is swiftly exposed when the *Archimedes* is drawn into the hurricane. The much-vaunted, lovingly described turbine-engines become useless, the radio, lights and rudder powerless, and the funnel, the guys of which 'were designed to stand a strain of a hundred tons!', (IH,4) is ripped from the deck. Once the storm takes hold, the early arrogance drops away and the storyteller's descriptive powers are devoted to evoking the power and workings of the cyclone:

> Those waves really had the size and almost the shape of trees – trees galloping about, lashing and thrashing each other to bits, like that game of Kings and Queens which children play with plantains . . .
>
> Huge spires of water would dash at the ship like maddened cathedrals: then the oil spread over them: they rounded, sank, passed away as harmless as a woman's bosom. (IH,119,123)

The reader too is invited to participate in this evocation, is kept guessing about what will happen, so that narrative suspense encourages speculation on the force and consequences of the cyclone.

When Captain Edwardes realizes that the wind-speed is unprecedented, beyond the measurement of any anemometer, the narrator comments:

> For the wind was blowing now with a velocity of about two hundred miles an hour. It begins to be called a hurricane when it reaches seventy-five; and the pressure at two hundred would be seven times greater. To be exposed to a wind like this was of the order of having to cling to the bare wings of an aeroplane racing. (IH,47–8)

For the moment, he makes no further comment. In the very first pages, however, he boasted that the funnel-guys could stand a pressure of one hundred tons, and that a wind of seventy-five miles an hour would exert a pressure of only fifteen tons. Putting these facts together, it is possible for the reader to calculate – by a simple sum – that the funnel must go. (Seven times fifteen equals a pressure of 105 tons on the guys: well over the limit first described.) This is what comes to pass, and only then – when there is a great smoking hole in the deck – does the narrator

himself do the calculation, even then leaving the reader to complete it:

> But the pressure exerted by air (leaving humidity out of account) increases
> according to the square of its velocity: the pressure of a wind at 200 mph
> therefore, would be roughly seven times as great. And that would mean a
> total of . . . but you can work that out for yourself, as Captain Edwardes
> did, in his head, while Mr Buxton ran into the engine-room yelling 'The
> funnel's gone! The funnel's gone!' like a maniac. (IH,72)

By receiving two chances to work out the wind's effect for himself, the
reader thus becomes actively involved in the making of the novel.

Just as the storyteller's tone was affected by the coming of the
hurricane, so its passing affects him too. As soon as the hurricane
begins to abate, his former confident tone begins to return. The wind, as
it slows, is now described dismissively as 'a strong breeze, – a
yachtsman's gale' (IH,213): a sailor's sneer. When a temporary funnel
is set up, the crew are congratulated on their ingenuity: 'they guyed it
very firmly with wire guys (which was very clever in that motion).'
(IH,218) Pride in human technology is reasserted. Then comes the
ostensible conclusion: as the ship is towed gently towards Belize, Mr
MacDonald – who opened the novel – falls overboard and drowns:

> Right up in the peak the look-out stood occasionally shifting his position
> from side to side. Presently he came aft a little, and rang six bells: the only
> bells ever tolled over the grave of Mr Ramsay MacDonald, once a Chief
> Engineer. (IH,273)

Marie Scott-James found the irony of the ending effective but facile.
This is so. The narrator's self-satisfied conceit of a ship's bell tolling
over a watery grave is as conventional and pat as the easy symmetry of
MacDonald opening and closing the novel; as with the over-assured
tone, though, these belong to the fictional narrator and are deliberate,
intended by Hughes to be noticed.

The storyteller's regaining of confidence after the hurricane is a
hollow, unconvincing thing. All it does is provide a superficial, even
glib way of finishing the novel, which would satisfy only the least
demanding of readers. This pseudo-ending is just one of several
inconclusive elements which the 'thoughtful reader' hoped for by
Hughes may recognize in the novel.[19] What is to become of Captain
Edwardes and Ao Ling, for instance? After so much interest has been
aroused in these characters, the reader is left in suspense as to the

captain's future, and whether Ling is executed. There is even a hint that the crew's endurance and courage were ultimately irrelevant to the survival of the ship. The first officer realizes that 'it was their worst disasters which had saved them'. (IH,164) And how is the reader to resolve that fracture between the treatment of the animate and inanimate elements in the novel, as noticed by the early critics? There is the tension, deliberately exacerbated, between the momentum of the plot and the lengthy interludes on China or Dick's childhood which interrupt and frustrate it (so irritating to some early reviewers). The complex time-scale (which Hughes admitted to be difficult) and the many voices and attitudes of the narrator must also, somehow, be accommodated in a coherent reading of the novel. The same is true of the apparent jumble of adventure, philosophy, meteorology and history into which the book sometimes seems in danger of fragmenting. There is even a contradiction in how the work demands to be read: the linear manner in which a fictional narrative is apprehended contrasts with the slower, more cogitative manner by which the technical passages must be comprehended. One reads about the dynamics of a cyclonic system in an utterly different way to how one reads the unfolding of a plot, of 'what-happens-next'.

This 'incomplete' appearance of *In Hazard* need not be seen as a flaw or problem, but may be recognized as an integral part of how the novel works. It is for the reader to devise an understanding of it which encompasses and resolves these disparate and contradictory elements. In doing so, it is necessary to look, in addition to the events of the plot, at other, more covert patterns and discourses within the novel. *In Hazard* contains many 'stories-within-stories'. As well as the biographies of Ao Ling and Dick Watchett, there is a whole sequence of dream-sections linking up different characters; Tung diverts the Chinese crew's attention from the hurricane by telling tall stories, and Captain Abraham does the same when he arrives with the salvage ship. All through the storm, Captain Edwardes records his ship's log scribbled on damp scraps of paper: it is this heap of jumbled notes which will be rewritten as the calm, retrospective official version of the hurricane's incoherent progress. When the storm is over, one officer allows himself to relax by reading Ethel M. Dell (a sentimental pulp novelist of the period). Another, the disgraced Rabb, makes up an entirely fantastic version of events in which he is an innocent, persecuted victim of the captain. Dick Watchett dramatizes himself as a hero saving the ship and overpowering a dangerous Chinese bandit,

then has day-dreams about rescuing Ling and, 'years later, in some desperate fracas in Central China', being saved by him in turn. (IH,257)

All of these different resorts to fiction of one sort or another suggest the various ways in which the crew use imagination to deal with their experience. In a comparable manner, the text implies, the reader must also engage imaginatively with the novel, redisposing and associating its parts in new ways, to create an original, coherent reading of the novel.

In Hazard picks up and develops a major theme of *A High Wind in Jamaica*, that of human consciousness. The first novel concerned primarily that period when the mind becomes conscious of itself, when matter – it might be said – becomes aware of itself. With *In Hazard*, Hughes's concern has shifted outward, to how the human mind becomes properly aware of external reality, of the uncontrollable universe of *things* which lies beyond itself. Through his imaginative re-creation of the storm and the reactions of his fictional crew, Hughes explores the nature of the encounter between consciousness and external reality, from the simple sense of touch to the whole philosophical basis of cognition and empirical science. In a 1966 introduction to the novel, Hughes distinguished between the work's 'inanimate' side (the factual record of the hurricane, matching one which actually occurred) and its 'animate' side, the crew who (though some details derived from the real seamen he had investigated) were the product of his imagination. It is through the engagement of these two major poles of the novel that *In Hazard* will be examined: first the delineation and meaning of the unprecedented storm conjured up by Hughes, and then the reactions to this by the individual points of consciousness on the ship, focusing on Ao Ling and Dick Watchett, whose utterly different lives and attitudes are linked (unbeknown to themselves) by the curious dream-narrative which flows beneath the events of the principal narrative. (Use of metaphor and allusion is far less flamboyant and dominating than in the first novel, and these are accordingly discussed in context rather than as sets of distinct patterns.)

As Hughes confessed almost thirty years after completing the novel, there was indeed a factual basis for it, as there had been for *A High Wind in Jamaica*:

> This *is* a novel, a story about people who never existed; but the whole inanimate side of it is fact.

Once in recent meteorological history, there really had been a hurricane as stupendous and as unpredicted as the one here recorded, and a British cargo steamer very like the *Archimedes* did live through it – just. Day by day, hour by hour, minute by minute that storm did behave in detail as is here narrated.

But there fact ends.[20]

This steamer was the *Phemius* of the Blue Star Line, and the hurricane had occurred during the November of 1932. When Lawrence Holt (a director of the company) told the story to the Williams-Ellises the following year, they soon passed it on to Hughes as the sort of extraordinary event which would interest him. It did indeed, just as the account of the *Zephyr* had before the writing of *A High Wind in Jamaica*: as the framework for a work of fiction.

Just as he had immersed himself during the 1920s in reading about Jamaica, so in the early 1930s he learned everything he could of what had befallen the *Phemius*, from the vessel's documents, and by interviewing members of the crew. Hughes even examined the *Phemius* herself in dock, and actually joined Captain Evans's crew for a trip as assistant purser on her sister ship, the *Glaucus*. His wider interest in sailing must also have been of help in rendering the ambience of the vessel. During the 1930s he wrote widely on sailing and kept up to six craft moored at Laugharne (in one of which he won the Bristol Channel Pilots' Race in 1936). The experience of the *Phemius* was not the sole source for Hughes's story of the *Archimedes*, then. Rather, as with the *Zephyr* incident and *A High Wind in Jamaica*, it provided him with an imaginative focus for whatever artistic concerns were brewing in his mind, 'under the threshold', as Hughes put it.[21] As with the first novel, too, the carefully researched factual material served as a framework within which to construct his work of art; once it was built up, this scaffolding had served its purpose and might be removed as the author thought necessary.

The cyclone is first described in evocative, but purely mechanical terms:

Thus the spin of the earth is only the turn of the crank-handle which starts it: the hurricane itself is a vast motor, revolved by the energy generated by the condensation of water from the rising air . . . So this extraordinary machine fifty miles or more wide, built of speed-hardened air, its vast power generated by the sun and the shedding of rain, spins westward across the floor of the Atlantic. (IH,35)

This description follows that of the ship's engine, the rotary motion of which is conversely described in terms of natural phenomena. In this way, the storm is made to seem equally subject to rational manipulation; such things are now understood and may be avoided, the narrator implies. This excess of confidence is, however, undermined by the power of the metaphor he unleashes. The resemblance, after all, is limited. Unlike a ship's turbine, the cyclone has no designed purpose, and is beyond any human intervention. Hughes's narrator is like the Sorcerer's Apprentice in the fairy-tale: having whistled up and evoked the hurricane, he finds the storm – when it arrives – is beyond the control of any human force.

The cyclone is also described using contradictory metaphors: it seems to have the volition of a living thing, yet with the senseless, destructive lack of direction possessed by out-of-control inanimate objects. On one occasion these two forms of metaphor conjoin, to shocking effect:

> Huge spires of water would dash at the ship, like maddened cathedrals: then the oil spread over them: they rounded, sank, passed away as harmless as a woman's bosom. (IH,123)

The sudden transformation of a cathedral spire (tall, sharp, inanimate, cold and hard) into a woman's breast (quintessentially warm, soft and alive) is a remarkable metamorphosis for the reader to observe, conveying the strange protean power of the storm, and also its disturbing aspect of seeming so full of vitality yet not being alive. By this and other juxtapositions of animate and inanimate metaphor, Hughes pin-points a real problem faced by consciousness, that of comprehending the physical world in its own terms, not in imagined human terms (a surprisingly difficult thing to do). His mixing of metaphors sets up a real tension, then, ensuring that the reader remembers these are translations into human terms, and not the thing itself.

There is one dominant metaphor of the cyclone which encompasses this whole sense of the physical universe, of the conditions of existence which lie beyond Mankind and its control: the circle. The ship is literally surrounded by the pressure-lines of the hurricane, the concentricity of which is persistently stressed. The storm is 'a circular system of gales', (IH,28) or a vortex which moves 'as a rapidly spinning top' (IH,31); the earth's rotation spins it 'in a gentle

spiral' (IH,34) which then turns ever more rapidly:

> The wind spins round the centre of a hurricane so fast it can no longer fly
> into that centre, however vacuous it is. Mere motion has formed a hollow
> pipe, as impervious as if it were made of something solid. (IH,35)

The word 'vortex' is repeated five times to describe the storm,
increasing the impression that the *Archimedes* is caught in no ordinary
hurricane, but some more elemental trap. The circle also recurs
elsewhere in the novel, broadening its symbolism in relation to physical
existence as an inescapable condition of being. Dick feels that he has
set Ao Ling's 'wheels, as it were, on the track that ran straight down to
death'. (IH,250) Motion through the sea is only possible through the
circular turning of the ship's turbine and screw: 'all the varying forces,
the stresses and resistances, proceeding from that welter of machinery,
are unified into the simple rotation of this horizontal column'. (IH,8) It
is only by means of another circle that the crew are able to see where
they are going: 'through the little "clear-vision screen" (a fast-spinning
wheel of glass which water cannot stick to)'. (IH,42) Dick even
imagines God in the form of his grandfather perched on a penny-
farthing bicycle: an old man balanced atop a great wheel. Captain
Edwardes, too, is associated with circular motion: in Ao Ling's dream
he springs from a ball of flesh which 'was rolling on the floor like a
wheel' (IH,270); he is said to be full of power and encouragement, 'like
a lighthouse on a rock'. (IH,80)

As well as spatial entrapment within the hurricane, time also
participates in this confinement. On initial reading it is difficult to work
out how many days and nights have elapsed in the novel. Presented as
experienced by the crew, time during the storm takes on a nightmarish,
nonsensical, elastic quality – quite unlike the regular passing of the
watches on board ship. Hughes himself acknowledged this complexity
when he added the running titles showing the day. In fact, when read
closely, the narrative does contain enough clues to piece together a
chronology covering fifteen days in November 1929. This objective
timetable, however, bears little resemblance to what is sensed by the
crew. Time, for them and as communicated to the reader, is twisted and
stretched according to the intensity of what they experience. Thus the
nine days before the storm are dealt with in just two chapters, while the
seven days of the hurricane take up twelve chapters, as everyone on the
ship waits from moment to moment for it to pass. From referring to

days passing, the narrative begins to note each hour going by as the ship is drawn into the cyclone, and finally – as the crew struggle to fit a hatch or fire a boiler – actions of a few minutes are given extended description. With the abandonment of watches, no regular sleeping-periods, and the fury of the storm making division of night and day meaningless, ordinary measured clock-time is made to seem irrelevant. Time, then, adds a fourth dimension to the *Archimedes*'s confinement within the cyclone.

In addition to the personal meaning which the hurricane comes to have for the crew, it has its own significance, representing the general material conditions of existence common to all, the physical universe. For Hughes, physics – the behaviour of the inanimate world – was a subject of recurrent and fascinated enquiry. He had a practical interest in science which persisted from youth into his adult years, and when asked for an essay on the arts for a Gollancz encyclopaedia in 1932, he wrote instead a piece called 'Physics, Astronomy, and Mathematics, or Beyond Common Sense', dealing clearly and enthusiastically with such mysteries as wave and particle theory, Cepheid Variables, and relativity theory – all in terms similar to those of *In Hazard* explaining meteorology and turbine engines. In his critical writings, too, Hughes drew attention to the unthinking anthropocentricity of the Novel, arguing that the non-human world was an equally valid subject of enquiry for the form.[22] In *In Hazard*, Hughes gives this subject particular attention – the hurricane is not simply a convenient metaphor, but a thing of integral importance to the work in itself. Through the cyclone, he actually makes the inanimate world a prime participant in the novel: the inescapable fact of material existence which must be faced and engaged with.

Opposed to the cyclone in this major dialectic of the novel is the ship. Seen by some as a prophetic representation of Britain at war, Hughes rejected this simplistic theory:

> that would be to misread it entirely since this is not allegory at all but symbol; and symbol (in the dream sense) is never concerned primarily with the future *qua* future but with a more timeless kind of truth.[23]

It is in this symbolic sense that the name of the ship becomes significant. Archimedes is popularly known for discovering the principle of displacement of liquid, but his work on physics and mathematics as a whole makes him one of the most significant

scientist-philosophers of the Ancient World. (The Axiom of Archimedes is still used today as one of the foundations of calculus.) His willingness to apply the results of empirical enquiry imaginatively, devising new ways to alter the world around him, made Archimedes an important precursor of the Scientific Revolution. What more suitable name, then, could be chosen for a ship – which only floats by virtue of the displacement principle? Archimedes's fame as a thinker also signals to the reader the central concern of the novel, which so exercised Classical philosophers: humanity's perception of, and relationship with, the physical world. This philosophical motif is stressed consistently throughout *In Hazard*. The ship is one of the 'Sage Line's fleet of philosophers', (IH,19) including the *Descartes*, and even Archimedes's Principle is alluded to when Dick becomes delirious after ten hours of oil-pouring:

> How crassly confident people were, to build ships and take it for granted they would float, even on top of miles and miles of water! It was all a question of weights, of course. They said the ship's weight exactly balanced the weight of water it displaced. But to his mind, now grown so giddy, mere balance suddenly ceased to seem very reassuring . . . What fools folk are, to go on building great ships, and sending them out on to the sea; taking for granted that they will all float because one has; taking for granted that because a ship floats one day she will float the next. (IH,146–7)

This passage is important, for it links the question of whether the *Archimedes* sinks to the central thematic concern of the novel. When Dick wonders whether the physical universe can be taken for granted in this way, Hughes uses displacement to invoke the whole issue of empiricism, the philosophical basis of all science.

Just as the *Archimedes* is placed in opposition to the cyclone, so further contradictions are set up within the crew. It is possible, however, to discern one pattern which dominates: that between acceptance of the hurricane, enabling a practical and imaginative engagement with it, and a denial of the storm's presence, a reluctance to admit the reality of something beyond the solipsistic self. In the latter, there is a failure of imagination as important as any failure of courage. This is a primary conflict within the novel which crosses boundaries of rank, class or nationality, concerned with a fundamental attitude towards the physical universe. Shortly after *In Hazard* appeared, Richard Hughes wrote, 'it is a book about fear'.[24] Regarding the novel from these polar perspectives,

it emerges as a book about two sorts of fear: one in the common sense, by which some hide from physical reality in their own selfish concerns; the other, in the sense of fear as a respect for things beyond one's power to alter or understand (as the word is used in a liturgical context). It is through the relationship of these two perspectives that Hughes draws together all the elements of the novel, and explores its fundamental, epistemological theme. In this study, attention will be focused on the most complex and interesting pair of characters who typify these attitudes: Ao Ling, whose negating of the world around him is the most extreme, and Dick Watchett, whose imaginative response to experience is similarly traced via lengthy digression from childhood to the crucial events on board the *Archimedes*.

Ao Ling is introduced in a curious manner, which in itself is worth noting. A minor member of the crew, with no part to play in saving the ship, he is suddenly focused upon – as though catching the narrator's eye – and the narrative sinks into the story of his life, leaving the endangered *Archimedes* far behind. Having so carefully built up tension to this point, Hughes suddenly halts, and gives almost thirty pages of the novel to this extended digression. When Ling is later arrested on Captain Edwardes's orders, for having false papers, the reader is naturally interested in his fate. Will he be handed over to the Nationalist authorities? Will he be executed? No one knows, for these events lie beyond the frame of the novel.

By introducing and abandoning Ling in this way, Hughes might be criticized for playing fast and loose with the narrative, simply succumbing to whim. The reader, after all, is asked to accommodate suspension of the main story-line and interpolation of an extended, wholly new line, which finally converges with the main narrative – only to be followed by more frustration, as one never knows Ling's fate after the ship is saved. For this to work, however, only requires consideration of the effect of these shifts upon the reader, rather than their contribution to the overt plot. Temporary abandonment of the *Archimedes*'s story reminds the reader that this is but the chronicle part of the novel, and that more is asked than just a sequential apprehension of events on board the ship. The open ending also works to this purpose. Life, after all, rarely has the neat conclusiveness commonly found in fiction, and ending *In Hazard* in this way is an ironic piece of naturalism by Hughes: art mimicking life's raggedy edges. To do it for this reason alone, however, would be a superficial trick: any writer, after all, could simply leave a story 'unfinished' and claim verisimilitude to experience.

Hughes's originality is to leave his chronicle incomplete in this way, but to imply a different sort of completeness: a coherence which the reader must achieve by imaginatively re-creating the work.

The structure of the digression itself must also be accommodated in this active re-creation. From the enclosed world of the ship where every minute seems to last an age, the reader is plucked and set down in the expanse of China. In this new terrestrial setting, years go by and hundreds of kilometres are traversed as Ling's tale is unhurriedly told. There is terrible flood and famine; his sister is sold to buy food; China's disintegration under the competing warlords finds him a soldier with General Ho Chien's army, from which he deserts to join the Communist forces of Mao Tse-tung (described by Hughes in 1938 as 'a slatternly peasant-politician of thirty, with an educated and humorous mind'). (IH,198) Accidentally separated from his patrol, Ao Ling then finds his way to the coast, where he signs on the *Archimedes* with forged papers. The way in which the reader is unexpectedly plunged into his alien world thus challenges us to include it in our view of *In Hazard*.

The utter contrast of Ling's experience with that of the British crew, and most of the work's audience, is conveyed by the use of certain powerful images, calculated to impress the reader by their strange quality. There is the starving crowd which gathers before a rich man's house, growling 'like a storm about to break'; the door-keeper pushes the person nearest him and the entire crowd go down 'like a house of cards'. (IH,186) In Kiangsi, Ling sees his first motor-bus, which moves very slowly 'because the proprietor, to economize petrol, had yoked a pair of bullocks to it instead of using the engine'. (IH,194) And in Nanking, Ling finds himself bound and ready for execution, only to be saved by news of an approaching army: 'he was left alone, one living man among four decapitated bodies, the cold sweat drying on his stiffened and aching face'. (IH,196) This episode is never explained (it certainly pre-dates his involvement with Communism), and is left as inexplicable as it was to Ling at the time – a bizarre interlude between his job at the theatre and 'a merry three months as conductor on the Hangchow bus'. (IH,196) Quite strange and exotic to occidental eyes, too, is the description of General Ho Chien's Nationalist army marching to attack the Communist forces in the mountains:

> And so, shouldering their umbrellas, their huge straw hats flopping on their backs, some carrying song-birds in cages, and a few even carrying rifles, the Government forces moved to the attack. (IH,199–200)

By recognizing the beauty and eeriness of these images, then, we receive a visual correlative for Ling's quite distinct view on the events of the main story, in this way incorporating an utterly different perspective on them, alongside the principal narrative viewpoint.

From the beginning, it is stressed that Ao Ling is a man who seems to feel no fear, and this is explained as follows:

> A sort of self-oblivion, too, seems to settle on a man, once he has identified himself with a Cause. He will be able to tell you minute details about the Cause itself, from A to Z: but he can hardly tell you whether he himself wears two legs or three . . . In this ecstasy of religion, small wonder that neither the storm, not his hunger, nor even the fire from the furnace which had seemed powerless to destroy him, could move him very greatly! (IH,181–2)

The comparison of Communism with religious devotion recurs elsewhere in the text (and is echoed by Ling's survival of an exploding furnace – like 'the three Hebrews in the fiery furnace' mentioned in *A High Wind in Jamaica*). (HW,246) His conversion comes to mean for him 'what the Road to Capernaum [*sic*] meant to St Paul'. (IH,200) He also carries no 'Marxist texts, for private devotion: the risk of discovery was too great' (IH,205), the secrecy and phrase 'private devotion' almost likening him to a recusant priest. For Ling, Communism serves to solve all the problems in his life:

> He absorbed the Marxian doctrine like a thirsty animal drinking. It refreshed every corner of his soul. For it freed him from his three great fears: fear of his father, fear of the supernatural, fear of the rich. Moreover it harnessed the three hatreds born of those fears, and told him they were proper and right – not the secret scars of a wandering outcast, but the honourable badges of a fraternity. In setting him to fight the Government it made his father hydra-headed – and gave him a sword for every neck. (IH,200–1)

It is notable here that a primary reason for Ling's embrace of dogmatic Marxism is hatred of his father. At the same time, his most tender memories are of female figures. His earliest recollections are of Chieh-chieh, his sister, of whom he 'had been unboyishly fond'. (IH,185) During the famine she is sold to buy food, and the matter-of-fact way in which this is recounted only makes more pathetic Ling's sense of loss: 'He saw his father give her: and the buyer, but quite kindly, take her away'. (IH,185) The other vivid memory is of suckling

in his mother's arms on the roof of their cottage, trapped by swirling flood-water: 'However, hardly had the milk begun to come when suddenly his father tore him from her breast, and tossed him, howling furiously, into the rescue-boat which had just drawn near.' (IH,192) In both cases his father is stressed as the agent of change and unpleasantness, yet he does this in the interest of Ling. Chieh-chieh's sale demonstrates how the girl in the family is sacrificed for the son. The violent expression, 'tore him from her breast', also belies the fact that his father is saving his life first. In fact, Ling's father has never done him harm, and dotes upon him: he 'was invariably kind to him' (IH,189), sends him to school, and dresses him all in red.

Hughes suggests a reason for Ling's irrational hatred for his father in pointing out that it is very much an exception to the rule (the Chinese being traditionally so obedient and devoted to their parents). This, he speculates, is due to 'that curious opposition, and tension (or at least tie), which exist in all men and indeed in all beasts, between parent and child'. (IH,179) Whereas an Englishman will often react to this by exaggerated revolt, he continues, a Chinese reacts – for the same reason – by making 'of his father a god: and that relation, lubricated by the very formality it entails itself, will probably not chafe either of them in the least'. (IH,180) Just as Ling resentfully smashes the household gods in anger at the famine, so he becomes almost parricidal in hatred for his father. Having first been a god-like provider, the father then expects Ling to understand their changing situation, to endure hunger and flood like everyone else, to lose his sister in order to eat. For Ling, this is a betrayal. In each case, he is unable to think beyond himself and simply refuses to accept the nature of things as they are. Even sorrow at his sister's departure – one may suspect – is self-pity at his prospective loneliness rather than at her unguessable fate.

Ao Ling's father, then, represents for him those undeniable parameters of physical existence, all those *things-which-are-necessarily-so*. By running away from home, by becoming a Communist, and by not acknowledging the hurricane, Ao Ling refuses – personally, socially and physically – to come to terms with these conditions, embodied in the figure of his 'hydra-headed father'. (IH,201) The way he does this, by uncritically embracing Marxism, becomes a way of hiding from the world, of not thinking about things rather than understanding them.

Ling's viewpoint is made pointedly mechanistic. The happiest period of his life is as conductor on a bus moving back and forth between

Hangchow and Nanking, 'always through the same countryside'. (IH,196) Ling has a twice-mentioned 'passion for machinery', and inhabits the mechanical world of the *Archimedes*'s engine-room. (IH,197) He is even promoted within the Red Army for 'the almost uncanny skill he developed at pingpong; a craze for which was then already sweeping the entire Red Higher Command like a fever'. (IH,201) It is as though Ling were willing himself to be an automaton, rather than the vulnerable human he fears himself to be.

This disengagement from physical reality is highlighted when he becomes separated from the army, and is alone for the first time in many months. Solitude soon shows up the inadequacy of his attitude to the world: 'The effect on him was immediate and terrifying: he felt himself shrinking, shrivelling.' (IH,202) His world consists of his fearful desires and beliefs only. He is unable to take in, with humility, the evidence of his senses, unable to conceive of things as distinct from himself, with an existence of their own, for which imagination is necessary truly to apprehend. While lost in Hunan, Ling also comes across a Taoist temple where the abbot tells him, '"When a tiger is expected in the path, it is foolish to remain and tickle its nostrils with a straw."' (IH,203) The immediate meaning of this is apparent: as the province is under the control of Nationalist forces, he is being warned to flee. These words also form a wider comment on Ling, however, unbeknown to their speaker. By refusing to accept or comprehend the ineluctable realities of existence, Ling remains metaphorically in the tiger's path – denying its existence the while. He comes face to face with his 'tiger' when locked up on the ship, with the prospect of being extradited to Canton and executed. He experiences a strange dream which is recounted in detail, and forms an alternative, almost apocalyptic ending to the novel, more disturbing and questioning than the closure of the overt plot, and forming a pair with Dick Watchett's dream, as we shall see.

The dream is a phantasmagoria of colour and movement, fantastic creatures and events. The black-bearded porpoise, the blue-faced bat-winged duke, the innumerable five-footed dragons – all suggest the breakdown of Ling's naïve, mechanistic view of the world, and the rushing into his mind of a chaotic, more imaginative vision of his life. Hughes deliberately gives this passage the distortion of an actual dream, yet three significant elements can be identified which allow a coherent reading: the presence of a girl, of water as a magical medium, and of Captain Edwardes as a paternal figure. All three draw together images

and episodes from Ling's life, creating a poetic vision from which he cannot escape (one cannot turn aside from something in a dream).

The way in to the dream is through a girl. Finding her in the cot beside him, Ling moves to embrace her, but realizes she is a fox in human form. Almost immediately she then begins to give birth – to a manikin which becomes the captain. This girl echoes the three other females mentioned in association with Ling, who each represented comfort before their withdrawal plunged him back into harsh reality: his mother (from whose breast he was torn), his sister (sold into bondage), and a boat-girl whose sight once moved him (and who simply sailed away). Throughout his life, then, the female figure represents to Ling an agent of disillusion, by which he is thrust into a world not designed according to his desires. An intellectual as well as emotional immaturity is thus exposed, a failure to accept and respond imaginatively to change. Ling's dogmatism is a static philosophy. In the dream, the physical universe flamboyantly asserts its opposing dynamical quality to Ling, engulfing the flimsy barrage he had erected against it. The dream is never still, everything constantly metamorphosing into something else – truly a nightmare for one who has resisted the very notion of change since lying at his mother's breast. As in the case of Emily Thornton, it is the figure of someone of the opposite sex which lures Ling beyond himself, only to reveal the flux and utter *otherness* of external reality.

Given this shocking revelation of the dynamic, fluid quality of existence, it is appropriate that Ling's dream is also dominated by water. As we have noted, water is associated with his mother and the beautiful boat-girl, at moments when he had a chance to learn the inevitable mutability of life.

In the dream, the sea also changes form to produce a horde of golden dragons and a great tree with leaves of jade:

> up the middle ran a transparent tube of pale yellow. The foliage was dense, and tinkled when a leaf fell. But now it was lightning-riven: and caught in the cleft was a blue-faced bat-winged duke, hollering in agony with his enormous monkey-mouth and hammering incessantly on the drums which were hung about him. (IH,271)

This is a wonderful evocation of the storm from the one who earlier had dismissed it as negligible compared with the anti-imperialist struggle. The 'tube of pale yellow' also identifies the tree (used previously to

evoke the turbine and hurricane) with the Yellow River. When Ling and his family are trapped on their cottage roof, 'yellow flood-water swirled around them'. (IH,192) The river is an apt reminder of the changeable and contradictory aspect of Nature: its flood waters are responsible for millions of deaths in China, yet also the alluvium is essential to the land's fertility. The sea acts in an equally arbitrary way in the novel: the hurricane waves which carry the *Archimedes* safely over the Caribbean reefs also drowned thousands who lived on low-lying islands, including 'Santa Lucia . . . one of the old buccaneering hideouts' (IH,244) – the pirate's base in *A High Wind in Jamaica*.

Finally, bestriding the dream is the figure of Captain Edwardes, who has come to represent Ling's father and all those things he has rebelled against. He remembers seeing Edwardes as 'this God-the-Father of a Captain' (IH,206) powerless before him, as a red light flashed from a lantern. In the dream, however, it is Edwardes who appears 'in a halo of red light' (IH,270) and asserts his dominance. The captain is born from a ball of flesh which rolls across the floor. He struts about the deck, destroying demons with magical darts and balls of fire. One great golden-scaled dragon seems to challenge him, but this too he straddles, tearing off the scales:

> so that it cried in agony, shrinking all the time smaller and smaller, and at last weeping with the hopeless, shuddering sobs of a despairing child.
>
> The voice was own infantile voice, weeping to him out of the far years of the past. (IH,272)

In this dramatic image (evoking the destruction of a Chinese carnival dragon to expose the man within), Ling is finally faced with his unavoidable subordination to physical existence. In Captain Edwardes he finds the embodiment of those who react positively to these conditions, actively using their minds to re-create and comprehend them. As he feels himself shrinking, and the phantasmagoria dissolves to the sound of his own childish weeping, Ling is presented with the lesson of his dream. All his life he has reacted to the challenge of new experience like a baby taken from the breast, thereafter clinging to substitutes, false certainties. By refusing to use his senses, his intelligence or his imagination, he thus fails to create an accurate, operable vision of existence, one which would be a dynamic system full of magical-seeming correspondences and relationships, not a static mechanical model.

Ao Ling's fate beyond the frame of the novel is unknown, is in fact unknowable, for Hughes surely intends that the young man be left locked up in suspense for 'ever', a reminder to his audience that time, within the special hermetic universe of his novel, ceases on its last page. The reader, then, is challenged to regard Ling's life not as a chronological narrative requiring a satisfactory 'conclusion', but more importantly as the evocation of an attitude to experience. Once this has been exposed, as an unreal compound of desires and beliefs, the novel has no further use for him. All of the characters, including him, can finally be put aside: their place in forming the narrative has been a means, not an end, of the work. For the reader to understand this is to undergo, too, a learning process like Ao Ling's.

Dick Watchett is ostensible hero of the novel. His real function, however, is as counterpart to Ao Ling in the deeper pattern of the text. His is the most obviously sympathetic character in *In Hazard*, but the temptation to see him as such must be resisted as another of Hughes's traps for the unwary. In a straightforward rendering of the plot Dick would seem the conventionally heroic figure of an adventure story: in a hurricane of unprecedented strength he swiftly overcomes his fear, stays on duty pouring oil for twenty-four hours without relief, then knocks out and imprisons a Chinese 'bandit'.

When Dick is examined in detail, however, this narrational perspective is shown to be inadequate in itself. The general subversion of the novel's chronicle, already noted in relation to Ling, suggests itself quietly with regard to Dick too. Hughes also hints that Dick should be re-examined, the last words on him being, 'But I will say no more of Dick Watchett: perhaps I have already said too much, about one who after all was a very normal young man.' (IH,269) This is disingenuous. By insisting on Dick's normality, he draws attention to it, and this attention reveals him as far from ordinary. His status as a conventional hero is most effectively undermined, however, by his own view of himself as this very thing. Throughout the novel, he repeatedly re-lives his actions in his imagination, as though telling an adventure story with himself as hero. The narrator's ironic reportage of this, then, questions what sort of hero Dick is, implicitly suggesting that he is as much a hero of imagination as of action.

By constantly imagining things he has done, or might do, Dick meshes together his internal existence with the external, phenomenal world, making the latter more 'real' to him, and enabling him to deal with, as well as know, it better. As the voyage begins, his thoughts seem quite

naïve, as though he actually were a boys' adventure-story character. With the advent of the storm, though, the extremity of his position drives Dick's thoughts and imaginative speculation deeper into the relationship between himself and what lies around him – from the elements to other people. By the novel's end he can be seen as quite a different person; a metamorphosis which takes place as much in the reader's apprehension as in the character himself. Once identified, this process is fascinating to observe, as though a two-dimensional cartoon figure were to change, before one's eyes, into a creature of flesh and blood.

When the ship enters the Caribbean, Dick looks forward to his first tropical storm: 'He hoped that the hurricane would do something spectacular.' (IH,38) He regrets that the *Archimedes* is such a large vessel, so that the storm will not affect it: 'No dismasting. No frozen helmsman lashed to the wheel, with salt spray glittering in his beard'. (IH,38) Dick is even encouraged to imagine himself as captain by Edwardes, who is training him: 'made him in imagination commander of the ship; required him to repeat, from barometer and wind-direction, the same calculations he had made himself, and say what should be done'. (IH,38) Dick's expectations are surpassed by the actual hurricane, of course. Like Edwardes, he soon adapts to the new circumstances, and his vivid imagination now draws a picture of Dick Watchett as Marryat-like hero:

> If only Sukie could see him now! No shore-going uniform and brass buttons, like a tailor's dummy; but stripped and steely, fighting the storm with superhuman strength, a dour devotion to duty. Hour after hour, hour after hour. Day after day. Indefatigable. (IH,150)

Captain Marryat's tales are very much the sort of thing on which Dick seems to base his self-dramatization. The following description of a Marryat story, from Patrick Brantlinger's *Rule of Darkness*, might almost be part of Dick's on-going autobiography, the tale he is constantly telling himself about himself:

> The hero is thrown into do-or-die situations that render his previous upbringing almost irrelevant. Of course it helps that he is the son of a gentleman, that he has the Anglo-Saxon racial traits of pluck and absolute integrity. Nevertheless, the imperialist hero's education is, in a sense, complete in the moment of his first storm or battle.[25]

The suggestive names of Marryat's plucky, no-nonsense characters –

Midshipman Easy, Peter Simple, Frank Mildmay – are also echoed in Dick Watchett's perky name.[26] Dick's self-dramatization, however, is immediately, if gently, mocked by the narrator:

> His face did not wear, as he thought, the lean, drawn, and lion-like aspect one expects of an unflinching hero. For the immediate effect on a hero's face of unflinching effort is seldom to make him look romantic; more often it makes him look liverish . . . With nothing but appearances to go on, you would probably guess that figure to be one of Life's Failures, who, sodden with drink, has spent the night on a garbage pile. (IH,150–1)

Dick's heroic status is not denied here, only reported in a wry tone. He has, after all, just spent twenty-four hours without rest, food or water, pouring oil through the ship's latrine-outlets. Ironic presentation of his 'heroic' appearance, then, serves to make us question what it is exactly that makes Dick 'heroic' – extraordinary by contrast with his shipmates.

Dick's Marryatesque feat of action is matched by a more profound imaginative feat, that of coming to terms with the existence of things and beings beyond himself, embodied in the whirling elements of the hurricane. While performing the hypnotic, rhythmic act of tipping the oil-drum hour after hour, Dick's mind drifts back into his childhood, and memories of this interact with his thoughts and fears about the storm. In this way, in the converse of Ao Ling's retreat from experience, he reaches an accommodation with it, a maturity of mind in which imagination and action can complement one another. This contrast is invited by the fact that they are 'the same age' (IH,181), their biographies are the most extensive digressions of the narrative (both lying at the centre of the novel), and the two are also brought together by the plot at the close of the work.

As we have seen, Ling's withdrawal from the 'visible world' (IH,205) is traced in his relations with his father and the several females who are lost to him: his mother, sister and the beautiful boat-girl. Dick's maturation – by which he asserts control over his surroundings through the use of imagination – may also be traced in his relations with his grandfather and with the two young girls who impress themselves on him: a crippled child in his village, and Sukie, whom he meets in Virginia.

Dick's grandfather figures large in his earliest memories, typically astride a penny-farthing bicycle. Dick yearns to ride a bicycle too, and makes do with one he has conjured up: 'Indeed, this pretended bike was

so real to him that anyone who could not see it must be very dense.'
(IH,134–5) From the first he associates his grandfather with the
omniscient, omnipotent Divine Being of his Anglican faith: 'He could
never visualize God: beyond a fleeting vision of black whiskers and
tight knickerbockers.' (IH,139) The image of an old man atop a great
wheel also suggests divine domination of the chaos of existence, as
suggested elsewhere in the novel.

An early stage in Dick's mental growth occurs in relation to this
figure. One day he dresses up in the old man's clothes and rides
clownishly around the market-place on the penny-farthing:

> He felt a pretty bright chap to be able to make them laugh like that: but he
> felt a bit less bright when presently he saw his Mother standing there;
> watching him make a fool of her old dead father, who had always been
> very fond of him. It was not a comfortable moment. (IH,137)

This episode is immediately linked with another in which he seems to
make a fool of God, again in front of his mother: he boasts to some
other children (untruthfully as it happens) that one Sunday he had
drunk up all the communion wine 'with the Rector pulling at the Cup
but him hanging on'. (IH,137–8) The significance of both these acts lies
not in the fact that Dick does them, but that he immediately feels a
genuine remorse afterwards. This is important because it reveals how
he is able to imagine, vividly and immediately, how someone else is
feeling: to understand his mother's thoughts via his sympathy with her.

A further stage in Dick's understanding is also intimately associated
with this grandfatherly deity. At the age of ten he accidentally leaves
his watch on the ground. Remembering this as he goes to bed, Dick
prays to God that it will still be there the following morning. He had
privately begun to have doubts of God's existence, and thinks that this
will decide the matter:

> Let this be a test case. I have told you that a compunction had always
> prevented him from asking anything too difficult, anything with a touch of
> the miraculous in it. So all these answered prayers might be only
> coincidence. But this prayer would be different: there was plenty of the
> miraculous in this one, since it would have to act backwards. He was
> asking God to guard his watch during all those hours which were already
> past! (IH,141)

When Dick does find the watch still lying upon the ground,

'thenceforward he was pledged, for the rest of his life, to believe in God'. (IH,141) The incident is of interest first for its evocation of time as susceptible to individual will, for 'God' here seems more an agent of Dick's imagination than a sole originator of events. The change in the nature of time, as experienced by the *Archimedes*'s crew, is also relevant here. As noted earlier, ordinary clock time becomes distorted and stretched as the ship is drawn into the hurricane, reflecting the crew's heightened experience of it while in hazard. It is thus appropriate that the end of the novel is marked by the ringing of six bells, a sign that 'normal', regular time has been re-established with the passing of the storm.

Watches, in fact, recur significantly in the novel. When Captain Abraham is sat at dinner with the *Archimedes*'s officers, one by one the apprentice-boys and then the mate silently begin to weep as their tension unwinds. It is not the tears which strike the salvage ship's captain however: 'it was the third boy. For he was wearing Captain Abraham's own gold watch.' (IH,260) This curious purloining is obviously not ordinary theft, but another symptom of the extraordinary mental stress under which the men have been placed. Why, then, should the midshipman steal a captain's watch and wear it openly? The answer is surely that the timepiece hanging on the breast of his 'rescuer' represents the return of ordinary conditions of space and time after the chaos of the hurricane: it is a totem of normality which he has grasped without thought, as palpable proof that he is safe. There is a further interpretation possible regarding watches. Hughes marks Dick's faith in God by the finding of a watch on the ground (and even draws attention to it by the pun on his name). It can surely be no coincidence that this scene invokes a work which famously sets out the teleological argument for the existence of God, popularizing the Newtonian model of the universe as a gigantic clock-like mechanism: William Paley's *Natural Theology: or Evidences for the Existence and Attributes of the Deity Collected from the Appearances of Nature*. The relevant passage opens *Natural Theology*, and is constantly referred to in the course of that work:

> In crossing a heath, suppose I pitched my foot against a stone, and were asked how the stone came to be there; I might possibly answer that, for anything I knew to the contrary, it had lain there for ever: nor would it perhaps be very easy to show the absurdity of this answer. But suppose I had found a watch upon the ground, and it should be enquired how the watch happened to be in that place; I should hardly think of the answer

which I had before given, that for anything I knew, the watch might have
always been there ... every indication of contrivance, every manifestation
of design, which existed in the watch, exists in the works of nature, with
the difference, on the side of nature, of being greater or more, and that in a
degree which exceeds computation.[27]

By introducing an incident which echoes Paley's famous passage,
Hughes invests it with extra significance, once again posing a question
to his reader: challenging us to work out just what 'belief in God'
means to Dick Watchett. We have already noted that 'prayer', for him,
seems to mean a combination of imagination and will-power: he
conjures up a hypothetical situation and then tests it against experience.
In a curious way, this is not so different from the methods of scientific
experiment and, in fact, Dick's recollection of this incident is followed
by further consideration of God in relation to science.

 This first arises when Dick remembers his preparation for
confirmation, when a more abstract concept of God was introduced to
him:

> A sort of impersonal Omnipotence who never interfered with Science (not
> that He could not, but simply because He was above that sort of thing, and
> meant us to learn Boyle's Law and so on): a vague, limitless Holiness,
> Who really preferred the Church of England to anything else. (IH,144)

This Anglican divinity, who the boy decides is not for him, is very
much the Newtonian God-as-Great-Mathematician. Dick's conception
of God is far less mechanistic than this: at once more mysterious and
unknown, and yet more personal and accessible too. Through prayer –
through imaginative thought and will – this Godhead is something in
which Dick actually participates. The next occasion on which science
and faith come into his thoughts is when, delirious after hours of oil-
pouring, he wonders why the vessel should float at all: 'How crassly
confident people were, to build ships and take it for granted they would
float, even on top of miles and miles of water!' (IH,146) By
questioning the Archimedian Principle, Dick questions the very
principle of empirical science, our understanding of the world based on
observation. That is to say, if we see that a ship floats today – by
displacing water – then we proceed on the assumption that tomorrow it
will not sink like a stone! Without this assumption not only scientific
enquiry, but daily life, would be impossible. Although such
suppositions are essential to comprehending the phenomenal world, the

novel also stresses that their contingent, theoretical status should also never be forgotten. An idea about how something *should* behave – however accurate – is a statement of a different order from one about how something has behaved in practice. This distinction is true not only of hurricanes, but also – as the novel insistently implies – of all physical phenomena, and human behaviour too.

Dick's response to this crisis of faith in the predictability of existence is, we now recognize, typical of him: he moves on from speculation – 'that about balance was rubbish' (IH,147) – and focuses on what he can actually experience, the effect on the ship's hull of the storm's battering. Knowing that he is doing everything physically possible to help the *Archimedes* stay afloat, he then prays to be saved too. The form of this prayer is interesting. He imagines a future situation in quite blunt terms – 'It was not spiritual well-being he wanted just now, he wanted to bloody well not be drowned in his twenty-first year' – then wills it to happen through God. (IH,148) He also makes this conditional, however: '"Oh Lord", he went on, "that is to say, only save me from drowning if that be already Thy Will."' (IH,148–9) Dick's imaginative workings then (unlike the fancies of Ling) are contingent on correlation with phenomenal reality, with how things actually are. Or as Dick thinks of it, he entrusts himself to God.

In discussing the term 'God' within the context of *In Hazard* we need to be quite distinct about its meaning, in particular with reference to Dick for whom the hurricane has meant a 'reawakened belief in God'. (IH,269) From identification of God with the mystical figure of his grandfather atop a huge wheel, the episode with the watch, and his whole argument with himself about faith, it is clear that the concept means much the same to him as to Ao Ling – with the difference that one embraces and one denies it. For Dick, faith in God is an act of trust in the potential coherence of all existence. To him, if this coherence necessitated that the ship be overwhelmed (and he drowned), then, as we have seen, he would accept this. Such an act of faith, in fact, remains the premiss of all scientific enquiry, which without it would be inconceivable. In his history of natural laws, *The World within the World*, physicist John Barrow has listed a number of these essential premises, such as ' "A" and "not A" cannot be true simultaneously'.[28] For Ling, on the other hand, such coherence is rent when experience does not match his desires and fancies.

The recurrent references to science in the novel echo Hughes's continued interest in it throughout his life. Confirmation of this is found

in 'Physics, Astronomy, and Mathematics, or Beyond Common Sense' where he reveals familiarity with a number of those ideas, discovered in the early twentieth century, which stressed the contingency of Man's understanding of the universe and the crucial importance the observer plays in it: Einstein's theories of relativity, Heisenberg's 'Uncertainty Principle', Gödel's discovery of the 'incompleteness' of mathematics, and Bohr's work on quantum mechanics, for example. In her introduction to the piece, Naomi Mitchison writes of Hughes: 'He does not see either physics or mathematics quite like a pure scientist, but he does see them newly and excitingly and in a way that connects them with the rest of life.'[29] Of particular relevance to *In Hazard*, written shortly afterwards, are the essay's concluding words, worth quoting at length:

> There is a natural tendency in man called 'anthropomorphism'; a tendency, that is, to see everything in his own image. When he first studied nature, he thought that rough seas were angry, that lightning struck him because he had offended it, that the sun ripened his crops out of kindness of heart . . . In the present age there is a fashion to say that 'God' (whatever that means) is a mathematician. He no longer reveals Himself as an angry God in the thunders, or a benign God in the warmth of summer; but He reveals Himself as a calculating God . . .
>
> Science, being Human enquiry, can hear no answer except an answer couched somehow in human tones. Primitive man stood in the mountains and shouted against a cliff; the echo brought back his voice, and he believed in a disembodied spirit. The scientist of today stands counting out loud in the face of the unknown. Numbers come back to him – and he believes in the Great Mathematician.[30]

This passage is not only germane to the novel, it is tempting to view it as germinal too – so closely does it address the concern which lies at the heart of *In Hazard*: that imagination, as well as observation, is essential to any understanding of the world. For Hughes, then, there is a great kinship between the function of the artist and that of the scientist, and between the artist and his collaborator, the reader. Both mathematics and language, he suggests, can produce only imaginative fictions which approximate reality, being made up of signs and symbols; at the same time, they are the only means available to us of rendering the apparent chaos of existence coherent to the human mind.

While the main concern of *In Hazard* is the relationship between the human mind and physical existence, Hughes's treatment of Dick

Watchett also deals with a sub-theme: the apprehension of other persons. This is explored in particular through Dick's recurrent memories of Sukie, a girl he meets before leaving Virginia, and his relationship with Ao Ling, with which these memories intertwine. Sukie is first encountered at a bootleg party. She is only sixteen, very drunk, and has a witty, fantastic turn of speech. She has a cat so smart, she tells Dick, it eats cheese to breathe down mouseholes 'with baited breath'. (IH,16) They spend the evening together, at the end of which Sukie is so drunk she takes off all her clothes and collapses unconscious. His reaction is one of tenderness for her vulnerability:

> suddenly he realized that he loved this girl more than heaven and earth. With shaking hands he rolled her in the hearth-rug, for fear she should catch cold; made her as comfortable as he could on a sofa; and returned, shaking, to his ship. (IH,17–18)

In truth, Dick hardly knows the girl, and his passion for her goes through a number of metamorphoses in the voyage, as his imagination responds to the storm. When terrified the ship will sink, he purposely calls up her picture in erotic daydream, to have something strong enough to take his mind from the hurricane:

> He was sad about this, in a way; because he knew that he could not love her as he believed he did, if he could think about her like that. Yet he deliberately continued. For his plight was so desperate: it was worth even spoiling his love, to keep himself sane. (IH,89)

Later, when oil-pouring, he needs to talk with someone (in his mind, at least) to distract himself from the monotony and fearfulness of his situation. This time, his mind calls up Sukie as a fairy-tale companion, floating in air 'in the mouth of a ferny cave' (IH,132) beside him in the ship's latrine. After his twenty-four-hour shift here he feels justifiably proud of himself, and imagines an admiring Sukie looking up to him. By the end of the voyage, though, she means nothing to him and he callously dismisses the thought of her:

> he was no longer in love with Sukie at all! After all, she was only a High School kid – and he was a grown man. A skinny little bit at that, with no more brains in her head than a pigeon! (IH,268)

As this dismissal shows, he did not really know Sukie at all: her wit

(which the reader can remember if Dick cannot) suggests strongly that she is far from pigeon-brained. It is not the actual Sukie he sentimentalized over, lusted upon and talked with in the ferny cave – but a series of simulacra, imagined in different ways appropriate to the different situations in which he finds himself.

If leaving Virginia prevents Dick from gaining more than an impression of Sukie, that first access of sympathy does allow insight into the existence of another being, Ao Ling. The explicit comparison of the Englishman and the Chinese is supported, as has been seen, by a number of correspondences between the two. One such association is the shared dreaming of a girl as a furred animal. This occurs when Dick's first dream of Sukie melts into the face of Thomas, the ship's lemur (the creature has entered his cabin and tried to open the sleeping man's eyes), and again when he imagines her while oil-pouring, metamorphosing into a lemur-girl: she hops away 'on her unnaturally elongated feet, nervously folding and unfolding her ears'. (IH,132) These exact words are used earlier to describe the lemur itself, this textual correlation simulating the association of ideas in Dick's mind. When Ling has his dream, it opens with a beautiful Fukienese girl whom he is about to embrace, 'but the fine hair on her face and hands warned him that she was but a fox in human shape'. (IH,269) The assonance between 'Sukie' and 'Fukienese' also associates the two.

While the female figure is an emblem of loss and of the chaotic malignance of existence to Ling, its meaning to Dick is quite contrary for he actually uses it to render his experience coherent. It is also the means by which he achieves the shocking recognition of another person's discrete existence. This occurs when Captain Edwardes orders him to arrest Ao Ling. Being nervous and not used to physical force, he unnecessarily punches Ling in the face, then has to carry the unconscious fireman away to lock him up. Before this episode Dick has hardly regarded the Chinese crew as people, naïvely sharing the racist outlook of the other officers. This naïvety is exposed when Dick tries to associate Ling with his previous impression of Chinese banditry:

> Dick sat silent, all the missionary stories of Chinese tortures that he had ever read rising in his mind. Could this decent-looking fireman have really done them? Toasted babies? Cut off old men's eyelids, and buried them up to the neck in the sand? And that one with the ants (he could not quite remember how it is done)?
>
> Perhaps he had. You can't tell by an Oriental's face whether he is wicked or not – not like an Englishman. (IH,246)

Dick's apprehension of the Chinese, then, lies at the opposite extreme to his deep sensibility towards Sukie. This changes when he arrests Ling:

> Like most white young men, he had not really looked on the Chinese as human, until he had touched one. In consequence, the shock of that touch had been much greater than it would have been in the case of another white man. (IH,249)

It is not only tactile contact which affects Dick, but the coincidence that Ling's skin and weight resemble those of someone else he has recently touched and carried: Sukie. The man's body feels 'curiously reminiscent of the feel of Sukie' (IH,249); his wrist is 'limp as a girl's'. (IH,210) Dick is instantly ashamed at his own brutality, and this too makes him more sensitive to the man he has punched:

> He was astonished at the softness, now, of the limp body in his arms: the smoothness of the skin: and his shame grew. Ao Ling hanging limp like that in his arms was almost as light as Sukie had been. (IH,211)

By this accident of touch and weight, then, a person utterly remote to him and someone to whom he feels most tender are conflated; he is suddenly able to realize this Chinese fireman as a human, deserving of the same respect as Sukie.

As well as this revelation, the encounter holds a further meaning for Dick – a discovery about himself. When he visits Ling the following day, 'his heart beat rather wildly, at the thought of seeing Ao Ling face to face.' (IH,250) This is not solely because of the identification with Sukie; he is also affected by the thought of having decisively influenced another's life: 'he could not get the man's fate out of his mind, he kept going over it, again and again: was inordinately concerned about it.' (IH,250) A mixture of feelings is discernible here: sympathy, pity, and curiosity, but also a certain exultation in having overpowered someone: 'Ao Ling was the first man he had ever knocked out: he was not prepared for what a satisfying pleasure that can be.' (IH,249) Dick is awed by the ambiguity of his feelings, that he can experience sympathy for someone and yet still enjoy a latent sense of power. This complexity is a direct consequence of his imaginative capacity for compassion. From regarding Ling as an object (which can be acted upon without concern), he comes to regard him as a sentient being. Dick then realizes, however, that one can still exert power over another,

disregarding wishes or feelings. This chilling discovery – of the capacity to impose one's will on others – is also a discovery of the immense responsibility this brings to every action.

This aspect of Dick's relationship with Sukie and Ling is emphasized through a third figure with whom both are discreetly linked: the crippled girl he remembers from his childhood. This figure is encountered when Dick is ten years old:

> Coming out of the post-office one day ahead of his mother, he found himself close up against a sort of flat trolley, as flat as a table, on which a little girl lay under bed-clothes as if in bed. He had seen her before, at a distance, wheeled through the streets like this: and his mother had told him she had a disease of the spine, and would never again walk, or even sit up: but he had never before been confronted with her close. Her face was pale, and moist; and rather proud. (IH,142)

Since finding the watch, Dick feels he can will anything to happen, if he wishes, even the curing of this girl. He realizes, however, that to do so would be to alter not only her life but his too; in a way, he would cease to be Dick, by taking on the responsibility of God. He does nothing therefore: 'he knew he was leaving the little girl to more years of pain; and presently, to death. He might be doing right: but he was being a kind of murderer.' (IH,143) The significance of this episode lies not in whether Dick 'really' possesses such power, but in the huge responsibility he feels himself to bear – even when deciding to do nothing – in possessing an imagination and a will to act. (In this he forms a great contrast with Emily in *A High Wind in Jamaica*, who also feels a God-like power, but resists any sense of responsibility in it.)

The similarity between this girl and Sukie is evident. Lying supine and naked on the floor after she passes out, Sukie is equally helpless:

> She had been lovely in her clothes, but she was far more lovely like this, fallen in a posture as supple as a pool; all that white skin; her forlorn little face, with its closed eyes, puckered already in the incipient distress of nausea. (IH,17)

As well as her position, the white skin and evocation of a pool recall the 'pale, and moist' face of the sick child. Despite Sukie's distress, however, Dick does not immediately go to her aid: the description of her posture, skin, face, eyes and expression mimic his gaze passing over her. Even though he eventually covers her up, he evidently enjoys

her vulnerability and the feeling of power over her. As with the polio-struck child, it is the complexity of Dick's response which is of interest, as much as what he eventually does. Even though he acts honourably towards Sukie, his 'wilder intoxication' (IH,17) at standing over the naked sixteen-year-old does reveal his capacity for enjoying dominance over her, for treating another person as an object.

When Dick realizes that he must bear responsibility for Ling's incarceration and possible execution, once again the child comes into his thoughts: 'if you give over a man to be shot dead you have at least a measure of responsibility in the matter. He found himself suddenly remembering the little girl laid flat on the trolley.' (IH,253) As with the child and Sukie, his sense of responsibility is a consequence of his imagination. He not only feels deeply what it is like to be that person, he also senses the complexity of his own response. At one extreme he regrets there is no souvenir of the arrest:

> It is a pity that when you arrest a murderer there are no horns or anything you can keep, to get the story started (I am sure it would stimulate our police in making arrests if they knew the judge, when it was all over, would send them, suitably mounted, the 'mask'). (IH,251–2)

This grisly speculation (in which Ling is contemplated literally as an object) is contrasted with another daydream in which he saves the fireman's life:

> At the thought of stealing to the cell quietly in the night, and letting the man go, a feeling of pleasurable warmth suffused Dick's body: the thought of Ao Ling's unspoken gratitude. Of meeting him, perhaps years later, in some desperate fracas in Central China, when all seemed lost: of Ao Ling recognizing him, and saving his life in turn (for a Chinaman never forgets). (IH,257)

That 'feeling of pleasurable warmth' which suffuses Dick reminds the reader of his association between Ling and Sukie: not that he is sexually attracted to Ling, but that he is excited (both thrilled and horrified) at the idea of contact with someone alien yet intimate at the same time.

Their last meeting sums up the counterpoint between the two men. Dick accompanies the captain to Ling's cell. The prisoner is utterly expressionless and seems unaware of anything beyond himself. Dick, on the other hand, is full of excitement at the thought of meeting Ling.

His heart beats 'rather wildly' (IH,250), echoing the use of 'wild' in his reaction to naked Sukie. When he sees Ling, 'Dick's curiously inquisitive gaze fastened on him . . . Dick stared as if his eyes were gimlets . . . stare, stare'. (IH,250) In the face of experience, then, be it vast hurricane or another person, Dick's imagination reaches out to the world – enabling him to understand both it, and himself, better in the process. While the relationship of the individual with other persons is a subsidiary theme of *In Hazard* – which is dominated by the dealings of humanity with the fact of physical existence – this was to become the theme of Hughes's final work: *The Human Predicament.*

In Hazard differs in a number of ways from *A High Wind in Jamaica.* We have seen, for example, how Hughes's use of metaphor is drastically reduced in his second novel, this selectivity increasing its effectiveness. Multifarious narrative voices are exploited to a greater degree, as are other traps for the unwary reader, and much greater use of ellipsis is made in the narrative as a whole – deliberately incomplete, unresolved or otherwise puzzling elements in the text. While these changes reflect adaptation to new subject matter, they also mark an undoubted sophistication of Hughes's novelistic methods. Within its relatively short length, *In Hazard* compresses an astonishing density and richness of discourse, made possible by a corresponding variety of techniques, powered – most importantly – by the imaginative participation of the reader. Although it would be a quarter of a century before *The Human Predicament* was published, the lessons learned in the writing of *In Hazard* were well remembered, and built upon in the creation of that last and most demanding novel.

Chapter 4

The Human Predicament

The Human Predicament appeared in two volumes, *The Fox in the Attic*, in October 1961, and *The Wooden Shepherdess*, in April 1973. Set between 1923 and 1934, the novel opens with the protagonist, Augustine Penry-Herbert, emerging from the mists of a Welsh marsh carrying the corpse of a drowned child he has discovered. Irrationally blamed for her death by locals, he abandons the great house he has inherited, and sets off on a peregrination which lasts for many years – for the extent of the novel, in fact. His wanderings take him to Dorset, where his sister lives with her husband (a prominent member of the Liberal Party); to Germany, where he stays with kinfolk, the von Kessens (and falls in love with his cousin, Mitzi); to New England, where he has a series of adventures with a gang of teenage renegades, and finally to north Africa. Each encounter with a new group of people sets off a separate narrative line, and as these multiply and weave in and out of one another, Augustine himself disappears for long stretches. The most impressive of these plots concerns the rise of Adolf Hitler, whose psychology is intimately examined. The novel then concludes with an extensive and chilling account of the Night of the Long Knives, when Hitler made bloodily sure that his power was absolute, and the prospect of another world war was assured. The extraordinary manner of *The Human Predicament*'s appearance make this aspect of it crucially important to any critical analysis. It was published in two volumes twelve years apart, and comprised only half of the time-span originally announced, inevitably influencing its reception by critics and readers generally.

The novel's germ lay in Hughes's experiences during the 1940s, as he later wrote:

It was somewhere in the middle of the Second World War that it suddenly struck me with force: here was I, a lifelong writer – indeed from earliest childhood I never dreamt of anything else – here was I, witnessing one of the most important, dramatic and crucial periods in human history! I should be false to my 'call' unless I took this theme for my work . . .

The decision had come like a thunderclap: pondering how to carry it out took me ten years.[1]

Hughes was certainly busy during those ten years. Wartime service with the Admiralty was followed by several years working with J. D. Scott on *The Administration of War Production*, a volume in the official history of the war. There was script-writing for films, regular reviewing for the *Spectator* and *The Sunday Times*, lecturing at Gresham College, and – of course – bringing up a large family in a remote Merioneth house. Early in 1955, however, after a busy year on the scripts of *The Divided Heart* and *The Herring Farm* for Ealing Studios, Hughes spent two months in Spain, where the compelling, enigmatic opening scene of the novel came into his mind: 'And out of that the whole story grew, spreading and ramifying out of those two lonely figures and the burden one of them carried.' [2]

By May of that year, Hughes's agent was able to send a draft of the whole of Chapter One to Chatto & Windus, and described the projected work thus: 'a War and Peace of the last war, with a certain amount of sea stuff . . . The working title is "Town and Country".'[3] By the January of 1956, Hughes had decided on the eventual title, and was already becoming aware that the scale of the work, and the time it would take to write, were going to differ from his original assessment, reporting to Chatto's:

Regarding the novel in hand, which I call 'The Human Predicament', I have now on paper drafts of the first two chapters . . . I think it is reasonable to hope the book will go a little quicker from now on. All the same it is not going to be easy to stick to my three-year programme, though I still hope to do so.[4]

The wild variance between Hughes's first estimate of how long the work would take to compose and the actual time taken – twenty-one years for little over half the intended story – became notorious, of course. A number of reasons for this are evident. Firstly, he will have wished to sound encouraging to his publishers: it was seventeen years since *In Hazard* had appeared and Hughes wanted them to feel

encouraged enough to offer him an advance. A second reason was his meticulous method of working, continually rewriting material which would in turn be continually rearranged or even discarded. Already, in July 1958, Chatto's were expressing concern not at how little was written, but at the quantity of work put on paper and then cut out.[5] This was always Hughes's preferred method, but the greater scope and complexity of the novel necessarily increased these activities of redrafting, redisposition and deletion. This was a consequence, in turn, of the third and most important reason. After writing the first few chapters, Hughes became aware that it would have to be far more extensive than first imagined: 'more complex' and 'on a considerably larger canvas' than the other novels.[6] After three years, only the first two books of *The Fox in the Attic* were complete – a fraction of the intended whole – and Chatto's expressed concern that the work would never be finished. Soon, however, they became reconciled to Hughes's new, extended vision of the work, and it was agreed that *The Human Predicament* be published in parts.

The first volume therefore appeared on 5 October 1961. After consideration of 'Fall '23' as a title, *The Fox in the Attic* was chosen. Hughes estimated that a further two volumes would be needed, writing in September 1961 that there would be 'probably three in all'.[7] He was soon at work on the second volume and the projected date for this slipped more than that of the first: from 1964 to 1968, to 1971, until *The Wooden Shepherdess* finally appeared on 5 April 1973. Once again his method of work was a publisher's nightmare. In 1963 Hughes reported to Chatto's, in a mixture of anguish and pride, that he had produced '30 pages of foolscap – and I've used over 500 sheets of paper producing it'.[8] By 1972 he was definite about the work appearing 'as four volumes, not as three'.[9] In April 1976, however, he died leaving the third volume uncompleted.[10]

Praise for *The Human Predicament* was tempered by much concern, even irritation, at the work's idiosyncratic construction and reputed inconclusion: criticism which, as we have seen, echoes the misinterpretation which dogged Hughes's pre-war work. It is also noticeable how features which some considered the weakest points in the novel were judged by others to be its strongest. Despite Hughes's clear statement in his introductory note that *The Fox in the Attic* and *The Wooden Shepherdess* were but volumes of a single novel, there was persistent reference to both as novels in their own right. There was further contradiction regarding the content. Stephen Spender admired

the 1961 volume's style but found the factual material unconvincing: he missed 'the sense of history as the deluge carrying not just these characters but all their contemporaries along with them'.[11] Julian Symons also found the intrusion of real political figures could be 'jarringly incongruous'.[12] Walter Sullivan in the *Sewanee Review*, John Bowen in *Time and Tide*, and the *TLS* reviewer, on the other hand, were principally impressed by the historical content. Bowen, for instance, characterized *The Fox in the Attic* as 'like a hack painting by someone who isn't a hack painter. In the foreground the dreary family, but the background is filled with grotesque and interesting characters.'[13] Concern was also expressed that both volumes, especially the latter, were difficult to review, being part of an 'incomplete' whole. Of *The Fox in the Attic*, Julian Mitchell wrote plainly in the *Spectator* that: 'It is impossible to judge a novel by a single part, particularly when it contains large numbers of plots and characters which are undeveloped.'[14] Paul Theroux's frustration with the protracted publication of the work was also very apparent in his review of *The Wooden Shepherdess* : 'Art is long', he wrote, 'but good God, is it that long?'[15]

Despite the praise given both volumes, then, this was often for quite contrary reasons, and qualified by a number of criticisms and doubts, particularly concerning the protagonist, Augustine Penry-Herbert. The *TLS* reviewer commented, 'He is an oddly absent character to occupy the centre of a book so charged with incident . . . His life is a matter of mistakes and accidents.'[16] Others were even doubtful about whether the novel could be judged as a coherent work of art at all. R. G. G. Price found *The Fox in the Attic* 'disconnected . . . the total effect is baffling'.[17] John Bowen, too, complained at the lack of evident causal relationships in the first volume, writing, 'violent actions are dropped into damp blotting paper'.[18] Nowhere was there recognition that ellipsis and distortion of viewpoint are crucial, intentional aspects of Hughes's art.

Of these numerous misunderstandings, the most fundamental was undoubtedly confusion over whether the two volumes were works in themselves rather than parts of a composite work – they were variously described as a single novel, trilogy, quartet or novel sequence. In practice, even those who acknowledged Hughes's own definition of the work's structure – 'a novel designed as a continuous whole rather than as a trilogy or a quartet [which] should appear volume by volume' (FA,7) – ended up treating them as discrete works. It could hardly have

been otherwise. When *The Fox in the Attic* appeared in 1961, how else could it have been discussed? *The Wooden Shepherdess*'s publication again appeared to invite separate evaluation, because of the twelve-year gap between the volumes, because the narrative did not seem to flow from the ending of *The Fox in the Attic* and also, importantly, because the volume was published and marketed as a discrete work. For the contemporary reader – having waited those twelve long years – it must have been near-impossible to read the novel's two volumes as a single text. Attempting to, however, was implicitly discouraged by the publishers who packaged and marketed the volumes as separate works. One can only have sympathy with Chatto and with Harper (Hughes's American publisher) in their dealings with the novelist. Indeed, Hughes's correspondence shows how well he, too, understood the different responsibilities of a publisher. Making books is, after all, a business, and Hughes had contracted to produce the complete novel by 1958. As it became clear that this date was unrealistic, and that a first volume only was forthcoming (with the prospect of an equally long wait for the others), the decision of both publishers to stay with Hughes, and make the best of the situation, was something he evidently appreciated.

Publication of the novel in parts nevertheless raised the very important question of how this was to be done. Hughes inevitably regarded the parts in the context of the whole, but the publishers were well aware that principal sales occur within the first few months of a volume's appearance – when publicity, reviews, and hence market interest were at their height. For the latter, therefore, it was in everyone's practical interest to have a series of publishable entities, each as discrete as possible. The tension between these two viewpoints on *The Human Predicament* is very evident from the Chatto & Windus letter-files between 1955 and 1973. By 1958, they were writing to Hughes rather worriedly about 'the new novel which we are so anxious to have'.[19] By September 1960 it was agreed to publish the first volume on the grounds of length, and the remainder as they were written.[20] It is at this stage that differences of opinion begin to arise, in particular about the wording of Hughes's introductory Note, title-page and dust-wrapper.

Discussion about the Note was extensive, the publishers obviously recognizing its importance. It had originally stated that the novel remained 'inconclusive' at the end of *The Fox in the Attic*; Harper's were insistent that this word be removed.[21] They also suggested

amending it to read that *The Fox in the Attic* was 'written and designed to be read and savoured by itself, without reference to the volumes to come'.[22] On this point Hughes strongly disagreed, and his editor at Chatto's concurred, writing to Harper's that this was not the case.[23] There was then polite disagreement over whether the Note referred to *The Human Predicament* as 'novel', 'saga' or 'work', all with subtly different implications – an argument evidently won in the end by the author.[24] Intense exchanges also took place across the Atlantic over whether '*The Human Predicament*, Volume One' should appear on the title-page and dust-wrapper. In the end, these words were printed on the title-page only of the British edition, and were completely omitted from the American edition. When *The Wooden Shepherdess* was finally published, the Note – which set the volume in context – was left out, a list of characters was inserted (in a clumsy attempt to make the volume more 'self-sufficient'), and a new wrapper illustration commissioned so that the volume's appearance was not uniform with its predecessor. Harper's even went so far as to describe *The Wooden Shepherdess* as 'the second novel in "*The Human Predicament*"' on the American jacket, contradicting the work's very form as repeatedly made clear by its creator. The Americans' bullish attitude was again made evident when Hughes died, leaving just twelve chapters of the third volume written; within a few weeks they were seriously enquiring whether someone else could be contracted to 'finish' this volume in order to get it out!

Hughes's publishers cannot really be criticized. In the circumstances it is difficult to see what else they could have done. Nevertheless, the exigencies of publishing dictated that *The Human Predicament* appeared in a very different form to that implicit in the text. In contrast to the various circumlocutions employed by the publishers, Hughes's own vision of the work was utterly simple and consistent. It is stated unequivocally in his introductory Note:

> *The Human Predicament* is conceived as a long historical novel of my own times culminating in the Second World War . . . The reader may wonder why a novel designed as a continuous whole rather than as a trilogy or quartet should appear volume by volume: the plain truth is I am such a slow writer that I have been urged not to wait. (FA,7)

As the extensive correspondence between Hughes and Chatto's shows, the novelist also requested that the parts of this whole, when published,

should bear the novel's full name at the top of the title-page and on the dust-wrapper, and that the wrappers should be of the same design, varying only by colour and the volume subtitle.[25] Hughes continued to stress that the volumes were parts of this 'continuous whole', not discrete novels. In 1972, for example, he wrote of *The Wooden Shepherdess*: 'this is a second volume – its tempo, construction and breadth of canvas all cry aloud that this is part of a larger work, not a separate novel in itself; and my own belief is that in the long run honesty will prove the best policy.'[26]

Having established how the circumstances of publication almost unavoidably distorted reception of *The Human Predicament*, the actual text can now be discussed. As I hope has been made clear (at the danger of labouring the point), it makes no more sense to discuss *The Fox in the Attic* and *The Wooden Shepherdess* sequentially (paying lip service to their overall unity) than to discuss the first seven chapters of *In Hazard*, and then the latter seven, as separate texts. Despite the gap between the two volumes' appearances, there was no hiatus in the composition of the novel which remained an intact unity in its author's mind. As time has passed, too, this gap has lessened in importance. *The Human Predicament* may now be read as intended: as a single, homogeneous text – not as long as originally hoped, but sufficiently coherent for Hughes to consider it publishable. It is never enough to accept an author's comments about his writings, of course, and the coherence and meaning of the novel can only fully be established by rigorous examination of the text itself. As with the previous two, an essential first stage is to understand how this is presented to the reader.

The Human Predicament's rhetorical aspect is especially important because of the ambitious nature of the project and the idiosyncratic nature of its publication, and must be properly appreciated if any reading of the work is not to be distorted. Before the meaning of the text is addressed, therefore, it is essential to draw attention to two important aspects of how the novel is apprehended: its status as a 'complete' or 'incomplete' work, and the nature of its narrator.

On Hughes's death, when it was clear that a third volume had not been finished, this almost seems to have placed an embargo on consideration of the work as a whole. *The Oxford Companion to the Literature of Wales*, for example, comments regretfully that 'the incompleteness of *The Human Predicament* must complicate any

attempt to assess Hughes's achievement as a novelist . . . It therefore
seems inevitable that Richard Hughes's reputation will rest upon his
two pre-war novels.'[27]

In the light of Hughes's peculiarly elliptic style, however, we are
surely justified in questioning the premiss of such a statement. Can the
novel indeed be termed 'incomplete'? If so, in what sense? It lacks the
hoped-for volumes three and four, of course, but it is not this fact alone
which has troubled critics; rather it is that elliptic, apparently
disjunctive effect of the existing text – something assumed to be
unintentional, and dependent upon the unwritten portion for resolution.
It can be argued strongly that this is not the case: that *The Human
Predicament* is 'incomplete', but in a sense which is intentional,
consistent with how his previous novels work, and – most importantly
– can be demonstrated as an integral aspect of the novel, a principal
tactic in Hughes's rhetorical strategy towards his reader.

Hughes considered the use of absent, discordant or even seemingly
unconcluded elements to be essential in his writings: a way of
provoking that imaginative participation by the reader which was
central to his conception of how art works. Examination of *A High
Wind in Jamaica* and *In Hazard* has demonstrated the consistency and
increasing sophistication of his use of these elements. The lack of
unambiguous narrative conclusion; the protagonist's muted presence,
or even absence from the action for extended periods; sudden jumps in
the story-line; restless geographic shifts; fracture between differing
elements of the narrative, and other unresolved internal contradictions;
confusion over the reliability of the narrative voice: it is these features
of *The Human Predicament* which have generated concern about the
novel's coherence, and for which the lack of successive volumes has
been made a scapegoat. As we have seen, however, these attributes are
not only present in Hughes's previous writings, they are also
fundamental to how these work in relation to the reader.

The never-completed final portion of *The Human Predicament* is a
chimera, therefore, and should not divert attention from the extant text,
considered by Hughes 'complete' enough to be published. It should
also be recalled here that his conception of art was always organic and
dynamic rather than mechanical and static; it simply does not apply to
Hughes's aesthetic to assume that there must be a final, 'completed'
text containing a single, authoritative meaning. Rather than the image
of a construction, requiring all its components in order to be
'complete', Hughes preferred the metaphor of a tree growing,

'complete' at every stage – as he indicated in a broadcast on the work in 1961:

> For me writing can never be like a piece of carpentry, done from a blue-print: it has to grow like a tree. You may say that such writing is bound to be formless: but is it? After all, a tree grows from the roots: but would you call a tree 'formless'?[28]

In Hughes's works, too, meaning is dependent upon the process of reading, is enacted by the reader. As he always insisted, art was concerned with asking the right questions, not with providing answers. Thus the 'incompleteness', the contradictions, gaps and other puzzling aspects of *The Human Predicament* are not problems to be worked around or even regretted by the critic; rather, they are things it is crucial to seek out, helping to frame those questions inherent in the work.

A final comment is also worth making on this last novel's reputation as 'unfinished'. Within a short while of beginning it, Hughes knew that the work would extend over several volumes, each as long as an average novel. He was also all too well aware of the many years each would take to write. Already nearing sixty when he embarked on the project, and well over seventy when the second volume was published, is it credible that Hughes ever expected the narrative to be completed in the conventional sense? I cannot believe this is so. Are not his jokes about a race between publisher and undertaker, or about still writing it in the twenty-first century, a tacit confession of this? Is it not possible, at least, that Hughes recognized this novel would never have a formal conclusion? That he therefore built this inconclusiveness into the overall shape of the work, just as he had always used inconclusive and contradictory elements in his previous works anyway? In this way, whenever the undertaker 'won the race' (to use Hughes's own expression) he could be sure that the extant published text – whatever the length – could stand on its own, and be as coherent as either of the other novels. It is examination of *The Human Predicament* alone which can show whether this interpretation is possible: whether it can be 'completed' by the imaginative act of reading. To do this satisfactorily, we must first clarify our understanding of the narrative medium of the work, in particular the nature of the narrator.

Hughes is often represented as an old-fashioned survivor of the pre-war world, a grand old man of letters whose magisterial reputation exhibited itself in a direct, authoritative, narrative voice. Peter Thomas expresses this in his review of the second volume:

> As in *The Fox*, Hughes proclaims authorial presence . . . both telling and
> showing, and behaving as though . . . the Dear Reader is as ready as ever
> to follow an omniscient guide . . . He assumes that position of moral
> confidence we associate with the great nineteenth century novelists as of a
> right. His narrative stance is thus as archaic as his subject is
> contemporary.[29]

To those who take this view of the narrator, the work is necessarily
explained by the passages where he breaks off and seems to supply an
authoritative perspective on the action. Such narratorial explanation is
accepted as an unironic thesis by Hughes about human society, which is
then illustrated by the events of the story. Can it really be, though, that
in his most ambitious and complex work, Hughes forewent one of the
most characteristic tactics in the strategy of his art, the fictive narrator?
A strong case can be made that there exists a mediating artificial narrator
in *The Human Predicament*, with attributes comparable to those of
Hughes's other storytellers: modulation of idiom reflecting the
perspective of characters under consideration, and in the principal
narrator, a playful, duplicitous variety of tones and puzzles for the
reader to unravel and solve. The commentary passages by this figure
must consequently be read sceptically, as part of the text, and not as *ex
cathedra* insertions by the author. This is not to imply that their contents
are always misleading, only that they should be regarded like the rest of
the novel as an invitation to thought and not a substitute for it.

Modulation of the narrative voice is used in a number of ways –
sometimes quite explicitly (almost as indirect reportage of a character's
thoughts), sometimes more discreetly, challenging the reader's obser-
vation. A striking example of this occurs early in the novel, when the
'unique self-governing township of Flemton' is memorably described:

> Flemton was crowded right on top of this rock, the peeling yellow stucco
> of its Regency houses bulging out over its mediaeval walls like ice-cream
> from a cornet.
> This was Flemton's great night – the night of the banquet – and now the
> rain had stopped. Princes Street was decorated: Chinese lanterns hung in
> the pollarded limes: signal-flags and other bunting, coloured tablecloths,
> tanned sails, even gay petticoats and Sunday trousers streamed from some
> of the poorer windows. The roadway milled with happy citizenry hoping
> for a fight presently but not yet: little Jimmy-the-Pistol was bicycling up
> and down among them letting off rockets from his handlebars, the pocket
> of his jacket on fire. (FA,27)

There is no reason to suppose that this delightful evocation is associated with any particular viewpoint – while it is being read. In the next paragraph, however, Dr Brinley is introduced, who 'saw all these people as he tended to see the world . . . with a heightening, Hogarthian eye'. (FA,27) This immediately brings back to mind the Hogarthian cast of the Flemton description: a chaotic, exuberant street-scene, slightly exaggerated, full of movement, and containing an eccentric ne'er-do-well frozen in an act of naughtiness. It is surely not the author alone, or even an authoritative impersonal narrator, who mediates this scene to the reader, but the aged, cynical doctor, only able to bear human society by making of it a spectacle, something to be observed from a distance. Once this is understood, the picturesque account of a happy citizenry (the poorer members merrily hanging out their trousers for bunting) becomes a viewpoint to be regarded with suspicion and scrutiny by the reader; a reservation justified when bigotry and violence surface in the community after discovery of the dead child, Rachel.

This assumption of different narrative viewpoints is even more dissimulating when it modulates suddenly from one to another, without any overt signal to the reader that it is happening. An example of this occurs when Augustine arrives at the Bayerischer Hof Hotel in Munich. His impressions of Germany from the train are followed by those of the 'rather worn and despondent hostelry' where he notices that the staff have a '*distrait*' air. He sympathizes, disliking hotels himself, and the paragraph then continues:

> No wonder the characteristic stale hotel-foyer smells here seemed to irk their clean young noses: these diluted, doctored alcohols, the coffee-sodden cigar-ends: the almost incessant rich eating which must go on somewhere just upwind of this foyer where he stood, so that even its portieres smelt permanently of food; and the nearer, transient smells of brand-new pigskin suitcases and dead fur, of rich Jews, of indigestion and peppermint, of perfumes unsuccessfully overlaid on careless womanhood. (FA,131)

Augustine then goes to his bedroom where he is surprised to find a duvet instead of blankets. Sandwiched between the young man's naïve, touristic impressions, the bitter, misanthropic tone of the foyer description reads oddly, like a *Punch* cartoon of *The-Englishman-Abroad* suddenly mutating into a shocking Georg Grosz picture. Surely Augustine's impressions are here alternated with the viewpoint of one of the hotel staff he noticed (probably Lothar Scheidemann, the young

Nazi who is encountered later in the narrative)? Is it not a hotel employee's eye which sees the watering of spirits, and cigar-ends left in coffee-cups? Are not the contemptuous references to luxurious accessories and to 'rich Jews', and that spitefully effective expression on 'careless womanhood', the observations of a resentful young anti-Semite and Fascist, rather than the wide-eyed Augustine? This use of changing narrative perspective forces the reader constantly to reassess the characters and events encountered in the light of how they are conveyed.

Reportage of direct speech also comments silently on the speakers, and affects the reader's attitude to them. When Bavarian characters are quoted, for example, what they say is translated so totally that it seems like English characters speaking. Thus when Otto von Kessen recalls Hitler serving under him, he remarks, '"Damned unpopular with the men too: such a silent killjoy sort of cove . . . Frankly, in the List Regiment we were a pretty scratch lot, all told."' (FA,202) The effect of such absolute translation is to make the character speaking immediately more sympathetic; this makes it doubly shocking when the speaker voices opinions as alien to the reader as to Augustine. When he arrives at Lorienburg he assumes that 'gentlemen were much the same everywhere: a sort of little international nation, based more or less on the English model'. (FA,134) This conviction is undermined the next day, however, when the polite, gentlemanly Franz begins to speak of Germany being reborn from the blood-red darkness of the hot womb of chaos; Augustine can only respond to this by murmuring, '"Golly"'. (FA,173)

The most frequent tone into which the narrative modulates, though, and that most easily taken for an authoritative narrator, is that of Augustine himself. To many in Hughes's generally well-educated, liberal-minded audience, Augustine's viewpoint would not, superficially, be too different from their own, an additional reason for the careful reader to view the narrative warily and resist identification with a supposedly impersonal narrator. His perspective is detectable in expressions of youthful prejudice, and even snobbery. For example, when Augustine leaves Wales to visit an Oxford friend, it is said, 'Douglas was a native (surprisingly) of Leeds and already, alas, beginning to revert to native ways: he was out all day at the "Works".' (FA,91) 'Surprisingly' to whom? And why 'alas'? There is an implicit double snobbery here which the reader must be aware of, directed at the north of England and at those involved in trade. This is surely the borrowed viewpoint of Augustine, with the unconscious prejudices of

his landed background. Finally, the way in which Augustine's actions are described suggests how he sees things. An example occurs when Augustine and a friend, Ludovic, are in Morocco and find themselves attacked by a mentally unstable Muslim:

> In this sort of situation it sharpens the English Explorer's wits no end not having a gun, and Augustine remembered a prep-school performance of his which always had little boys in stitches; so out he went now, and presented himself to this one-man Holy War in the role of a monkey catching fleas. (WS,294)

Here the capitalization of 'Explorer' betrays that this is how Augustine sees himself; playing a role, therefore, in more ways than one. He soon realizes this himself, wondering later, 'What on earth could have made him behave almost like somebody out of the Boy's Own Paper the way he had?' (WS,295)

This modulation of the narrative voice, then, is extensive and varied, and proves a fruitful medium for the content of the text, fulfilling at least three valuable functions. By providing a 'signature' for so many passages in the novel, these are made all the more vivid for having an individual perspective of their own; our understanding of the associated character is also enriched. A second important function is simply to emphasize the number of contradictory perspectives on events held by the novel's characters: the many different ways of – literally – seeing things. Finally, the repeated slipping from one viewpoint to another works to keep the reader in a state of heightened alertness to the narrative, constantly having to imagine how something is being told, as well as what. This continual reassessment of the relationship between text and reader then generates a critical tension which is integral to an understanding of the work. The reader is thus inveigled, almost without realizing it, into a collaborative role in the novel.

This last function is also an attribute of the narrational medium when not being modulated, as examination of this primary narrative voice shows. Albeit very common, modulation into the characters' voices is not continuous. Even when suspended, however, the narrative does not revert to a straightforward, authoritative mode. On the contrary, this primary voice is far from unambiguous, and is more dissembling than any of the assumed characters' voices. In this it maintains the central importance of rhetoric in Hughes's art, that emphasis on challenging and involving the audience rather than patronizing it. At times the

narrator encourages a view of himself as an omniscient and reliable purveyor of information. In addition there are descriptive passages which give the impression of the narrator as an all-seeing eye. The opening pages of the novel, for example, describe a rainy November day in west Wales. When Augustine goes to sleep that night, this narrating observer still wanders around the house, noting how the moon shines on dead Henry's portrait and Rachel's drowned body – things no human is present to see. As the scene then moves to the following day in London, this weather is used to link the locations:

> Augustine waited till the morning before starting; but the belt of rainy weather travelled eastward ahead of him across Carmarthen and Brecon. Clearing even the eastward counties of Wales about midnight, long before dawn it had arrived in London (where Polly was). There it poured heavily and steadily all day. (FA,42)

While all the characters sleep, it seems as though this ever-wakeful observer is hovering above the clouds, Europe spread beneath him like a map and nothing escaping his notice – like Mitzi's imagining of God at the close of the novel: 'God was an Eye; and the Eye never slept'. (WS,387) This encouragement to see the narrator as absolutely authoritative is, however, deliberately misleading. The spurious tone of authority is a device, a challenge to the reader – to be discovered as inadequate, for the more complex meaning of the work to be realized.

This more demanding definition of the main narrator is hinted at by certain passages which read as metafictional clues on how the novel works. Mitzi, for example, imagines her search for God as a game of 'blind man's bluff' where she cannot rely on others to say whether she is 'hot' or 'cold'. In the novel, too, readers must participate by constantly making decisions about whether they are 'hot' or not. Augustine also comments that modern science has moved on from the dogmatic, Victorian system of seeking answers onto 'the altogether higher level of systems of valid questions' (FA,72) – while ironically remaining susceptible to dogmatic theories of 'progress' himself. A further example is very pertinent to how the primary narrator operates. It occurs when the Flemton carter, Tom, attempts to prise information from Mrs Winter about Augustine's whereabouts:

> When Tom wanted to find something out he never asked questions: he formed working hypotheses, announced them like this, and observed the effect . . .

> 'After all,' he resumed, 'now Young Squire has turned Roman Catholic
> and settled in Rome . . . bought a very fine house there they tell me, next
> door to the Pope . . .' (FA,315)

As with Tom's announcements, the narrator's comments are of value
for their function of inciting responses, rather than as statements of
reliable fact.

When the narrative is examined, this principle of operating a 'system
of valid questions' may be seen carried into effect. At least five
different tactics of dissemblance are employed, seducing the reader into
discovering the hidden structure of metaphor and association within the
novel. The first of these is a selectivity in what information is passed to
the reader, and when. The assumption of ignorance reminds the reader
of the fictive narrator's intermediary presence; that what is read cannot
be taken uncritically. An example of withheld information is the
identity of the dead child shown in the opening page – only revealed as
Mrs Winter's niece twenty chapters later. The section's title, 'Polly and
Rachel', and other clues make this seem possible, of course, but not
actually stating it has let the reader deduce – with increasing dread –
that the little corpse is Nellie's beloved daughter.

Three further tactics are the manipulation of time, the offering of
choices, and the laying of traps. The chronicle of *The Human
Predicament* is generally linear, progressing from October 1923 to June
1934. Within this overall time-scale, however, the fourth dimension is
stretched, compacted, and twice reversed – subjugated to the artistic
aims of the novel just as much as its geography is. Time and space are
thus given an equally dislocated, unsettling presence in the novel. This
contingent aspect of time is emphasized when Augustine visits
Morocco:

> Thus Mary was once more nearing her time, with Augustine on this
> occasion even further removed in Epoch than Space – in the Calendar
> Year 1345. That was by Muslim computation of course; but he might just
> as well have been back in Christendom's Middle Ages. (WS,276)

Time can suddenly run faster, as when it lurches forward five years
within a single chapter: from the German elections of 1928 to January
1933 when Hitler gained power. At other times it slows down in an
equally disconcerting way: as when Augustine is chased by police in
New England while carrying bootleg liquor. This chase, with him at the
wheel of a borrowed Stutz, lasts only a few minutes yet is extended

over two chapters. When the pursuit moves into a forest, the narrator states, 'The chase was a slow-motion one'. (WS,96) Augustine's enjoyment of dangerous driving, of living at his nerve-endings, makes time stretch for him, so intense is his experience of every second (a feeling familiar to anyone who has survived a motor accident). Time also slips back on occasions, wandering down the path of a character's memory or returning to a locale within the narrative, left behind by developments elsewhere. After Augustine sets off for Canada in the late summer of 1924, the narrator remarks, 'Think back now to the previous winter,' (WS,117) and picks up the story of Mitzi and other German characters from December of the previous year. This stream of the narrative then 'overtakes' Augustine, continuing until Christmas Eve 1924, when it picks him up newly returned to England from Ottawa. In this way, we are reminded of the characters' continuing existence when not under the narrator's eye, and thus encouraged to use our imagination to construct this 'missing' part of the novel. Time, then, is exploited in order to shape the narrative's presentation and reception, rather than being a straightforward, unambiguous dimension of the work.

The primary narrator also offers choices on occasion, rather than leading us simply from one event to the next. This 'branching' occurs in a chapter which begins:

> This summer of 1925 was indeed a notable summer: the Rhineland summer when Göbbels joined the Nazis, the Mellton summer when Mary had really begun to convalesce, the West Wales summer when Newton Llantony grew a new roof – and the unforgettable Coventry summer when Norah fell through the floor. (WS,221)

Within one sentence the word 'summer' is used six times, offering four different locations in a repeated phrase. By so deliberately giving Germany, Dorset, Wales and the Midlands parity in this opening paragraph, the narrator teases the reader about what will follow. Even though the effect is only momentary, it works to stimulate the reader's imagination about which locale will be chosen, and to retain a memory of the other three for implicit comparison. When the following paragraph then takes the narrative to Coventry and a light-hearted account of a slum floor collapsing, this triply ironic context makes the passage more sombre than the sentimental anecdote it might seem. Recollection of Mellton reminds the reader that Mary has carelessly

allowed Nellie to descend into this slum-life. The naming of Newton Llantony brings to mind that Augustine too is having trouble with dry rot, needing to reroof a whole wing because otherwise he would be left with 'only a measly twenty-nine bedrooms'. (WS,205) Mention of the Nazi Party in this context, then, reminds the reader of the destruction of Coventry in the Second World War (the name of Slaughterhouse Yard looking forward to the mass death inflicted by air raids).

The narrator also lays traps, offering a perspective, but then contradicting it – encouraging the reader to take an independent view rather than accept the narrator's. An example of this is when the new bishop hears the Flemton women railing against Augustine's eremitical existence:

> But why this anathema against solitariness?
> 'Women who have failed to achieve companionship in their homes, in their marriages: women with loneliness thrust upon them, I suppose they're bound to be outraged by anyone who deliberately chooses loneliness.' (FA,29)

The ugliness of the women's expressions naturally leads the reader to agree with the narrator's puzzlement and the bishop's reasonable explanation. Immediately, however, the narrator turns against this view, dismissing it thus: 'A man of orderly mind, the bishop liked to get things generalized and taped like that. Now, his generalization achieved, the tension in his dark face relaxed a little.' (FA,29) The reader is lured into accepting a viewpoint which is then attacked; it is the reader whom the narrator now archly accuses of generalization. The reader is therefore made to learn heuristically that interpretation cannot simply be accepted from this apparently impersonal narrator.

The fifth and subtlest tactic lies not in what the narrator writes, but in the telling absence of comment at certain points, and in the order of presentation of his narrative. For instance, when Christmas Day at Lorienburg Castle is described, the reader is shown the festive dinner table where 'everyone laughed and joked till the meal was over' (WS,141); presents are exchanged, then – in a lachrymose climax – the Baron plays 'Stille nacht' on the piano while his family gather round to sing. It is at this point, with the reader caught up in the emotional moment, that the narrator comments baldly, 'and only Mitzi was absent'. (WS,142) The narrative returns immediately to the Lorienburg Christmas tree, but the reader cannot help seeing this sentimental

occasion differently now. That brief mention of Mitzi makes it plain
that her family are quite happy (and certainly more at ease) without the
troublesome blind girl. No comment is necessary; the narrator's silence
here is far more eloquent.

Juxtaposition of passages is also used as a more effective way of
inviting interpretation than explicit comment. This occurs notably at
the following Christmas, when an account of the season in Coventry is
sandwiched in the middle of the account of festivities at Mellton, the
Wadamys' country house in Dorset. In between the sudden, exciting
return of Augustine from Canada (having sent his Bentley to the docks
to await him) and Polly's 'heavenly Christmas' (WS,189), there lies
a Christmas undreamt of by the Wadamys and their guests: of poverty
and pawn-shops, of owing money to the doctor. There is more to
this ordering of the narrative than a simple indication of differences
in wealth. The placing of the Coventry passage implicitly invites
pity for Nellie and the other inhabitants of Slaughterhouse Yard.
This, however, forms another trap for the unwary reader, a sly
invitation to share the muddled, sentimental viewpoint of Mary
Wadamy which was partly responsible for Nellie going to Coventry in
the first place.

The evident contrast between the two settings is also qualified by a
number of correlated phrases which hint at the cultural homogeneity of
the two groups of characters. After the evocation of Mellton's
seventeenth-century architecture, the rotting, unsanitary slum court is
also said to be 'centuries old'. (WS,180) The 'fine Jacobean front'
(WS,175) of Mellton is echoed in Coventry too, when Nellie wanders
through the city without any money, noticing shop-windows decorated
'with yew and holly and paper-chains garlanding oak-coloured
Jacobean suites'. (WS,183) Finally, there is the moment when Nellie
wakes up on Christmas Eve and finds the squalid yard transformed by a
fall of snow, taking on a romantic, medieval aura:

> As if by Merlin-magic (all yesterday having been spent re-reading
> Tennyson's 'Morte d'Arthur') the rusty old lean-to shed where the beasts
> were killed was turned to a pure white knightly tournament-tent; and
> above this mournfully-lowing pavilion the backs of the next-door court
> were a magical castle wall . . . beside the pavilion door that bundle of
> poles and the wheel-less pram were turned to a jewelled trophy of arms.
> (WS,181)

This fancy echoes that of Mary Wadamy, when she takes the

irresponsible, disastrous notion of putting Nellie and her family into the Gothic hermitage at Mellton:

> Moreover as Mary neared the Hermitage all practical thoughts were banished by the beauty of the setting. The chase, this tract of land preserved unchanged by man for a thousand years or more, was a piece of Ancient Britain itself . . . These thickets had never known the axe, these huge hollow yews and holly and random natural timber all tangled in old-man's beard and bryony.
> This was the very Britain King Arthur knew! (FA,94)

Even though the women are in utterly different material situations, they are linked by a common British heritage and cultural ideology. Both locales are also linked by the presence of yew and holly, on the ancient chase and in a tawdry window display. This reminder of the culture shared by all the British characters, despite their many differences, is not solely ironic. The very word 'Coventry' has strong connotations of wartime destruction, and it was the Second World War – especially after the blitzing of whole cities – which temporarily drew British society together as no political edict could have done. The myth – shared by Nellie and Mary – of an idealized, romantic, ancient island actually had an important part to play in the coming conflict with Hitler, therefore, an importance not belied by its fantastic nature.

The narrative of *The Human Predicament*, then, is far from a transparent, reliable medium for unfolding the events of the novel. On the contrary, narration is exploited as a rhetorical medium, designed to be ambiguous and to challenge the reader's imagination. The narrator assumes the voices of his characters and uses a whole battery of tricks, puzzles and pretences to involve the reader in helping to 'complete' the novel. In this movement from the apparent chaos of the story-line to a coherent understanding of the work, based on imaginative association of images and metaphors, the reader thus enacts a major theme within it: the problem of how to make sense of that most complex relationship, that of human to fellow human, individually and in society.

Turning from the rhetoric of *The Human Predicament* to more detailed examination of the text, let us first consider its general status as 'a long historical novel' (FA,7) as Hughes termed it. The title will also be considered, the phrase 'human predicament' having a precise philosophical

meaning. We will then see that the novel contains many conflicting viewpoints, reflecting a fractured social reality, with a correspondence in the fragmentation of the narrative structure. Within this welter, Augustine occupies a crucial position. The opposition of Mitzi and Hitler, as suggested by the commentary passages, is indeed valid – but recognition of the former's spiritual qualities by no means provides a solution to *The Human Predicament*. Despite the polar importance of Mitzi as Hitler's contrary, her significance lies rather in helping to frame Augustine's dilemma. She and the dictator form the essential axis of the novel, at the centre of which Augustine is placed. He has characteristics in common with both, and the young man's troubling over his relationship with others also has wider social connotations: of the crisis of liberalism in the twentieth century, and of the conflicts inherent in any system which attempts to reconcile the needs of the individual and of society.

Augustine thus stands at the very crux of *The Human Predicament*. The meaning of this situation emerges with recognition of those covert patterns of metaphor and association, linking him with Mitzi and Hitler within the apparent incoherence and incompletion of the work. He thus embodies one of the most problematic aspects of human existence, which develops naturally from the concerns of Hughes's previous novels. By the end of *The Human Predicament*, at that moment when Hitler's power becomes absolute, Augustine has been led to a precipice and left standing there. With the Night of the Long Knives and Mitzi's realization of its significance, the work achieves a provisional climax, to which Augustine's absence is in fact a crucial factor. The novel provides no easy answers here; indeed, to put forward any 'answer' to the questions raised would be to descend into glibness. Instead there is a profound articulation of that problem implicit in the title, a questioning of modern, liberal attitudes about society, and of our assumptions about human behaviour itself.

When an author introduces a work as a 'historical novel', we need to be quite clear what this means. In the twentieth century, the form has largely become one of popular entertainment, using history as a picturesque backdrop for invented characters. *The Human Predicament*, however, conforms to what Georg Lukács calls 'the classical form of the historical novel' – expressing history as a dynamic process rather than a tableau vivant, representing

a particular social reality at a particular time, with all the colour and

specific atmosphere of that time . . . Since the novel portrays the 'totality of objects', it must penetrate into the small details of everyday life, into the concrete time of the action, it must bring out what is specific to this time through the complex interaction of all these details.[30]

This description is particularly relevant to Hughes's last novel, in which the 'complex interaction' of details to render a 'particular social reality' is a characteristic feature. The novel also suggests the dynamic quality of history through a detailed interlinking of fictional and actual characters and events, rather than using historical sources to create a colourful stage set.

Hughes's choice of a historical subject for his final work does not differentiate it from his previous novels. In each case he was inspired to write by hearing of a true, historical episode, which was then researched exhaustively before turning this material into a work of art. The difference with *The Human Predicament* is that, instead of an act of piracy or a Caribbean hurricane, he took as a starting point the history of Europe between 1919 and the Second World War! The huge scope of this subject was rendered more manageable by the fact that he had a personal perspective on it, as someone who had participated in the historical events of the period.

As before, Hughes did a great amount of research. In addition to consulting historical sources, he sent enquiries to ascertain, for example, details of a specific American car, of the weather on a particular day in Coventry, and so on. Hughes's own experience, as well as that of acquaintances, was drawn upon in this way. There are certainly a number of correspondences between him and Augustine: the fathers of both died young, they both just escape serving in the trenches, go to Oxford, admire French paintings, travel widely and love sailing. Hughes even lends the protagonist one of his own poems. There are just as many differences, however. The novelist commented trenchantly upon the comparison in a 1975 interview:

> Well, he is not an autobiographical character. I made him my own age because I wanted him to go through some of the same experiences . . . But, after all, I have never been a rich landowner, and I don't think his character is based on mine at all.[31]

We can believe this not simply because Hughes says so, but because he treats his own life just as he treats all other source material – with a ruthless expediency. If a detail fitted, it was in, no matter where it

came from, and the original context forgotten.

The same is true of much else in the novel. The idiosyncratic character of Flemton obviously has its origins in Laugharne, where Hughes lived during the 1930s (like Dylan Thomas's *Llaregyb* – it was in late-night conversation with Hughes that the poet had the original idea for *Under Milk Wood*).[32] Mellton resembles Hatherop Castle in Gloucestershire, the home of Frances Hughes, from where the couple were married. The novelist had also known Unity Mitford in the 1930s, and memory of her will have contributed to the picture of Polly as an adolescent 'fan' of Hitler. Hughes's position in the Admiralty during the 1940s and subsequent appointment as an official historian, will have given him a detailed knowledge of how government operates. His grasp of this is evident in passages dealing with Gilbert Wadamy and with Jeremy Dibden's career in the civil service. Penelope Hughes also recalls how valuable were her father's visits in the 1950s to Schloss Neuberg and Schloss Heidenburg in Bavaria, home of Frances Hughes's kinsfolk, the von Aretins. Memories and documents of the family, architectural details, the pet fox, and many other details were assimilated to be used or, as Penelope Hughes puts it, 'added to Diccon's vast stock of "things to leave out"'.[33]

Hughes's Note to *The Human Predicament* is important for placing this factually derived material firmly within the context of a work of art. He makes a point of emphasizing that the characters in the foreground are wholly fictitious, and reminds the reader twice that this is a novel. His insistence may seem superfluous, but shows Hughes's concern that the work be read as art, not potted history. The hard-won historical accuracy of *The Human Predicament* is present not simply to display naturalistic verisimilitude; Hughes takes the history of his own times and metamorphoses it within the literary process, to question the whole nature of the individual's relationship with society.

This fundamental relationship is indicated by the name Hughes chose for his work. '*The Human Predicament*' does have an undeniably portentous air to it. Even in its title, however, this last novel plays with the reader's expectations. Beyond the obvious general meaning of 'predicament' as a trying situation lies a more specific connotation. In political philosophy, 'the human predicament' describes that problem outlined by Thomas Hobbes in *Leviathan*: how is it possible for humans – each with personal survival and desires paramount – to live together, without a disintegration into war and chaos?[34] This

interpretation is supported by a number of allusions within the novel, corroborating the Hobbesian meaning of the title.

As well as references to absolute monarchy (the form of government considered most stable by Hobbes), *Leviathan* is quoted when Augustine considers taking up the life of a bootlegger, outside the law: 'But even he had the sense to know that'becoming a gangster was only a picaresque pipe-dream for someone like him: he was such a hopeless amateur, life would indeed prove "nasty, brutish, and short".' (WS,63) Quotation of this well-known expression ensures that the allusion to *Leviathan* is recognized, and it is worth noting briefly the original context of the phrase. It occurs in that chapter entitled 'Of the Natural Condition of Mankind, as concerning their Felicity and Misery'. Here Hobbes considers the state of humanity when social organization is absent:

> Hereby it is manifest that during the time men live without a common power to keep them all in awe, they are in that condition which is called WARRE; and such a warre, as is of every man against every man. For WARRE, consisteth not in Batell onely, or the act of fighting; but in a tract of time, wherein the Will to contend by Batell is sufficiently known . . .
>
> Whatsoever therefore is consequent to a time of Warre, where every man is Enemy to every man; the same is consequent to the time, wherein men live without other security, than what their own strength, and their own invention shall furnish them withall. In such condition, there is no place for Industry; because the fruit thereof is uncertain: and consequently no Culture of the Earth . . . no Society; and which is worst of all, continuall fear, and danger of violent death; and the life of man solitary, poore, nasty, brutish, and short.[35]

Hobbes's solution to this predicament was that each individual should contract to surrender government, on condition all others do the same, to a single, absolute ruler: 'This done, the Multitude so united in one Person, is called a COMMON-WEALTH, in latine CIVITAS.'[36] While very much a work of its time, *Leviathan* remains of interest for the clarity with which it delineates the basic problems of political science.

Hobbesian allusion in *The Human Predicament* is of value, then, as a prime contribution to the 'systems of valid questions' (FA,72) raised by the novel. In this, it takes its place alongside the narrator's comments on the individual and society, as well as allusions to other philosophers. The most important of these occurs at the close of 'Polly and Rachel',

and is introduced by the sole use of 'human predicament' by the narrator:

> Primitive man is conscious that the true boundary of his self is no tight
> little stockade round one lonely perceiving 'I', detached wholly from its
> setting: he knows there is always some overspill of self into penumbral
> regions – the perceiver's footing in the perceived. He accepts as naturally
> as the birds and beasts do his union with a part of his environment . . . Yet
> the whole of civilized man's long and toilsome progress from the taboos
> of Eden to the psychiatrist's clinic could be read as a tale of his efforts, in
> the name of emergent Reason, to confine his concept of self wholly within
> Descartes' incontestable cogitating 'I'; or alternatively, recoiling rebuffed
> off that adamantine pinpoint, to extend 'self' outward infinitely – to
> pretend to awareness of everyone as universal 'we', leaving no 'they'
> anywhere at all . . . For the absolute solipsist – the self contained wholly
> within the ring fence of his own minimal, innermost 'I' and for whom
> 'we' and 'my' are words quite without meaning – the asylum doors gape.
> (FA,101–2)

The opposition established here has an immediate relevance to Adolf
Hitler and Mitzi von Kessen. Of Hitler it is later remarked, 'the
universe contained no other persons than him, only things . . . Hitler's
then was that rare diseased state of the personality, an ego virtually
without penumbra.' (FA,266–7) The reader's emotional reaction
against Hitler naturally leads to a sympathy with Mitzi who seems his
opposite. This contrast is made explicit when the narrator continues, 'In
Mitzi, the central "I" had become dislodged: it had dwindled to a
cloudlet no bigger than a man's hand beneath the whole zenith of God.'
(FA,267)

Despite the passion with which Mitzi pursues her faith, and
opposition to this 'Satan loose in the country', (WS,387) her position
does not address the general problem of social existence. When Mitzi
enters Carmel, even this community is, it is stressed, 'a community of
solitaries'. (WS,135) Her way does not concern itself with the human
predicament, therefore, but serves in opposition to the insane solipsism
of Hitler: it is between these poles that the protagonist stands.
Augustine seems to prize respect for the individual above everything:
'Any relationship which involved one human being constraining
another repelled him.' (FA,65) There is an unavoidable paradox in this
idealistic liberalism, however. It is his friend Jeremy who gleefully
points out the contradiction:

'What do you suppose would happen,' Jeremy continued, 'if there were more people like you? Mankind would be exposed naked to the icy glare of Liberty: betrayed into the hands of Freedom, that eternal threat before which the spirit of Man flees in an everlasting flight!' (FA,66)

This Liberty of which he speaks is Hobbes's 'Natural Condition', the liberty of anarchy, chaos and terror. For Augustine, however, it is its opposite, government, which fills him with horror, and seems to lead inevitably to 'the *Flanders* mud, the slime of putrefying bodies. The accusing sunken eyesockets trodden in the trench floor. The gargled pink-froth, and an all-pervading smell'. (FA,108) The contradictoriness of Augustine's position is emphasized elsewhere when the narrator comments on the 'Liberal mystique of *laissez faire*' in the nineteenth century, that 'rational doctrine of *total separation of persons*'. (FA,105) This was the philosophy, he points out, which allowed for 'stunted women sweating in the mills, naked child-Jezebels dying in the mines and the sore chimney-boys'. (FA,105) Without being mentioned, Augustine's own philosophy of 'separation of persons' is surely implicated in this critique of liberalism. Clarification of this paradox means that no solution is offered, but that the predicament is framed in yet more refined and urgent terms.

Allusion to other philosophers amplifies this aspect of the novel. The phrase 'Descartes' incontestable cogitating "I"' (FA,102) and a further reference to 'false Cartesian bonds' (FA,106) being burst by war emphasize the individual, perceiving consciousness as the focus of the novel. Four further philosophers are mentioned, contributing to the novel's ideological context, when Augustine and Jeremy argue about the value of government: Hegel, Fichte, Treitschke and von Savigny. These were important originators of the modern concept of the State, and their invocation places Augustine's attitudes against a broader background of political philosophy and contemporary events in Germany. The exquisite paradox of his position is thus emphasized: civil government, with the constraining of others that necessarily implies, is essential for social organization and to save men from anarchy; yet it can also be the means by which the State becomes an engine of destruction and anarchy in itself – as happened in Germany during the twentieth century. Having come to an understanding of the novel's title, we can now examine this 'predicament' itself, as indicated by the patterning of metaphor and allusion in relation to the principal characters.

Within its apparent chaos, examination of the dominant metaphorical patterns reveals a hidden order. Augustine's fragmented vision of human society – 'but a procession of separate, naked men pretending' (FA,68) – is echoed in a consistent use of metaphors and allusions referring to disintegration, contradiction and disablement. Amidst this storm of conflicting perspectives, Augustine's key position between the extremes of Hitler and Mitzi forms the focus for four dominant patterns which confer order on the narrative, not by resolving it in the conventional sense, but in helping to articulate the dilemma of the work's title.

Allusions to fracture and disintegration of many sorts recur persistently. To begin with, there are a remarkable number of literally 'broken' characters, people disabled by war, nature or accident. Many are partial survivors of the First World War, of course, like Otto von Kessen with his artificial leg – used to bludgeon him to death on the Night of the Long Knives (linking the violence of the Great War with that of Nazism which brought about the Second World War). There is also the young veteran at the Flemton Banquet:

> Briefly and gravely the bishop said his piece. As he did so he tried to keep staring at the Legion banner on the wall opposite, but his gaze was drawn down willy-nilly to a young man under it with ribands on his chest. All that young man's face except mouth and chin was hidden in a black mask which had no holes for eyes . . . and suddenly the whole room reeked overpoweringly of beer. (FA,36–7)

At the festivities of the banquet, this ex-soldier seems a delegate from another world of mutilation and chaos.

Disablement is not only associated with warfare; many persons and creatures in the novel are crippled by nature or accident. Augustine's uncles are deaf in different ears. Before Sylvanus, Nellie has given birth to 'a downright monster' (FA,61) of which nothing further is heard. Her husband, too, is fatally ill with tuberculosis and dies grotesquely after falling from his Bath chair. This incident is echoed when Mary Wadamy (who had so patronized Nellie and Gwilym) is herself paralysed in a fall: remaining alive inside while her body 'passed from the limp to a rigid state like a rigor mortis – as if her body were already really dead'. (WS,202) Wolff, in his Lorienburg attic, dreams he is paralysed, while Hitler, in his Uffing attic, lies truly injured and delirious after the failed *putsch*. Jeremy Dibden's

appearance, like that of a classical statue, is marred by a withered arm, the mark of polio in youth. When Jeremy and Joan mistake an unemployed miner for Augustine, they realize their mistake when he turns round: 'Though much of the same age and height, Augustine's "Doppelgänger" had lost one eye and his blue-black nose had been crushed back into his face'. (WS,286–7) Even those physically well are said to feel metaphorically broken. Thus Augustine is 'rent' (WS,112) by his affection for Ree; Adele von Kessen is 'torn in two' (WS,143) over whether to visit Mitzi; the expression 'torn in two' (WS,263) is also used to describe Augustine's and Joan's feelings for one another, and again for Lothar's wish to hear Göring speak without being disillusioned. (WS,318)

These examples are complemented by comparable allusions to civil society, and humanity's fractured perception in general. Augustine wonders, 'how was it so great a gulf divided his own from every previous generation, so that they seemed like a different species?' (FA,23) Later, when he argues with Jeremy about the necessity of moral judgement, the latter responds, '"But that lands us with two dichotomies instead of one . . . and sometimes they clash."' (FA,73) American society, too, is described dichotomously: 'Prohibition had split America – split her as nothing had split her since slavery! This was democracy's ultimate nightmare, a nation attempting to tyrannize over itself with the People's Will plumb opposed to the people's wishes.' (WS,9)

Further allusions suggest that human perception itself is irretrievably fractured. This is hinted when Augustine visits the billiard room at Newton – the male preserve of his bachelor uncles, 'which no woman except housemaids ever entered'. (FA,19):

> Hardly anything in this room was quite what it seemed at first sight. That ribbed glass picture looked at first just an innocent rustic scene, but as you walked past you saw from the tail of your eye the billy-goat going incessantly in and out, in and out. (FA,20)

His uncles, so respectable that no Liberal was allowed in the house, enjoyed the schoolboy obscenity of this toy in private. And while such things are for the eye of 'no woman', they had not cared what housemaids saw, as though these were not considered as people. Another image which expresses the arbitrariness of human perception occurs when Hitler lies delirious at Uffing. A bookcase looms over him,

and 'Hey presto before his very eyes those books had started exchanging titles like jugglers throwing balls to each other!' (FA,264) This vivid picture suggests how everything beyond the observing self may be regarded as chaotic, and that any meaning attached to things is merely a matter of arbitrary labels, assigned by the perceiver. Such a view is very much in accord with Hughes's Hitler, of course, for whom all creatures are but objects to be manipulated by his will.

Many of these allusions to incoherence are associated with Augustine, emphasizing the centrality of his dilemma. Discovering that Mitzi has gone to take her vows, he feels a terrible panic that life lacks any sense, and rushes from the *Schloss*:

> When Augustine at last reached the plain of the river-bed, he was surprised to find there no snow at all. There was ice there instead: on the road it had been swept into untidy heaps like a dump for shattered window-panes: on the fields it just lay around on the ground like more window-panes shattered. (FA,350)

This image of heaped, broken window-panes is very suggestive, for windows recur frequently as viewpoints for characters in the narrative. The glassy heaps are an emblem of these various perspectives, all shattered and equally useless to Augustine's eyes. An extensive pattern of allusions to incoherence and contradiction exists within *The Human Predicament*, therefore – strongly supporting the view that the fractured appearance of plot and narrative is a deliberate strategy, and integral to the meaning of the work.

Within this context of incoherence, Augustine is a focal point for a whole range of metaphorical patterns, offering access to a more coherent understanding of the novel. Characters are said to find experience whizzing around them like the patterns in a kaleidoscope, as when Mary sees her garden as a 'whirling kaleidoscope' (WS,218), and when Mitzi spends her first night in Carmel: 'her head was beginning to spin with things and places, whirling in any order of time . . . But bit by bit the kaleidoscopic phantasmagoria slowed'. (WS,137–8) While Mitzi and Hitler take their own opposed but equally absolute paths in response to this confusion, Augustine remains in a kind of limbo, to be observed and coldly considered by the reader, like the subject of a laboratory experiment. While *A High Wind in Jamaica* was dominated by its rich metaphorical texture, and *In Hazard* worked through the juxtaposition of characters, *The Human Predicament* synthesizes these

approaches. Meaning emerges from examination of metaphorical pattern, as it relates the central character to the two who contrast with him in such different ways. The characterization of Hitler, Mitzi and Augustine will be outlined first, therefore, before turning to those patterns.

Adolf Hitler is first encountered indirectly, an obscure street-corner politician brought to the attention of others by his role in the failed *putsch* of 1923; by the end of the narrative, he has consolidated absolute power over Germany. Paradoxically it was the very failure of the *putsch* which allowed him to exploit his sinister gift, that of the demagogue. It is this attribute which Hughes selects for emphasis in the novel, making the Nazi leader a charismatic performer who entrances his audience by telling them what they secretly want to hear. As Dr Reinhold comments, Hitler has

> 'a superhumanly sensitive nose for what potential followers think and want. He must find that out before the bulk of them know it themselves, then announce it as his unchangeable will – when of course they will follow his lead like sheep, because that's the way they're already unconsciously wanting to go.' (WS,214)

It might be said that Hitler as Hughes describes him is 'democratic' in the worst possible sense. His power is not so simple as this, however, for he understands too the value of inaction, of not acting at a crucial moment. It is Reinhold who comments again later:

> 'There are times when sudden and violent action is needed to change the course of events, times simply to sit still and be carried along by the tide – and Hitler always knows which. Those constant complaints of his "indecision" are simply a failure to grasp that *what* you do often matters so very much less than *when*.' (WS,314)

He is also referred to as 'the Great Non-Decider' (WS,334) for slyly allowing the SA crisis to arise by doing nothing.

Hitler's most characteristic attribute, however, is that constantly stressed solipsism, by which no other creature is recognized as having an independent existence. This is interestingly revealed in his response to the Night of the Long Knives:

> Given the Führer's solipsist Weltanschauung (whereby the rest of the universe human and otherwise equally ranked as inanimate 'things'),

yesterday's slaughter of awkward old friends should have roused in him no more compunction than bulldozing old buildings which stood in the way of development schemes; and yet he seemed strangely obsessed by his yesterday's doings. (WS,373–4)

As one of the puzzled guards realizes, Hitler's very self-obsession is the cause of his disturbance: 'For after all nothing on earth can equate with a solipsist losing his life, since that is the End of the World itself: so this was simply the after-effect of an eschatological class of fright unknown to mere mortals!' (WS,375) Hughes's Hitler, then, is characterized by a pure willingness to act, untrammelled by consideration of anything whatsoever beyond his own desires.

Mitzi von Kessen is first encountered through Augustine's eyes when he arrives at Lorienburg. As the reader soon discovers, this image is highly misleading for Augustine decides he has fallen in love with her, and has an utterly sentimental impression of Mitzi. He barely speaks with her, never has the slightest idea of her spiritual and intellectual depth, and is moved mainly by her passivity and girlish sweetness: '*Her frost-pink face, half-hidden in furs*'. (WS,6) The reader is made privy to Mitzi's thoughts from early on, following her from an impressionable teenager to the mature Sister Mary of Bartimaeus who – though blind and immured within the silent order of Carmel – has a profound understanding of what has happened to her country. Her attitude is the very opposite of Hitler's: utter submission to her circumstances, even that of blindness. This embracement of fate is described thus:

> Mitzi at last made her necessary 'leap' into the stretched blanket . . .
> Thereafter all thought of Hell – all thought of punishment, even – was
> suddenly gone as completely as a finished thunder-storm is gone. What
> remained was a feeling of floating: of floating on God's love. It soaked her
> through like sunshine . . . There was now no obstacle at all between
> herself and God: her will and His were one. (FA,249)

The special access to Mitzi's thoughts makes her loom large in the novel, yet this should not blind the reader to her insignificance as far as the other characters are concerned. Within weeks of the narrative commencing, she disappears into the Convent at Kammstadt, never to emerge again. Her family are glad to see the blind girl shut away, and hardly visit her. Unlike Hitler she limits to the absolute minimum her activity in the world as it affects others – not cynically as when he uses

inactivity, but in a positive submission to the will of God, as conceived by her.

The difference between Mitzi and Hitler is not one of straightforward morality, a monochrome contrast of saintly nun and evil Führer. The dictator, it is stressed, only articulates the covert desires of many Germans after Versailles. It might be asked, too, what 'good' Mitzi actually does? Considering her voluntary exile within Carmel, cut off from humanity, the answer – in a narrow sense – must be not a great deal. Certain similarities also exist between them: in 1923 she is just as committed as Hitler to a reborn, militaristic Germany, to be wrought by the *Reichswehr* on a mountain of corpses. As well as this nationalistic idealism, they share an absolute confidence in themselves: Hitler is sure that God's will coincides with his own (believing himself effectively to be God); and Mitzi is happy that her will coincides with that of God (in accepting herself as a tiny part of an ultimately coherent universe). The potential confusion of these two must be realized, if their true difference is to be appreciated.

The essential contradiction of Hitler and Mitzi lies rather in their intellectual attitudes to the world. Hitler, for whom people are literally objects, is the embodiment of the principle of action; he is utterly unrestrained in his willingness to act upon others. Although social acts are done by him in a uniquely brutal manner, it should be recognized that any social act necessarily imposes upon the integrity of other individuals. Mitzi, by contrast, is the person of inaction, not in any negative sense, but as an austere positive attribute – pursuit of a contemplative life impinging upon others as little as possible.

Between these extremes, Augustine stands enigmatically at the centre of the novel. His youthful love of Mitzi persists ten years later when he refuses to visit Germany because of its painful associations. There are other, less obvious links between them and, significantly, between Augustine and Hitler. 'A.H.', the identical initials of their names, is a hint of this, and once such points of comparison are sought, their number is impressive, lending a sinister new side to the naïve young protagonist.

We have noted how Augustine's apparent passivity disappointed and confused many critics. The *TLS* reviewer commented, for example, that 'he is an oddly absent character to occupy the centre of a book so charged with incident . . . His life is a matter of mistakes and accidents.'[37] This point was even put to Hughes before the novel was published, by his daughter Penelope:

I remember complaining to Diccon in the previous winter that from Augustine's arrival in Germany onwards, as a hero he was disappointingly wet. Everyone else said the same. Diccon just looked at me enigmatically, with a slightly mischievous light in his eye, and refused to take up the issue. It was not until after he was dead that I began to understand a little of the complexity of this method, of how he 'manipulated events in the reader's mind', as he put it.[38]

This curious feature of the protagonist is actually discussed within the narrative, corroborating that it is a deliberate tactic. The discussion takes place between Jeremy Dibden and Joan, whom it is understood Augustine will marry. He has stayed on in Morocco without writing to her, and Joan 'began to rehearse in her head her private list of Augustine's faults: his lack of ambition of any kind, and even of any consistent aim in life'. (WS,282) She then complains out loud that he could take up any career he wished, yet does not. These are the very concerns about Augustine voiced after publication, and Jeremy's reply forms an interesting response to this criticism. With biting sarcasm he proposes three ways in which their rich friend could assume a public presence: as an artist, as a politician, or even – easiest of all – to settle down as squire at Newton Llantony, opening bazaars and sitting as a magistrate. Joan's embarrassed silence shows that she would be pleased with any of these – and how much easier for the reader, too, having the protagonist an artist or backbench MP, able to travel and comment wryly on the events in Europe.

To desire Augustine other than he is, however, is to miss a crucial point: his wilful refusal to assume a social role forms a positive act in itself, as Jeremy also hints:

> But misery made Joan stubborn: 'All right then, over to you! What does Augustine intend to do with his life?'
> 'Perhaps it's a rarer gift than you imagine, Augustine's knack of having things happen to him without ever needing to lift a finger to make them happen,' said Jeremy softly. (WS,283)

Jeremy's words imply more than that Augustine simply lets things happen to him; rather that *not* doing things is used effectively by him. By not entering the squirearchy or a dilettante existence, Augustine reveals more strength of will than falling into these ways of life would show. Throughout his life, in fact, inactivity is shown to be a powerful force, revealing much about him. By staying on in Morocco without

writing, he gives a plainer message than any letter that he will not marry Joan. By not accepting twelve-year-old Ree's offer to make love, he hurts her emotionally, but this refusal probably saves his sanity. This deceptive passivity is all the more challenging for the elliptical manner in which Augustine is presented. He vanishes disconcertingly from the story more than once. His speech is often reported indirectly. Parts of his life are passed over, or barely hinted at. There is almost nothing of the relationship with Joan, and his support for the miners is also glossed over – in both these cases, direct description would have given a far more active impression of Augustine, unbalancing the image of a man poised constantly between 'doing' and 'not-doing'.

Augustine, then, for all his passivity and absence, stands at the crux of *The Human Predicament*. A curious glimpse of Hughes's view of him is given in a letter to Chatto's, where the dust-wrapper of *The Fox in the Attic* is discussed. He suggests using a portrait of Augustine and continues, 'I envisage Augustine as something half-way between the young Rembrandt self-portrait at Kenwood and Augustus John's portrait of the young Dylan Thomas.' It is fascinating to speculate on this choice of faces: Thomas lending his charm and red-headed openness of expression; Rembrandt, the self-absorbed obsession which his portraits reveal – half-delighted, half-frightened by his own gaze. A further indication of Augustine's centrality is the use of his full initials, carved into a schoolroom table: 'A.L.P.-H'. (FA,17) It is unlikely that attention would be drawn to Augustine Penry-Herbert's initials in this way if they did not suggest 'Alpha', first letter of the Greek alphabet – for Augustine is indeed the starting-point of the novel, and only through comprehension of his situation can *The Human Predicament* begin to be understood.

Augustine cannot be ignored or dismissed, therefore, but must be recognized as a complex figure at the core of the novel, riven by internal contradictions. He hates class distinction, for example, yet is quite capable of snobbery and of railing at servants: '"That woman ought to be sacked! . . . You can never trust that class!"' (FA,78), he mutters of Polly's nanny. As well as being intensely solitary, he is also driven to people. He is fascinated by others and, on occasions, desperate for human kind: 'He who so loved to be alone felt now a sudden unmitigated longing for living human company.' (FA,40) Just as Emily's situation in *A High Wind in Jamaica* was prolonged by having puberty come upon her during the long pirate-voyage, Augustine's dilemma is prolonged for years by his very wealth, that 'blight of the

silver spoon in his mouth' (WS,284), as Jeremy puts it. Not needing to support himself, and with too much self-respect to drift into some profession for the sake of it, Augustine remains throughout his twenties and into his thirties, an individual haunted by the human predicament.

To comprehend this situation it is necessary to look beyond the linear unfolding of the narrative to those metaphorical patterns which inform the work. It contains a great many, some of just a few instances, others containing scores of allusions. Four groups are particularly effective in conveying Augustine's predicament, and will be discussed here. These are the groups concerned with religion, water and fluidity, vision and sexuality.

Allusions to religion form the most evident group, and cluster around the three principal characters. Mitzi's genuine devotion and mysticism become apparent after she loses her sight: the arbitrariness of existence is accepted by her as part of a coherent whole beyond understanding. She is associated with two other notable Carmelites: Saint Thérèse of Lisieux (WS,122), whose simple faith – the Little Way of trust and absolute surrender – led to canonization in 1925; and Saint Teresa of Avila, famous for the intellectual passion and rigour of her faith. Saint Teresa is referred to once directly (FA,293), and again indirectly when Mitzi senses God as an invisible companion: 'the queer idea of a "presence" felt so close that she need only stretch out a hand for help'. (FA,138) This latter image strikingly resembles Saint Teresa's account of God's immanence:

> how is it that I can understand and maintain that He stands beside me and be more certain of it than if I saw Him? I am like a person who feels that another is close beside her, but because I am in the dark I see Him not, yet I am certain that He is there present.[39]

Mitzi's faith is notably ascetic and she works towards it with a highly formal logic, moving from question to answer, which generates a further question in the Socratic manner. In this way she discovers a meaning of being 'with God' as 'never a static condition: it is rather a journey – and endless'. (FA,296) In this she recognizes the words of Thomas à Kempis as relevant to her: *'That, having forsaken everything else, he leaves also himself: go wholly out of himself, and retain nothing of self-love'*. (FA,295) After ten years, Mitzi is discovered still in Carmel, still happy, and still thinking – as Sister Mary of Bartimaeus (Bartimaeus being the blind man cured by Jesus at the gates of Jericho).

It is here, on learning of the Night of the Long Knives, that she becomes truly aware of 'satan loose in the country she's grown up to love'. (WS,387)

This satanic figure of Hitler is also surrounded by religious associations. The extreme nationalism shared by Mitzi and him early in the novel is bound up with Catholicism. The description of Lorienburg's gorily realistic crucifix is followed by references to 'human sacrifice' (FA,146) for the Cause, and to Wolff's intended murder of Augustine and Mitzi as 'his last and supreme sacrifice to offer on Germany's altar'. (FA,248) The Führer himself is compared to Saul, Samson, a martyr, messiah, saint and one of the Magi – all reflecting the oleaginous devotion which Hitler encouraged. The irony of these allusions is sharpened by the repeated comparison with Christ. He imagines himself in Berlin 'scourging the money-lenders from the temple'. (FA,265) Putzi Hanfstängel's son dreams of 'the Christus Kind and Uncle Dolf in identical old blue bath-robes' (WS,172), and when Polly and Janey are asked why they want to visit Munich in 1933, they reply:

> 'We want to see some of the Holy Places.'
> 'The street where the Martyrs died.'
> 'The inn where Hitler was born.' (WS,326–7)

The effect of such references is twofold. They suggest the near-religious reverence invited by Nazi propaganda, and also – because of the obscenity of the comparison – encourage the reader's view of Hitler as an Antichrist, the satanic figure stalking the earth imagined by Mitzi. This black-and-white view of Hitler and Mitzi is not incorrect in itself – they are indeed opposites – but is misleading as a sole explanation. As we have seen, both share a background of pan-Germanic, militaristic nationalism, and both identify themselves totally with godhead (one by dissolving herself in it, the other by arrogating it to himself). This more complex relationship is then articulated in the person of Augustine, with his religious associations.

Augustine's attitude to religion is full of contradiction. He is avowedly atheist, yet his most natural expressions of surprise are 'Lord' (three times), 'Heavens' (twice), 'Good God', and 'Christ'. 'Christ', in fact, is almost his last word in both volumes. He claims to be completely rational and against superstition, yet shows himself susceptible to one 'faith' after another: 'the great revelation which was

Freud' (FA,73); the theory of Significant Form which he learns from
Jacinto, for whom it was 'what the Cross of Christ Crucified was for St
Paul' (FA,335); the Modernist cult in painting; and even his
romanticization of the south Wales miners, and of T. E. Lawrence,
which 'was something he should have got wise to ages ago'. (WS,290)

Augustine combines the positions of Mitzi and Hitler, and he too is
surrounded by religious allusions. His house has a stone temple in the
grounds, and the gun-room 'had been a domestic chapel once'. (FA,17)
He is 'transfixed' (WS,6) by the thought of Mitzi, and follows her
through the snow like Wenceslas's page. This image is echoed when
Ree takes him into the abandoned Warren House in Connecticut: 'Dust
on the floor was so soft and deep it accepted their footprints like snow.
So Ree (like the page in the carol) imprinted her small ones inside his
big ones'. (WS,43) This is recalled in turn when Ree remembers her
science teacher blurting out that 'he as a scientist had to believe in God,
just as the page in the Wenceslas carol believed in the king whose
footsteps he trod in'. (WS,66) This multiple reflection of Augustine,
then, suggests how his love for another is potentially part of a greater
faith. Augustine's visit to Morocco is important in this context. Having
travelled to north Africa, across desert and through mountains closed to
Europeans, the climax of his journey is a peaceful night spent in a
castle high in the Atlas. His room is completely bare, with a polished
plaster floor and small unglazed window: 'Augustine had never seen
any room quite so lovely – or quite so ominous, chilling and
comfortless.' (WS,281) He comes so far to discover this moment of
contentment in a small bare cell – the abode Mitzi had taken up years
before in Carmel.

In addition to this discreet religious strain, Augustine shares some of
Hitler's God-like attitude towards others. He makes the young people at
Lorienburg and New Blandford devoted to him, yet abruptly leaves
both places without regard for these feelings he had encouraged.
Having broken down the von Kessen twins' distrust, he simply ignores
them when it pleases him: 'At this incredible betrayal the twins did
what they never did – burst into a wail, puncturing the surrounding
snow with tear-holes while Augustine vanished out of sight.' (FA,343)
He leaves the American 'pack' with a similar callousness, exploiting
their good nature to get out of the country: 'in a tragedy-voice he told
them all crossing of frontiers was out where he was concerned: for his
passport was lost' (WS,100), keeping to himself that 'once out of their
sacred United States they wouldn't see him for dust'. (WS,101) As a

child, Augustine also believed himself to be God, as does Hitler (and as do Emily and Dick in the previous novels, of course).

This tension is expressed by the motif of a rope or stairway leading up into thin air, like Jacob's vision in the Bible. Describing Augustine's childhood, it is said:

> To most boys at any time school is life, is itself the cosmos: a rope in the air you will climb higher and higher, and – then, quite vanish into somewhere incomprehensible anyhow. (FA,110)

Augustine also recalls the story of a mad neighbour, Sir Rhydderch Prydderch, who had torn out his staircase, 'and thereafter swarmed up a rope every night to go to bed'. (FA,224) He dreams of doing this himself (FA,155), and in New England actually climbs a stairway which leads into air, at the ruined Big Warren Place. This image is reflected in a number of other references to stairways, rope and Jacob: Wolff hangs himself with a rope, and Ree considers doing this too when spurned by Augustine; Hitler is compared to 'wretched Jacob' (FA,262), as is Mitzi, being one of the Carmelites whose 'souls climbed alone each one her separate Jacob's ladder to God'. (WS,135) The effect of this motif is to place Augustine metaphorically in mid-air, halfway between heaven and earth. Like Jacob, Augustine is torn between extremes, and this image provides an apt illustration for his dilemma and his humanity.

The significance of the protagonist's name should finally be noted in this context, recalling Saint Augustine. Allusion to the saint is pertinent for several reasons. He is particularly known for the *Confessions* (which describe his movement from dualistic Manichaeism to Christianity), for *The City of God* (which uses Roman civil organization as a metaphor to study contending spiritual forces), and for the sensual passion of his faith. Each of these reflects upon the protagonist of *The Human Predicament*. Augustine Penry-Herbert, too, is racked by a fractured perspective on the world; he cannot reconcile his inner life to any social context, and is tortured by an incapacity to direct physical passion towards any worthwhile object. The saint is not simply an ironic foil, therefore, but is recruited by Hughes to expand the meaning of Augustine's predicament.

The Human Predicament is the only novel by Hughes not set at sea, yet it is still suffused with images of water, numbering almost a hundred. Augustine seems to move through a fluid, aquatic world even

when on dry land. Almost every significant episode in the narrative occurs by water: the finding of the dead child; Polly's introduction (springing from her bath into Augustine's arms); the stay in Lorienburg by the Danube; Augustine's spell as a sailor and meeting with Ree by the Connecticut pool; the car-crash into the lake; the Coventry children's trip to Quinton Pool, and the arrest of Röhm at the Wiessee lakeside resort. Water and the marine world permeate the novel metaphorically too. Characters are compared to fish, frogs, octopuses, seals and eels. Nature is said to be as wasteful of young men in war as 'she is of fish spawn'. (FA,70)

The principal impression of these allusions is the flux of existence within which the characters move. This corresponds closely to how water is used in *In Hazard*, and brings to mind Hughes's persistent interest in Taoism, in which water has a special significance – representing the fluidity of existence and its infinitely changeable yet unchanging nature. The re-formation of liquid as ice has a particularly ominous presence, suggesting the passion locked up in German society after Versailles, which must eventually be released and come rushing down on Europe. This is first hinted when Augustine arrives at Lorienburg:

> Someone (he noticed) had left a bottle of beer on the sill overnight: it had frozen solid and then burst, so that the beer still stood there – an erect bottle-shape of cloudy amber ice among the shattered glass! (FA,165)

This inherent danger is also suggested by a further reference to ice, describing Weimar society during the 1923 crisis:

> Thus in their manner they reminded one rather of skaters caught far out too late in a thaw, who know their only but desperate hope lies in speed. The ice is steaming in the sun and there can be no turning back. They hear anguished cries behind them but they lower their heads with muffled ears, they flail with their arms and thrust ever more desperately with their legs in their efforts to skate even faster still on the slushy, cracking, sinking ice. (FA,201)

Germany's volatility is repeatedly indicated in this way. Thus the 'manly idealism' which Lothar finds in Fascism is like 'a desert waterspring' (FA,123); when Walther lets loose his passion in playing the piano, 'those swelling thunderous chords were a very Niagara of *lacrimae rerum*' (FA,154), and Franz is captured during the 1919 revolution by a 'tide' (FA,186) of Communists.

Within this context, Mitzi, Hitler and Augustine each have a penumbra of aquatic allusion. When struck by blindness, Mitzi seems plunged in water: she feels 'waves of black despair' (FA,243), and goes to the chapel where baroque decoration shows 'babies submerged in silver soap suds'. (FA,251) When she accommodates herself to this loss, it is as though water becomes her natural element: 'floating on God's love', which 'soaked her through'. (FA,249) Her passage from postulant to nun is described as a tadpole growing to a frog (WS,125), and – in contrast with Augustine's shattered beer bottle – she discovers a crock of frozen water on her first morning in Carmel – intact, with ice and pot in harmony. This image of fluid in a container recurs at the close of the novel, when the prioress comments to Mitzi of God's purpose:

> 'Man cannot live without God . . .' The Prioress hesitated a moment, and then went on: 'But even the heathen know that. Surely the Good News Jesus of Nazareth brought was rather that God cannot do without Man, not even the men who would drive the nails. Himmler and Himmler's men are also his children.' She paused again; and then added, the ghost of a smile in her voice: 'Though as to His purposes for them – as for ourselves, we can know no more about that than a tea-cup knows about tea.' (WS,385)

Here, in terms reminiscent of a Taoist aphorism, Mitzi's relationship with God, her trust in the latent coherence of existence, is again rendered by the metaphor of a vessel, whose significance lies in its function – containing liquid – rather than its substance.

This use of liquid to convey Mitzi's quietist position contrasts with Hitler's antipathetic relationship with water. When the *putsch* fails, his marchers 'melted clean away'. (FA,223) In Landsberg Prison, Hitler's mind 'ran like a mill-race' (WS,158), and his own 'boiling Storm Troops' (WS,342) become a danger to him. The Nazis are reported as recruiting a quarter of a million unemployed to be kept busy 'draining marshes'. (WS,337) Hitler's impotence is described in terms of his 'frost-bitten loins' (WS,320), and his aversion to water is mentioned several times: 'the Führer's fine-strung nerves couldn't bear bobbing about in boats with all that water below him' (WS,335), and listening to rain awakens his 'obsessional fear of water'. (FA,261) He then dreams of drowning, and in the water sees his dead mother's face: 'But now that face was multiplied – it was all around him in the water. So his Mother *was* this water, these waters drowning him!' (FA,268) This set of allusions forms a clear antithesis to that associated with Mitzi: her

absolute acceptance of the conditions of existence is contrasted by the Führer's revolt against them, in his hatred of the all-embracing medium of water, of the woman who bore him, of life itself.

Augustine too has his set of aquatic allusions. He suffers melancholy 'in waves' (FA,348); he roots through his memory 'like searching sea-caves for old echoes' (FA,176), and his heart jumps 'like a fish in his breast' (FA,247) at the thought of Mitzi. Unlike Hitler, he loves water, 'learning to swim, as a child in his bath' (WS,103–4), and the only time he is utterly happy is on the rum-runner *Alice May* which 'had taken Augustine to seas that were streaked with more greens and blues, and more bluey-greens and greeny-blues, than even Pissarro in Paris had painted with'. (WS,27) This affinity is not like the mystical surrender of Mitzi, however. The appeal of water to Augustine is as something which engages his attention fully, as something with which he can strive and be in harmony simultaneously – thus his delight in working as a sailor on the schooner, working with the winds and the tides, and the crew who 'ensured he would dance to their tune'. (WS,27) By this engagement with the sea, Augustine reveals an attitude midway between those of Mitzi and Hitler: wishing to be in concord with the world around him, yet needing to act upon it too. While a sailor, this is possible for Augustine at a practical, material level, but to do the same with society is a different matter. Herein lies a further, more refined metaphorical definition of Augustine's predicament.

The third set of allusions is that related to vision. References to sight and blindness amount to well over a hundred. Mitzi's complete loss of sight is a plain symbol of the inner vision which she gains. Her acceptance of this 'chaos of meaningless sight-sensation' (FA,235) also signals an acceptance of imperfection as part of existence. It is thus she expresses 'perfect contrition' (FA,248) for taking so much in life for granted. Mitzi's last vision of God in the novel is as an Eye which 'never slept' (WS,387), able to stare into whatever blackness lies within men.

Hitler's eyes are frequently noted, remarked upon as blue, popping, affectionate, staring, and able to compel any meeting's attention. He is said to have 'as many eyes as a fly' (WS,162) and 'all-seeing eyes'. (WS,367) At the same time his gaze is 'half-conscious: vague, shifty, glassy, settling nowhere and seeing nothing'. (WS,351) Hitler can be said to 'see nothing' because 'this solipsist mind' (WS,374) sees only itself and projections of its own will. It is this undeniable power – to imagine something and will others to do it – that resides in Hitler's

staring eyes, and is described as an ideal Fascist quality: '"the Eye of Horus" – their private name for that rare hawklike eye that pierces to the spiritual behind every mental veil'. (FA,123) This contrasts with the ever-open eye of God imagined by Mitzi.

Of all the characters, none is said to look, stare, scan and gaze more than Augustine. He is well aware of this, thinking he would rather lose any sense than sight:

> to the joy of seeing Augustine was perhaps exceptionally addicted, as if his whole consciousness were concentrated behind his eyes and almost craning out of them, like someone who can't tear himself from the window. (FA,239)

As well as this innocent delight in the world around him – 'the almost infinite and incessant pleasure to be got from just "looking"' (FA,240) – there is also a more sinister aspect to Augustine's gaze. He loves to spy and watch in secret, to peep. He makes himself a 'peep-hole in the window-ice' (FA,240); he 'found himself peeping' (FA,143) at Mitzi and 'peeped gingerly into the dark confessional' (FA,252) when looking for her. On discovering that Mitzi is blind, his first thought is the pleasure he can now get from staring at her: 'He could gaze right at her face at six inches range without giving her offence'. (FA,247) He even spies on her when she goes to pray alone. The scene is described wholly from his viewpoint, and when he creeps forward to touch her hair, the reader is invited to share his excitement: 'she surely could not help but hear!' (FA,254) The tacit invitation to take Augustine's view is something to be recognized and spurned, however. As when he spied on a little girl urinating when a boy, Augustine's behaviour does more than 'give offence', whatever he tells himself. Regardless of whether the objects of his gaze know or not, this peeping is voyeuristic and a violation of privacy. His attitude is associated with Hitler by the Führer's fondness for pornography – he sends his niece letters adorned with drawings 'depicting her own private parts' (WS,320) – and by his use of other men's eyes as 'peep-holes into the brain behind'. (WS,363)

Augustine's secret stare, then, is a way of imposing his will vicariously. Following Mitzi he fantasizes that they are lovers, yet attempts to impose this somehow without her knowledge: 'Augustine was trying to *will* Mitzi into the right path . . . and they must have looked unequivocally a pair of lovers . . . as if neither of them had eyes at all for the outside world'. (FA,255) An extreme example of this

attitude occurs in New England, when he imagines escaping the police
by driving across a dam:

> there came a flash of vision so vivid it hurt in which his mind's eye saw –
> like watching an epic scene in a film – that knife-edge top of the dam with
> his yellow Bearcat driving across it. (WS,97)

The dam is actually impossible to drive on – 'a detail his "vision" had
somehow left out' (WS,98) – and Sadie only saves their lives by
yanking the steering-wheel to put the car into the lake. Sight is again
used here to represent the attempt to impose one person's vision on the
external world (and on others) by sheer force of will.

Augustine's intoxication with the idea of 'Significant Form' is
relevant here. He has a natural love of paintings – things designed to be
looked at – and after his brief, drunken tutelage from Jacinto, becomes
excited by an aesthetic which seems built on sight: 'the concept of
"Significant Form" as an immanence in the perceived which the
painter's eye can uncover'. (FA,339) Clive Bell's concept seems to
formalize and make respectable his own wilful staring at the world.
'How on earth do you teach a blind person about Significant Form!'
(FA,340), he wonders, revealing a lack of real understanding of the
term.

Augustine's contradictory position is neatly expressed when his
pleasure in shooting is explained in visual terms. When following
Mitzi, he makes no sound, being 'an adept wildfowler' (FA,251), and
there are many other allusions to his delight in hunting, which seems to
be an extension of his obsession with looking:

> it was galling for someone so eye-conscious to have no aptitude for
> painting, however hard he tried. But Augustine's natural skill at shooting
> was some consolation, for here it was the exact visually-imagined pattern
> in space and time of the bird's flight intersecting with the brief trajectory
> of his pellets that was the attraction; that, and the utter loveliness of the
> plumage of the fallen bird.
> Only one thing equalled this last – the utter loveliness of Mitzi's hair.
> (FA,241)

In this one image of intersecting lines can be seen Augustine's
combination of Mitzi's and Hitler's ways of seeing: of a genuinely
respectful love of things as they are, and of an equally strong pleasure
in imposing his will on them. The immediate association of Mitzi with

the lovely, shot bird is then deliberately chilling, a reminder to the reader of the dilemma in which this attitude places Augustine in relation to others.

The final set of allusions which helps illuminate Augustine's predicament concerns sexuality. These references number over fifty, endowing the novel with a definite sexual dimension. From the Penry-Herbert uncles' salacious drawings to Walther von Kessen's clumsy approaches to his wife (beneath the picture of a charging elephant); from the pederastic orgies of Fritz Krupp (financed by arms production) to the strange Dionysian assault on Brian by Norah and her friends: all these and many other allusions create a sexual ambience within which the principal characters move.

Mitzi has a sexual existence mainly as an object of desire for Augustine and Wolff. Despite imagining themselves in love, neither in fact knows Mitzi or has any inkling of her inner life. Initially, at least, it is her physical presence to which they react – projecting their sentimental fantasies onto her appearance. When Augustine learns that she has been won by his 'rival', Carmel, he instinctively thinks of this in sexual terms: 'A second Persephone's Rape!' (WS,126) Even Mitzi's own faith has its sexual aspect. As a nun she goes through the ceremony of marriage to Christ, and, like Teresa of Avila, expresses her relationship with God in very sensual terms. She imagines herself naked before him, for example, and 'when she pulled the blanket over her head it was Him she pulled up and hid under – and shut Him in with her'. (WS,387) These expressions need not be regarded as sublimation, but simply as a natural, human way of articulating a close and intimate relationship such as she feels with God.

In contrast with Mitzi's assumption of sensuality as something gentle and expressive of sympathy, Hitler's understanding of sex is purely as a tool for his own pleasure, both physically and by dominating others. When he speaks before a meeting, a witness tells: 'He was profoundly excited. Indeed whenever he faces a crowd it seems to arouse him to a veritable orgasm – he doesn't woo a crowd, he rapes it.' (FA,192) Images of rape are also used several times to describe international relations in the preceding years, including nationalism and warfare within this metaphor of ultimate coercion.

In his Uffing delirium Hitler recalls visiting the brothel quarter of Vienna when young. He did not visit the prostitutes, but went 'just to look at them'. (FA,266) Just as Augustine likes to stare at girls, Hitler 'would stare' at the most attractive, walk on, then return to 'stare her

out again, pop-eyed'. (FA,266) He imagines 'scourging the little flash jew-girls till they screamed' (FA,265), and in this hatred is resentment of what females make him fear – that something can exist which is not him:

> After all, how could that monistic 'I' of Hitler's ever without forfeit succumb to the entire act of sex, the whole essence of which is recognition of one 'Other'? (FA,266)

To the dictator, for whom 'the Universe contained no other persons than him, only things' (FA,266), this is a terrifying thought and suggests why, in this area above all, he needed to assert his will. This is done by the novel solution of incest. Hitler takes his niece Geli as mistress for, being closely related, this was almost auto-eroticism anyway:

> This sexy young niece was blood of his blood, so could perhaps in his solipsist mind be envisaged as merely a female organ budding on 'him' as forming with him a single hermaphrodite 'Hitler', a two-sexed entity able to couple within itself like a garden snail. (WS,320)

The falsity of this theory is exposed when Geli asserts her 'other-ness', her independent existence, by the only means available: she shoots herself.

Augustine's attitude to sexuality is deeply confused, and a prime index of his attitude to others. His feelings towards Mitzi, towards six-year-old Polly and twelve-year-old Ree all contain genuine affection. Towards women in general and young girls in particular, however, there is a more sinister attitude, one which is reminiscent of Hitler's and betrays a regard for females as objects. As noted earlier, sexuality is closely associated with 'looking' for Augustine, emblematized by his youthful watching of three young girls:

> He came to know intimately almost every hair of those three heads; for the telescope brought them seemingly within touching distance. I suppose he fell half in love with them, impartially with all three: a little private, abstract seraglio – so very close to him always, and yet ethereal visionary creatures without even voices. (FA,240–1)

The choice of 'seraglio' here suggests how Augustine regards females, even as a boy – as though the passivity of looking absolves him of responsibility for his imaginings.

A further degree of abuse in this 'telescopophilia' is that they 'weren't quite gentry' (FA,240), as though this made his behaviour more excusable. This class-component of regarding females sexually is emphasized by a recurring image in the novel: a working-class woman on her knees, exposing her legs. This first occurs when Augustine shamelessly contemplates the legs of a fifteen-year-old maid, surprised to find they 'could look quite so soft (and indeed almost babyish) on any young woman quite so stalwart as Lies'. (FA,239) This scene is echoed ten years later when Franz von Kessen's children peer at her exposed legs, and again when Jeremy tries to tell Joan what her life would be like, poor: '"You, still not out of your teens and down on your two knees scrubbing the doorstep, showing a great deal of leg."' (WS,286) He plainly means to shock her by the indignity of this position. The contrast of Lies and Joan emphasizes the part played by class in attitudes to females within the novel. Augustine would never dream of staring unashamedly at the legs of a female of his own class, but the fact that Lies, like the three little girls, is not gentry seems to make this acceptable to him – as though they were not quite human.

Augustine also has an ambiguous attitude to the three girl-children in the novel: dead Rachel whom he carries back from the sea-marsh, his niece Polly, also six, and Ree, the twelve-year-old whom he befriends in Connecticut. The drowned corpse seems to fascinate him. Arriving back at Newton Llantony he does not lay it down immediately, but is 'still humping the little body' (FA,18) when he telephones the police, and only 'at last' (FA,16) is it laid down in a remote room:

> It had taken into its soft contours the exact mould of the shoulder over which it had been doubled and it had set like that – into a matrix of him. If (which God forbid) he had put it on again it would have fitted. (FA,18)

The narrative is presented via Augustine's viewpoint, and it is surely his strange thought that the corpse would fit back onto his shoulder – a human body as utterly subservient to his will as any inanimate object.

Augustine's feelings for Polly are of perfectly normal avuncular affection as far as he is concerned. However, the fact that he can only give affection freely to children becomes complicated when such a relationship acquires a sexual dimension. Ree is on the verge of puberty and Augustine cannot help being attracted to her. A suggestive image of this attraction occurs when he climbs through a window after her,

and notices 'her jeans were too tight and too tender: they split, and a pale efflorescence of all that incongruous crepe-de-chine escaped through the rent on her rump.' (WS,42)

While not acknowledging this attraction consciously, it forces itself on him in a curious dream, in which Ree, Rachel and Polly are combined in one horrifying image:

> Sleeping, he dreamed of that fateful day back in Wales, the day he came home from the Marsh to his empty echoing house with a drowned child doubled over his shoulder, and found to his horror on lifting it down it had stiffened bent double. But there things changed . . . he'd got to undress it, like putting a live child to bed. Yet as soon as he started to do so, he found that instead of bare skin underneath this child was downy all over with delicate fur; and a fur attractively soft to the touch, like a mole's . . . When he pulled her last vest over her head – leaving all the downy body uncovered except for the socks – he saw that the wide-open eyes in the small dead face were alive and were eagerly watching him take off her clothes; nor were these even the pair of eyes which belonged, they were Ree's. (WS,52–3)

In this dream Augustine – 'who tended to treat all lids as something to sit on' (WS,54) – is faced with his commingled affections, sexual desires, and strange interest in exerting his will over a passive female body, all in a single vision which makes him wake with a silent scream.

As well as this attraction to pre-pubescent girls (a motif present in Hughes's writings from the 1920s, long before *Lolita* was published), the necrophilic aspect of Augustine's dream is also reflected elsewhere. Joan decides to marry Augustine because he resembles his cousin Henry, to whom she was secretly engaged and who was killed at the Battle of Ypres. Brian, who helps in the Coventry slaughterhouse, is described by Nellie as 'that little ghoul caressing the beasts he meant to help kill'. (WS,187) Gilbert Wadamy, too, enjoys exerting his will over the corpse-like body of his paralysed wife: 'And at night it gave him a strangely elated feeling I can't describe to be handling Mary's body while Mary slept without it possibly waking her.' (WS,204) As a result of this, Mary – to her surprise – becomes pregnant:

> It must have happened while Mary slept, and the doctor guessed that a 'nurse' who had got in the way of interpreting night-duty quite so widely could hardly be proud of his near-necrophilous practices. (WS,265)

It is not sufficient to recognize these paedophilic and necrophilic elements and then simply conclude that Augustine is sexually perverted: that would be pointless within the terms of the novel, and of little help in explicating it. Rather, it must be understood that Augustine's horrific vision vividly indicates the conflicts within him: a confusion of the line between affection and sexual love; a difficulty in reconciling involvement with other persons and respect for their integrity; a desire to be solitary and a desire to extend one's will over others; indecision regarding action and inaction; and a reluctance to come to terms with all of these impulses.

Augustine is made to confront these conflicting desires when his dream is partially brought to life – when the American child, Ree, offers him her body:

> He looked: she lay on her back stark naked, lit by a flicker of lightning brighter than any lamp: and his loins were seared by a pang that seemed the lightning itself. 'I don't *want* you to put out the lamp', she repeated, then cupped her half-apple breasts on her hands for her elbows to take her weight and playfully ran her two little feet up the wall like mice till her hips were lifted clear. (WS,108)

He actually moves towards the bed, but – seeing Ree's 'matchstick arms of a child' (WS,108) – stops and brutally tells her to cover herself up: 'There wasn't a sound from the bed; but nothing would make him look'. (WS,108) It is deeply ironic that at this moment Augustine, who so loves to look, turns his eyes from Ree and never sees her again. As with the von Kessen children, he has carelessly encouraged someone to love him, intending to leave with no more regard for her feelings than for someone seen through a telescope. Correlating with his memory of Mitzi's little face peeping from her furs, he now becomes haunted by Ree's frightened face which 'went smaller and smaller, her eyes went larger, her mouth fell open and started to shake . . . Again and again he saw those feet running up the wall . . . and after the pain in that small, terrible face'. (WS,108)

It is only here, inescapably confronted by the pain he has caused in another, that Augustine realizes the responsibility which lies upon him in action and inaction, in imagination as well as in deed: 'a weight he couldn't crawl out from under. For he was the one who had clumsily done it to someone he loved and who loved him'. (WS,113) If Augustine learns something of himself here, it is not a solution to his

problems, but does help to make their nature clearer. In a broader sense this is what the sexual dimension of the novel, and Augustine's relationship with Ree in particular, does for the reader. Being potentially the most intimate contact between persons, it serves as an emblem for the social nexus in the novel. Augustine's dilemmas here – to love without imposing or being imposed upon, the necessity of making decisions where both choices cause pain, the equal power of inaction and action – all work to elucidate the meaning of *The Human Predicament* from the most personal to the most universal terms.

In Hughes's last novel, then, no ready answers are supplied, any more than in his previous writings. To provide a 'solution' to the question posed by the title would have been trite and utterly out of keeping with the development of his art. Instead, in an ambitious extension of how his other novels were written, Hughes uses 'systems of valid questions' (FA,72) to examine the Hobbesian dilemma of how men, by their nature inclined 'to live separate, each like some solitary predatory beast' (FA,119), can exist in society with one another. To this end he exploits a battery of techniques refined from *A High Wind in Jamaica* and *In Hazard*: the unique handling of narrative viewpoint; rhetorical manipulation of the reader's response; use of metaphorical and allusive patterns complementary to the plot, and of paradoxical and apparently incomplete elements which make it seem to strain with contradiction.

In this idiosyncratic, challenging and ultimately successful manner, *The Human Predicament* works.

Notes

Notes to Introduction

[1] Walter Allen, *Tradition and Dream: The English and American Novel from the Twenties to Our Time* (London, 1964), pp.58, 62.

[2] For more detailed accounts of Hughes's life, see Peter Thomas's *Richard Hughes* monograph in the Writers of Wales series, Richard Poole's *Richard Hughes: Novelist*, and Richard Graves's forthcoming authorized biography.

[3] 'Fear and *In Hazard*', in Richard Poole (ed.), *Fiction as Truth: Selected Literary Writings of Richard Hughes* (Bridgend, 1983), pp.42–4 (p.43).

Notes to Chapter 1

[1] Richard Hughes, 'A preface to his poetry', in Richard Poole (ed.), *Fiction as Truth: Selected Literary Writings of Richard Hughes* (Bridgend, 1983), pp.17–24 (p.17).

[2] Richard Hughes, 'On *The Human Predicament*', in Richard Poole (ed.), *Fiction as Truth: Selected Literary Writings of Richard Hughes* (Bridgend, 1983), pp.50–2 (p.51).

[3] Interview with Richard Hughes, in Peter Firchow (ed.), *The Writer's Place: Interviews on the Literary Situation in Contemporary Britain* (Minneapolis, 1974), pp.183–208 (p.207).

[4] 'A preface to his poetry', p.18.

[5] Richard Hughes, *A Comedy of Good and Evil*, in *The Sisters' Tragedy and Three Other Plays* (London, 1924), pp.51–140 (p.51).

[6] *The Sisters' Tragedy and Three Other Plays*, p.vi.

[7] Richard Hughes, '*Mrs Dalloway*', in Richard Poole (ed.), *Fiction as Truth: Selected Literary Writings of Richard Hughes* (Bridgend, 1983), pp.131–2 (p.132).

[8] Arthur Waley, *The Way and its Power: A Study of the Tao Te Ching and its Place in Chinese Thought* (London, 1934), p.51.

9 Richard Hughes, 'The writer's duty', in Richard Poole (ed.), *Fiction as Truth: Selected Literary Writings of Richard Hughes* (Bridgend, 1983), pp.59–63 (p.63).

10 Vladimir Nabokov, *The Real Life of Sebastian Knight* (London, 1945), pp.121–2.

11 'The writer's duty', pp.60–1.

12 'A preface to his poetry', p.17.

13 Richard Hughes, 'The poet and the scientist', in Richard Poole (ed.), *Fiction as Truth: Selected Literary Writings of Richard Hughes* (Bridgend, 1983), pp.92–102 (p.95).

14 *The Writer's Place*, p.188.

15 Yvonne Thomas, 'A line and a half a day: an interview with Richard Hughes', *Guardian*, 14 April 1973, p.24.

16 Richard Hughes, 'Fiction as truth', in Richard Poole (ed.), *Fiction as Truth: Selected Literary Writings of Richard Hughes* (Bridgend, 1983), pp.70–4 (p.71).

17 'Fiction as truth', p.73.

18 'The writer's duty', p.63.

19 'The writer's duty', p.62.

20 Richard Hughes, 'Under the nose and under the skin', in Richard Poole (ed.), *Fiction as Truth: Selected Literary Writings of Richard Hughes* (Bridgend, 1983), pp.55–8 (p.56).

21 'A preface to his poetry', p.18.

22 Richard Hughes, *A High Wind in Jamaica* (London, 1929), p.160.

23 Penelope Hughes, *Richard Hughes: Author, Father* (Gloucester, 1984), p.108.

24 *Richard Hughes: Author, Father*, p.52.

25 Harold Rosenburg, Introduction to Richard Avedon, *Portraits* (London, 1976), pp.1–21 (p.16).

26 Angela Carter, *Fireworks* (London, 1974), p.122.

27 Richard Hughes, 'The novel behind your eyes', in Richard Poole (ed.), *Fiction as Truth: Selected Literary Writings of Richard Hughes* (Bridgend, 1983), pp.64–9 (p.69).

28 'The novel behind your eyes', p.65.

29 *The Complete Works of Aristotle*, edited by Jonathan Barnes, revised Oxford translation, 2 vols. (Princeton, 1984), II, p.2155.

30 'A preface to his poetry', p.19.

31 Walter Benjamin, *Illuminations* (London, 1970), p.69.

32 'The writer's duty', p.63.

33 'A preface to his poetry', pp.21–2.

34 'The novel behind your eyes', p.64.

35 'The novel behind your eyes', p.66.

36 'The novel behind your eyes', p.65.

37 'The novel behind your eyes', p.68.

38 'The novel behind your eyes', p.66.

39 '*Mrs Dalloway*', p.131.

40 '*Mrs Dalloway*', p.132.

41 Richard Hughes, 'Fear and *In Hazard*', in Richard Poole (ed.), *Fiction as*

Truth: Selected Literary Writings of Richard Hughes (Bridgend, 1983), pp.42–4. (p.44).

42 Richard Hughes, 'The voice and the pen', in Richard Poole (ed.), *Fiction as Truth: Selected Literary Writings of Richard Hughes* (Bridgend, 1983), pp.103–6 (p.105).

43 *Illuminations*, p.100.

44 *The Writer's Place*, p.195.

45 Umberto Eco, *The Role of the Reader* (London, 1981).

46 Umberto Eco, *Postscript to The Name of the Rose* (San Diego, 1984), p.47.

47 *Postscript to The Name of the Rose*, p.50.

48 R. G. Collingwood, *The Principles of Art* (Oxford, 1938), p.315.

49 Amabel Williams–Ellis, review of Richard Hughes, *Gypsy-Night and Other Poems*, *Spectator*, 3 June 1922, pp.695–6 (p.695).

Notes to Chapter 2

1 Richard Hughes, 'Introduction to *A High Wind in Jamaica*', in Richard Poole (ed.), *Fiction as Truth: Selected Literary Writings of Richard Hughes* (Bridgend, 1983), pp.38–41 (p.40).

2 Interview with Richard Hughes, in Peter Firchow (ed.), *The Writer's Place: Interviews on the Literary Situation in Contemporary Britain* (Minneapolis, 1974), pp.183–208 (p.206).

3 *The Writer's Place*, p.191.

4 The novel had appeared in April 1929 in the United States, under the title, *The Innocent Voyage*. Hughes's original title had been, *The Girl in the Egg*. A *Chatto & Windus Miscellany* (London, 1928) advertises it as 'in preparation' with this name. After Henry Leach published an excerpt as 'A High Wind in Jamaica', though, Hughes liked this title so much, he appropriated it for the work as a whole. Harper's insisted upon their own more explicit title.

5 National Library of Wales, MS 11047D.

6 Lyn Irvine, review of *A High Wind in Jamaica*, *Nation*, 28 September 1929, p.830.

7 J. E. S. Arrowsmith, review of *A High Wind in Jamaica*, *London Mercury*, 21, no.2 (November 1929), pp.78–9 (p.78).

8 J. E. S. Arrowsmith, review of *A High Wind in Jamaica*, p.78.

9 Review of *A High Wind in Jamaica*, *John O'London's Weekly*, p.904.

10 Cyril Connolly, review of *A High Wind in Jamaica*, *New Statesman*, 5 October 1929, p.780.

11 V. S. Pritchett, review of *A High Wind in Jamaica*, *Spectator*, 28 September 1929, pp.417–18 (p.417).

12 L. P. Hartley, review of *A High Wind in Jamaica*, *Saturday Review*, 28 September 1929, pp.355–6 (p.356).

13 L. P. Hartley, review of *A High Wind in Jamaica*, p.355.

14 Cyril Connolly, review of *A High Wind in Jamaica*, p.780.

15 'Introduction to *A High Wind in Jamaica*', p.40.

16 'Introduction to *A High Wind in Jamaica*', p.40.

17 Richard Hughes, 'Fear and *In Hazard*', in Poole (ed.), *Fiction as Truth,* pp.42–4 (p.44).

18 Richard Hughes, 'A preface to his poetry', in Poole (ed.), *Fiction as Truth,* pp.17–24 (p.21–2).

19 'Shop talk by Richard Hughes', *Christian Science Monito*r, 2 March 1967, p.5.

20 'A conversation with Richard Hughes', *Listener,* 23 October 1975, pp.546–7 (p.546).

21 Hughes used the first edition when researching his novel, and it was coincidentally republished shortly after *A High Wind in Jamaica* appeared.

22 Louise Morgan, 'Richard Hughes: artist and adventurer', *Everyman,* 9 April 1931, pp.327–9 (p.328).

23 Clinton Black, *A History of Jamaica* (London, 1983), p.124.

24 No estates on the island are recorded with the names used by Hughes. Information supplied by the Institute of Jamaica, Kingston (personal communication, 5 February 1988).

25 Patrick Swinden, *Unofficial Selves: Character in the Novel from Dickens to the Present* (London, 1973), p.184.

26 *The Philosophical Works of René Descartes*, rendered into English by Elizabeth S. Haldane and G. R. T. Ross, 2 vols. (Cambridge, 1911–12), I, p.292.

27 Amabel Williams–Ellis, *All Stracheys are Cousins* (London, 1983), p.88.

Notes to Chapter 3

1 Graham Greene, review of *In Hazard*, *Spectator*, 8 July 1938, p.68.

2 Chatto & Windus Archive (CW), letter from Richard Hughes to Harold Raymond, 23 May 1938.

3 CW, letter from Richard Hughes to Charles Prentice, 14 January 1927.

4 Richard Hughes, 'Notes on the way', *Time and Tide*, 6 July 1940, p.708.

5 Richard Hughes, 'Introduction to *In Hazard*', in Richard Poole (ed.), *Fiction as Truth: Selected Literary Writings of Richard Hughes* (Bridgend, 1983), pp.45–9 (p.46).

6 'Introduction to *In Hazard*', p.45.

7 'Introduction to *In Hazard*', p.45.

8 CW, letter from Richard Hughes to Harold Raymond, 19 May 1938.

9 CW, letter from Richard Hughes to Harold Raymond, 4 May 1938.

10 CW, letter from Richard Hughes to Harold Raymond, 27 October 1938.

11 'They think *In Hazard* great', *News Chronicle*, 22 August 1938, p.8.

12 Glyn Jones, review of *In Hazard*, *Life and Letters Today*, 19, no.3 (1938), pp.127–8 (p.128).

13 Marie Scott-James, review of *In Hazard*, *London Mercury*, August 1938, p.272.

14 Edwin Muir, review of *In Hazard*, *The Listener*, 21 July 1938, p.153.

15 James Grant, review of *In Hazard*, *Queen*, 21 July 1938, p.153.

16 Edith Shackleton, review of *In Hazard*, *Time and Tide*, 9 July 1938, p.984.

17 Richard Hughes, 'Fear and *In Hazard*', in Poole (ed.), *Fiction as Truth*, pp.42–4 (p.43).

[18] 'Introduction to *In Hazard*', p.46.
[19] 'Introduction to *In Hazard*', p.46.
[20] 'Introduction to *In Hazard*', p.45.
[21] 'Introduction to *In Hazard*', p.47.
[22] Richard Hughes, 'Notes on the way', *Time and Tide*, 3 December 1938, pp.1686–8.
[23] 'Introduction to *In Hazard*', p.48.
[24] 'Fear and *In Hazard*', p.43.
[25] Patrick Brantlinger, *Rule of Darkness: Literature and Imperialism, 1830–1914* (Ithaca, 1988), pp.50–1.
[26] In a curious coincidence, Marryat's own log as a midshipman records his ship being lifted by a great wave and carried safely over a reef, just as happens to the *Archimedes*. Quoted in Brantlinger, p.49.
[27] William Paley, *Natural Theology: or Evidences for the Existence and Attributes of the Deity collected from the Appearances of Nature* (London, 1802), pp.1–2.
[28] John Barrow, *The World within the World* (Oxford, 1988), p.25.
[29] Naomi Mitchison, introduction to Richard Hughes, 'Physics, astronomy, and mathematics, or beyond common sense', in *An Outline for Boys and Girls and their Parents* (London, 1932), pp.303–57 (p.306).
[30] 'Physics, astronomy, and mathematics, or beyond common sense', pp.356–7.

Notes to Chapter 4

[1] Richard Hughes, 'On *The Human Predicament*', in Richard Poole (ed.), *Fiction as Truth: Selected Literary Writings of Richard Hughes* (Bridgend, 1983), pp.50–2 (pp.50–1).
[2] 'On *The Human Predicament*', p.52.
[3] Chatto & Windus Archive (CW), letter from David Higham to Ian Parsons, 16 February 1955.
[4] CW, letter from Richard Hughes to Ian Parsons, 16 January 1956.
[5] CW, letter from Ian Parsons to Cass Canfield, 31 July 1958.
[6] CW, letter from Richard Hughes to Cass Canfield, 5 January 1955.
[7] CW, letter from Richard Hughes to Ian Parsons, 11 September 1961.
[8] CW, letter from Richard Hughes to Ian Parsons, 26 January 1963.
[9] CW, letter from David Higham to Ian Parsons, 7 February 1972.
[10] The unpublished chapters are not discussed in this study. Without the slightest doubt, they would have been drastically revised by Hughes before publication. They cannot be regarded as homogeneous with the published text and should not, therefore, be discussed in the same terms. Their contents are outlined in an Appendix.
[11] Stephen Spender, review of *The Fox in the Attic*, *Encounter*, 17, no.6 (December 1961), pp.78–80 (p.80).
[12] Julian Symons, review of *The Fox in the Attic*, *Twentieth Century*, 170, no.1012 (Winter 1962), pp.147–54 (p.150).
[13] John Bowen, review of *The Fox in the Attic*, *Time and Tide*, 5 October 1961, p.1660.

[14] Julian Symons, review of *The Fox in the Attic*, *Spectator*, 6 October 1961, p.472.
[15] Paul Theroux, review of *The Wooden Shepherdess*, *The Times*, 5 April 1973, p.16.
[16] Review of *The Wooden Shepherdess*, *The Times Literary Supplement*, 6 April 1973, p.369.
[17] R. G. G. Price, review of *The Fox in the Attic*, *Punch*, 11 October 1961, pp.551–2.
[18] John Bowen, review of *The Fox in the Attic*, p.1660.
[19] CW, letter from Paul Scott to Richard Hughes, 30 September 1958.
[20] CW, letter from Ian Parsons to Richard Hughes, 27 September 1960.
[21] CW, letter from Cass Canfield to Richard Hughes, 29 November 1960.
[22] CW, letter from Ian Parsons to Cass Canfield, 10 July 1961.
[23] CW, letter from Ian Parsons to Cass Canfield, 10 July 1961.
[24] CW, letter from Richard Hughes to Ian Parsons, 11 July 1961.
[25] CW, letter from Richard Hughes to Norah Smallwood, 24 January 1961.
[26] CW, letter from Richard Hughes to Ian Parsons, 23 February 1972.
[27] *The Oxford Companion to the Literature of Wales*, compiled and edited by Meic Stephens (Oxford, 1986), p.270.
[28] 'On *The Human Predicament*', p.51.
[29] Peter Thomas, review of *The Wooden Shepherdess*, *Planet*, 18/19 (1973), pp.152–5 (p.155).
[30] Georg Lukács, *The Historical Novel* (London, 1962), pp.150–1.
[31] 'A conversation with Richard Hughes', *Listener*, 23 October 1975, pp.546–7.
[32] Constantine Fitzgibbon, *The Life of Dylan Thomas* (London, 1965), p.268.
[33] Penelope Hughes, *Richard Hughes: Author, Father* (Gloucester, 1984), p.161.
[34] An example is G. J. Warnock's essay, 'The Human Predicament', in *The Object of Morality* (London, 1971), pp.12–26.
[35] Thomas Hobbes, *Leviathan* (London, 1914), pp.64–5.
[36] Thomas Hobbes, *Leviathan*, p.89.
[37] Review of *The Wooden Shepherdess*, *The Times Literary Supplement*, p.369.
[38] *Richard Hughes: Author, Father*, p.162.
[39] Saint Teresa of Avila, quoted in Vita Sackville-West, *The Eagle and the Dove* (London, 1943), pp.54–5.

Appendix

THE HUMAN PREDICAMENT:
the unpublished fragment

Between 1973 and his death in 1976, Richard Hughes had completed the first twelve chapters of volume three in draft form. These amount to fifty typescript pages, totalling 16,000 words. There can be no doubt that these chapters would have been extensively rewritten before eventual publication. The typescript bears no title, although 'The Man in the Moon' strongly suggests itself. The following summary is based on examination of the copy deposited with David Higham (Hughes's literary agent), and is reproduced with the kind permission of the Richard Hughes Estate.

Norah is discovered having just been sacked after six years as a seamstress. She is determined not to stay out of work for long; considers trying to get a post teaching sewing at Coventry Art School, then remembers that Sylvanus's aunt works for a rich cripple in the south who wants to learn weaving. She goes straight to Nellie's spotless house in Slaughterhouse Yard (where pale, eleven-year-old Syl is busy with his homework) and within days the matter has been arranged. She is to travel to Dorset, to Mellton, before the end of the week.

The evening before leaving, Norah has a farewell fish-and-chip dinner with friends. She has no trepidations about going, but wonders whether she will be able to stomach the company of the rich, whose extravagant

lives she has learnt of at the cinema. The King's Head Hotel on Broadgate is described. It is here that Norah is to be collected. She does not even consider enquiring at Reception, but goes round the side to the garage entrance. A chauffeur mistakes her enquiry about 'Wadamy' for 'sodomy' and makes an obscene suggestion, but she silences him with her eye. The man collecting her is an unimpressive figure dressed in flannels and tweeds, leaning on an old-fashioned two-seater. The mystery man tucks her into the passenger seat, and they leavé the garage with a roar like a cathedral organ.

On the journey down, Augustine explains who he is, and that it was his idea for Mary to take up weaving. From his account of the family to Norah, the reader learns that Polly is sixteen years old and has twice run away from school to catch a glimpse of Hitler, and that Mary's eight-year-old son, Gillie, is backward. Norah decides Augustine has a BBC accent, and is horrified to learn he has visited Slaughterhouse Yard. Augustine finds Coventry a curious city: the intact medieval centre ringed by smoky factories. By the time they drive up the sunken lane to Mellton, a sympathy is beginning to settle in between them.

On her first day at Mellton, Nellie discovers that Gilbert Wadamy is a minister in the National Government and hardly leaves London. She has her first meeting with Mary, and is frightened by the impression of a live head atop a corpse, like a head popping up at you from a grave: someone starting to resurrect but who had got stuck. Mary senses Norah's reaction and tries to be kind with her.

The recently widowed Joan arrives for a brief visit. Her presence brings Gilbert down to Dorset. Augustine's friend Jeremy also arrives for dinner. The latter still works at the Admiralty, described as a vast, complex living thing, like a Portuguese man-of-war. Augustine would have left, to avoid Joan, but remains as he feels responsible for Norah, already a victim of the other servants' snobbery at her Midland accent and special position in the household.

Over dinner Augustine asks Jeremy what life is like at the Admiralty. Discussion of the Navy and its royal prerogative brings the conversation round to the Prince of Wales. Jeremy criticizes the Prince's behaviour and an argument develops with Gilbert who says he will not have the Crown attacked in the house of a minister.

After dinner, Jeremy and Gilbert continue to argue about the need for rearmament. The former reels off facts and figures of how the Germans are overtaking Britain militarily, gives a Nazi salute with his polio-crippled arm, and asks the others to imagine Hitler driving in state down a bombed Whitehall. Gilbert is insistent that war can be avoided, and says a statesman like Chamberlain is worth more than battleships. Talk of war takes Augustine's mind back to Bavaria; a picture comes into his mind of the frozen Danube: the inconceivable force locked up in the mountainous ice-floes. Joan only thinks how unchanged Augustine seems: a sultan and his sister an Egyptian mummy.

Two days later, Augustine leaves for south Wales to visit friends, then continues to Newton Llantony. The house is looked after by Jimmy and Lily (servants sacked from Mellton ten years before), and is largely shut up: as though in an enchanted *Mabinogion* sleep. Thirty-five-year-old Augustine takes his gun out into the rainy afternoon – to think rather than shoot. His mind keeps returning to Norah: her gamine appearance and sensitive eyes.

Later, having been back in Dorset a week, Augustine decides he is in love with Norah. He thinks how hopelessly class divides them; that someone like her would hardly regard him as a man. Norah watches him climbing a tree with Susan and Gillie. She joins them, then leads all three hand-in-hand back to the house. Augustine is deeply moved by her touch, and vows to keep his love secret, for this would put her in an impossible position. She, in turn, thinks he needs looking after, and – feeling happy – recalls childhood picnics in the country beyond Coventry.

Mary receives a letter from Polly saying she has been sent down from her school in Geneva, and recounting her trip with Janey to see Hitler. The girls had cheekily introduced themselves, and were invited to Berchtesgaden for tea (Hitler has learnt that Polly's father is in the government). She is ecstatic at having met the Führer and gazed into his wonderful eyes.

A meeting that same day between Hitler and an informant, Pagannazi, is described. Pagannazi reports on the position in the Saar, and Hitler predicts no opposition from the Allies to annexation. In his opinion, Britain is a degenerate, Jewish democracy susceptible to bombers,

which will not last out the century as an independent nation. Pagannazi returns home under a sickle moon, wondering to himself if Hitler's mind is no more than a cinema screen, showing a shadowy caricature of the German race. The Führer's will is also compared to the moon's effect on the tides.

Augustine travels to London to collect Polly. At sixteen she is unaffectionate, dresses like a grown woman, yet retains a child's moon-struck face. Mary considers she just has a crush on the German leader, and Augustine wonders whether it was right to shield her from religion as a child, leaving her vulnerable to such enthusiasms later in life. In her room, Polly looks out at the moon, recalling Augustine showing it to her through his telescope. She is deeply moved by the thought that it is totally unconnected to her: a dead world which had witnessed the ice age and would shine on when she was dead herself. There seems to be some kind of answer to the questions which trouble her in this vision. She retrieves her teddy-bear from its secret place, and goes to sleep with it clutched to her breast.

Manuscript Sources

Reading. University of Reading Library
The Chatto & Windus Archive contains a substantial amount of material relating to Richard Hughes. The correspondence file includes almost 4,000 letters between novelist and publisher, written between 1923 and 1976. Other files contain material relating to publicity and artwork for his publications.

The Jonathan Cape Archive also contains a small amount of correspondence with Hughes.

Bloomington. Lilly Library, Indiana University
The Lilly Library holds the principal collection of Hughes writings in manuscript, acquired from the novelist's family during the 1970s. Forty-three cartons contain manuscripts of poems, plays, stories, broadcasts, essays and novels, as well as professional and family correspondence.

Reading. BBC Written Archives Centre
The Centre holds five files of correspondence relating to Hughes's broadcasts between 1924 and 1962; a file on plays and stories broadcast between 1934 and 1962; a file of *Children's Hour* work between 1931 and 1933, and a file on television appearances between 1938 and 1961. Scripts of talks by Hughes from 1924 are also held on microfilm.

Aberystwyth. National Library of Wales
The BBC Wales Archives are held on deposit in the Department of Manuscripts. These contain scripts of six broadcasts made by Hughes from Cardiff between 1937 and 1953.

Twenty letters written by Hughes are held elsewhere in the

Department of Manuscripts. These contain correspondence with John Wilson, H. A. Piehler, Elwyn Davies, Dyfnallt Owen, Cledwyn Hughes, Ifan Kyrle Fletcher, A. O. Roberts and Henry Goddard Leach.

Harvard. Houghton Library

The Houghton holds eight letters from Hughes, addressed to Henry Goddard Leach, Ronald Tree, Alexander Woollcott and Sir William Rothenstein.

Miscellaneous manuscripts and letters written by Hughes may also be found at Eton School Library, Birmingham Reference Library, the Brotherton Library, University of Bristol Library, the House of Lords Record Office, King's College (Cambridge) Library, University of Sussex Library, the Bodleian Library and the Royal Society of Literature.

Bibliography

The Bibliography is divided into two sections:

A. Publications by Richard Hughes
A.1 The works.
All known editions are listed, based on examination of copies from the novelist's library, now owned by the National Library of Wales. British editions are listed first, followed by US and other editions.
A.2 Other writings.
Essays, articles, introductions, reviews, and other writings are listed by year of publication. I am indebted to Richard Poole's bibliography in *Richard Hughes: Novelist* for references to many of the reviews. In a very few cases, I have been unable to obtain a page number for a reference; the source in these cases is a cutting with the page unnumbered. Individual appearances of poems and stories are not included.

B. Publications on Richard Hughes
B.1 Books.
B.2 Articles, book chapters, and interviews.
B.3 Reviews.

A. Publications of Richard Hughes

A.1 The works

Gypsy-Night and Other Poems
Waltham St Lawrence: Golden Cockerel Press, 1922.

US edition:
Chicago: Will Ransom, 1922.

Lines Written upon Observing an Elephant Devoured by a Roc.
Waltham St Lawrence: Golden Cockerel Press, 1922.

The Sisters' Tragedy
Oxford: Blackwell, 1922.
London: Chatto & Windus, n.d.
Carmarthen: Druid Press, 1948.

US edition:
Boston: W. H. Baker, 1956.

Meditative Ode on a Vision
Plaistow: Curwen Press, 1923.

Danger: A Play
London: Chatto & Windus, 1924.

German edition:
Frankfurt am Main: Diesterweg, 1975.

Norwegian edition:
Oslo: s.n., 1973.

A Comedy of Good and Evil
London: Chatto & Windus, n.d.

The Man Born to be Hanged
London: Chatto & Windus, n.d.

The Sisters' Tragedy and Three Other Plays
London: Heinemann, 1924.
London: Chatto & Windus, 1928.
London: Chatto & Windus, 1966.

US editions: entitled *A Rabbit and a Leg*
New York: Knopf, 1924.
New York: Harper and Row, 1966.

Ecstatic Ode on a Vision
Plaistow: Curwen Press, 1925.

Confessio Juvenis: Collected Poems
London: Chatto & Windus, 1926.
London: Chatto & Windus, 1934.

A Moment of Time
London: Chatto & Windus, 1926.
London: Chatto & Windus, 1930.
London: Chatto & Windus, 1931.

Italian edition:
Milano: Bompiani, 1957.

A High Wind in Jamaica
London: Chatto & Windus, 1929.
London: Chatto & Windus, 1931.
London: Royal National Institute for the Blind, 1931 [Braille edn.]
London: Chatto & Windus, 1940.
London: Chatto & Windus, 1943.
London: Chatto & Windus, 1948.
Harmondsworth: Penguin, 1949.
London: Chatto & Windus, 1956.
London: Landsborough, 1958.
London: Chatto & Windus, 1964.
Harmondsworth: Penguin, 1965.
London: Chatto & Windus, 1975.
Bath: Lythway Press, 1976.
St Albans: Triad Panther, 1976.

US editions: entitled *The Innocent Voyage* on first and occasional
 subsequent editions.
New York: Harper, 1929.
New York: Grosset and Dunlap, 1929.
New York: Random House, 1929.
New York: Harper, 1930.
New York: Random House, 1932.
New York: Editions for the Armed Forces, n.d.
New York: Heritage Press, 1944.
New York: Limited Editions Club, 1944.
New York: Penguin, 1947.
New York: Harper, 1958.
New York: Watts, 1958.

New York: Harper, 1959.
New York: New American Library, 1961.
New York: Time, 1963.
New York: Harper, 1972.
Mattituck, NY: Ameron, n.d.

Bulgarian edition:
Varna: Bakelov, 1982.

Czechoslovakian edition:
Bratislava: Slovensky Spisovatel, 1982.

Danish editions:
Copenhagen: Westermann, 1943.
Copenhagen: Achehoug, 1954.
Copenhagen: Gyldendal, 1966.

Dutch editions:
Amsterdam: Kosmos, n.d.
Antwerp: Het Spectrum, 1955.

Finnish edition:
Helsinki: Tammi, 1956.

French editions:
Paris: Plon, 1931.
Paris: Nicholson and Watson, 1948.
Paris: Plon, 1952.
Paris: Plon, 1958.
Paris: Plon, 1962.

German editions:
Berlin: Reiss, 1931.
Berlin: Suhrkamp, 1950.
Reinbek: Rowohlt, 1965.
Frankfurt am Main: Suhrkamp, 1973.
Frankfurt am Main: Suhrkamp, 1984.

Greek edition:
Athens: Angyra, 1975.

Hungarian editions:
Budapest: Franklin, 1933.
Budapest: Europa, 1958.
Budapest: Europa, 1969.
Budapest: Szepirodalmi Kiado, 1974.

Israeli edition:
Tel Aviv: s.n., 1970.

Italian editions:
Milan: Treves, 1933.
Milan: Bompiani, 1955.
Milan: Longanesi, 1967.
Milan: Garzanti, 1967.

Japanese edition:
Tokyo: Chikuma Shoba, 1970.

Lithuanian edition:
Vilnius: Vaga, 1980.

Norwegian edition:
Oslo: Gyldendal, 1951.

Polish editions:
Warsaw: Roj, 1934.
Warsaw: Czytelnic, 1968.
Warsaw: Ksiazka i Wiedza, 1979.

Portuguese edition:
Lisbon: Estudios Cor, 1957.

Spanish edition:
Barcelona: Ediciones Destino, 1944.

Swedish editions:
Stockholm: Norstedt, 1930.
Stockholm: Norstedt, 1965.

Swiss editions:
Lausanne: La Guilde du Livre, 1945.
Zurich: Gutenberg, 1953.

Burial and the Dark Child
London: Privately printed, 1930.

An Omnibus
New York: Harper, 1931.

The Spider's Palace and Other Stories
London: Chatto & Windus, 1931.
London: Chatto & Windus, 1933.
London: Chatto & Windus, 1962.
Harmondsworth: Penguin, 1972.

US editions:
New York: Harper, 1932.
New York: Random House, 1960.

Czechoslovakian edition:
Prague: Nakladatelstvi 'Kruh', 1936.

German editions:
Berlin: Fischer, 1933.
Frankfurt am Main: Suhrkamp, 1953.

Italian editions:
Milan: Bompiani, 1952.
Milan: Bompiani, 1962.

Japanese editions:
Tokyo: Bunken Shuppan, 1974.
Tokyo: Hayakawa Shobo, 1979.

In Hazard: A Sea Story
London: Chatto & Windus, 1938.
London: World Books, 1941.
London: Chatto & Windus, 1944.
London: Chatto & Windus, 1948.
Harmondsworth: Penguin, 1950.
London: Chatto & Windus, 1952.
London: Chatto & Windus, 1953.
London: Chatto & Windus, 1963.
Bath: Lythway Press, 1974.
London: Chatto & Windus, 1975.
St Albans: Triad Panther, 1977.
London: Chatto & Windus, 1992.

US editions:
New York: Harper, 1938.
New York: Harper, 1962.
New York: Time, 1963.

Gloucester, MA: P. Smith, 1969.
New York: New American Library, 1971.
Alexandria, VA: Time-Life, 1982.

Australian editions:
Kew, Vic.: St Paul's School for the Blind and Visually Handicapped, n.d. [Braille edn.].
Sydney: Hicks Smith & Sons, 1965 [abridged edn.].

Brazilian edition:
Rio de Janeiro: Vecci, 1954.

Danish editions:
Copenhagen: Bestermann, 1944.
Copenhagen: Gyldendal, 1962.

Dutch edition:
The Hague: Zuid-Hollandsches Uitgevers Midj, n.d.

Finnish edition:
Helsinki: Tammi, 1959.

French editions:
Paris: Stock, 1939.
Paris: Le Club Français du Livre, 1948.

German editions:
Berlin: Fischer, 1938.
Berlin: Suhrkamp, 1948.
Berlin: Suhrkamp, 1956.
Frankfurt am Main: Suhrkamp, 1977.

Hungarian edition:
Budapest: Europa, 1957.

Italian editions:
Turin: Frassinelli, 1939.
Milan: Bompiani, 1949.
Milan: Bompiani, 1963.
Milan: Garzanti, 1967.

Japanese edition:
Tokyo: Shobun-Sha, 1975.

Norwegian edition:
Oslo: Gyldendal, 1939.

Polish edition:
Warsaw: Panstw. Instytut Wydawn, 1967.

Spanish edition:
Madrid: Ediciones Lauro, 1945.

Swedish edition:
Malmo: Allhem, 1952.

Don't Blame Me! and Other Stories
London: Chatto & Windus, 1940.

US edition:
New York: Harper, 1940.

Japanese edition:
Tokyo: Iwanami Shoten, 1979.

The Administration of War Production
London: HMSO, 1955. With J. D. Scott.

The Human Predicament: Volume One: *The Fox in the Attic*
London: Chatto & Windus, 1961.
Bungay: The Reprint Society, 1962.
Harmondsworth: Penguin, 1964.
London: Chatto & Windus, 1975.
St Albans: Triad Panther, 1979.

US editions:
New York: Harper, 1961.
New York: New American Library, 1963.

Argentine edition:
Buenos Aires: Sudamericana, 1963.

Canadian edition:
Toronto: Clarke, Irwin, 1961.

Danish edition:
Copenhagen: Gyldendal, 1962.

Dutch editions:
Utrecht: Fontein, 1962.

Merksem: Westland, 1962.

Finnish edition:
Helsinki: Tammi, 1965.

French editions:
Paris: Stock, 1962.
Paris: Le Cercle du Nouveau Livre, 1962.

German edition:
Frankfurt am Main: Insel-Verlag, 1963.

Hungarian edition:
Budapest: Europa, 1964.

Italian edition:
Milan: Rizzoli, 1963.

Norwegian edition:
Oslo: Gyldendal, 1962.

Russian editions:
Moscow: Progress, 1979.
Kisinev: Lumina, 1981.

Spanish edition:
Barcelona: Plaza y Janes, 1964.

Swedish editions:
Stockholm: Norstedt, 1962.
Stockholm: Norstedt, 1974.

Gertrude's Child
s.l.: Quist, 1967.

US edition:
New York: Harlin Quist, 1974.

Danish edition:
Copenhagen: Berg, 1975.

Swiss edition:
Zurich: Diogenes, 1985.

Gertrude and the Mermaid
New York: Harlin Quist, 1968.

Danish edition:
Copenhagen: Berg, 1972.

French edition:
Boissy St Léger: Quist-Vidal, 1971.

German edition:
Cologne: Middelhauve, 1971.

The Human Predicament: Volume Two: *The Wooden Shepherdess*
London: Chatto & Windus, 1973.
Harmondsworth: Penguin, 1975.
St Albans: Triad Panther, 1980.

US edition:
New York: Harper, 1973.

French edition:
Paris: Stock, 1975.

Hungarian edition:
Budapest: Europa, 1978.

Israeli edition:
Tel Aviv: Zmora Bitan, 1987.

Italian edition:
Milan: Rizzoli, 1976.

Soviet editions:
Moscow: Progress, 1979.
Kisinev: Lumina, 1981.

Swedish edition:
Stockholm: Norstedt, 1974.

The Wonder Dog: The Collected Short Stories of Richard Hughes
London: Chatto & Windus, 1977.
Harmondsworth: Puffin, 1980.

US edition:
New York: Greenwillow, 1977.

Italian edition:
Milan: Bompiani, 1982.

Spanish edition:
Madrid: Alfaguara, 1982.

In the Lap of Atlas: Stories of Morocco
London: Chatto & Windus, 1979.

Fiction as Truth: Selected Literary Writings of Richard Hughes, edited
and introduced by Richard Poole.
Bridgend: Poetry Wales Press, 1983.

A.2 Other writings

1917
Editor, *The Carthusian*, 12, no.297 (1917)–12, no.403 (1918).

1919
Joint editor, *The Topaz of Ethiopia*, 1.
Review of *The Owl*, *The Topaz of Ethiopia*, 1, no.3, p.2.

1920
Joint editor, *Public School Verse*, 1920–7.
Letter to *The London Mercury*, 3, no.14, pp.200–1.
'What's wrong with the stage?', *Evening Standard*, 5 June.
Reviews of A. E. Grantham, *The Wisdom of Akhnaton*; D. H.
Lawrence, *Touch and Go*; Sturge Moore, *The Power of the Air*,
Saturday Westminster Gazette, 28 July.
Reviews of Edward Thomas, *Collected Poems*; W. H. Davies, *A Song
of Life and Other Poems*; Gerald Bull, *Wayside Poems*, *Saturday
Westminster Gazette*, 25 September.
Reviews of Robert Graves, *Over the Brazier*; Edmund Blunden, *The
Waggoner and Other Poems*; J. C. Squire, *The Moon*, *Saturday
Westminster Gazette*, 2 October.
Reviews of Herbert Asquith, *A Village Sermon*; Sir Cecil Spring-Rice,
Poems, *Saturday Westminster Gazette*, 23 October.
Reviews of Edna St Vincent Millay, *Aria da Capo*; F. S. Flint,
Otherworld: Cadences; E. E. Bradford, *The Romance of Youth*;
T. G. W. Henslow, *Poems of Expression*, *Saturday Westminster
Gazette*, 30 October.
Review of Harold Williams, *Outlines of Modern English Literature*,
Saturday Westminster Gazette, 6 November.

Reviews of Torahiko Khori, *Absalom: A Tragedy*; C. E. Scott Wood, *The Poet in the Desert*; John A. Lomax, *Songs of the Cattle Trail and Cow Camp*; William Dudley Foulke, *Today and Yesterday*; Charles Murray, *Hamewith*, *Saturday Westminster Gazette*, 27 November.

1921

Joint editor, *Oxford Poetry 1921* (Oxford).

'Diary of a steerage passenger', *Saturday Westminster Gazette*, 19 November, pp.4–5.

Review of *The Collected Prose of James Elroy Flecker*, *Saturday Westminster Gazette*, 12 March.

Review of Ralph Straus, *Pengard Awake*, *Saturday Westminster Gazette*, 19 March.

'Some notes on W. E. Henley', *Saturday Westminster Gazette*, 19 March.

1922

'A diary in Eastern Europe', *Weekly Westminster Gazette*, 9, 16, 23, 30 September; 7, 21 October; 4 November.

1923

'Mutations of the Phoenix', *Nation and Athenaeum*, 23 June, pp.399–400.

'Loin cloth and crinoline', *Nation and Athenaeum*, 21 July, p.523.

'Literature and the schools', *Nation and Athenaeum*, 25 August, p.663.

'Four and twenty minds', *Nation and Athenaeum*, 13 October, pp.62, 64.

Review of Lewis Spence, *The Gods of Mexico*, *Spectator*, 25 August, pp.258–9.

Review of A. S. M. Hutchinson, *The Eighth Wonder*, *Spectator*, 22 September, pp.391–2.

Review of Luigi Pirandello, *Three Plays*, *Weekly Westminster Gazette*, 29 December.

Review of *Come Hither*, edited by Walter de la Mare, *Spectator*, 29 December, p.1035.

1924

Editor, John Skelton, *Poems* (London).

'Wales and the Welsh: drama among the mountains', *Review of Reviews*, May–June, pp.641–6.

'How listening plays are done', *Evening Standard*, 16 January, p.3.
'The cinema's new rival', *Women's Pictorial*, 29 February.
Review of D. H. Lawrence, *Birds, Beasts and Flowers*, *Nation and Athenaeum*, 5 January, pp.519–20.
Review of J. C. Squire, *Essays on Poetry*, *Weekly Westminster Gazette*, 19 January.
Review of Richard Jefferies, *The Story of My Heart*, *Weekly Westminster Gazette*, 2 February.
Reviews of Miles Malleson, *The Fanatics*; Hermon Ould, *The Dance of Life*; Sutton Vane, *Outward Bound*; A. V. Lunarchski, *Three Plays*; Georg Kaiser, *Gas: Four Short Plays*, *Spectator*, 5 April, pp.550–2.
Reviews of Howard Peacey, *Fifth of November*; Gwen John, *The Prince*; Allan Monkhouse, *First Blood*; *Tolstoi's Dramas*, *Spectator*, 28 June, pp.1044, 1046.
Review of Walter de la Mare, *Crossings: A Fairy Play*, *Spectator*, 15 November, p.744.

1925
'New trends in the theatre', *Forum*, 73 (June), pp.869–76.
Review of Virginia Woolf, *Mrs Dalloway*, *Saturday Review of Literature*, 16 May, p.755.

1926
'Aspects of the cinema', *Outlook*, 57 (2 January), p.8.

1927
Review of Ramon Fernandez, *Messages*, *Nation and Athenaeum*, 27 August, p.696.

1928
Introduction, Frank Penn Smith, *Hang!* (London).

1929
'Under the nose, under the skin', *New York Herald Tribune: Books*, 16 June, pp.1, 6.
'Rum runners I have known', *Daily Chronicle and Liverpool Mercury*, 13 December, p.8.
Review of Iris Barry, *The Last Enemy*, *New York Herald Tribune: Books*, 3 November, p.4.

1930

Introduction, William Faulkner, *Soldiers' Pay* (London).

'Nightingales and daggers in Morocco', *Radio Times*, 17 October, pp.161, 180.

'Illogic and the child', *Saturday Review of Literature*, 15 November, pp.328–9.

'Strange Christmasses', *Harper's Bazaar*, December, pp.75, 96.

1931

Introduction, William Faulkner, *The Sound and the Fury* (London).

'My first day in the air', *Daily Express*, 20 April, p.12.

'Under the nose and under the skin', *Listener*, 10 June, p.979.

'Time to burn boats', *Week-End Review*, 10 October, pp.424–5.

Review of William Bolitho, *Camera Obscura*, *News Chronicle*, 17 June, p.4.

1932

'The relation of literature to nationalism', *Transactions of the Honourable Society of Cymmrodorion*, 1930–1, pp.107–28.

'Physics, astronomy and mathematics, or beyond common sense', in *An Outline for Boys and Girls and Their Parents* (London), pp.303–57.

1933

Introduction, Frank Penn Smith, *The Unexpected* (London).

'Cave drawings: a new theory', *New Statesman and Nation*, 1 April, pp.414–15.

'Northern Africa', *Listener*, 19 April, p.629.

1934

'Safe among lions', *Spectator*, 29 June, pp.992–3.

'The theatre in Wales', *Bookman*, 87 (November), pp.97–8.

Introduction, Lance Sieveking, *The Stuff of Radio* (London), p.7.

1935

'On reading plays', *Fortnightly*, 144 (October), pp.495–7.

'"Everyship" on the Welsh seas', in H. A. Piehler, *Wales for Everyman* (London), pp.13–16.

Review of Uffa Fox, *Sailing, Seamanship, and Yacht-Construction*, *New Statesman and Nation*, 20 April, p.556.

Review of T. E. Lawrence, *The Seven Pillars of Wisdom*, *Spectator*, 2 August, p.193.
Review of Hendrik Van Loon, *Ships*, *Spectator*, 20 December, p.1042.

1936
'Open the door!', *Time and Tide*, 4 April, p.478.
'Notes on the way', *Time and Tide*, 19 September, pp.273–5; 26 September, pp.1306–8.
Reviews of Uffa Fox, *Uffa Fox's Second Book*; Frank G. G. Carr, *A Yachtsman's Log*, *New Statesman and Nation*, 1 February, pp.158, 160.
Reviews of Stanley Rogers, *Freak Ships*; Howard I. Chapelle, *The History of American Sailing Ships*, *Spectator*, 24 July, pp.150–1.
Review of Harry Martinson, *Flowering Nettle*, *Observer*, 4 October.
Reviews of Howard I. Chapelle, *American Sailing Craft*; Brian Tunstall, *The Anatomy of Neptune*; Gregory Robinson, *Ships That Have Made History*; G. E. Manwaring, *The Flowers of England's Garland*; David Masters, *Crimes of the High Seas*, *Spectator*, 16 October, pp.650, 652.

1937
'Notes on the way', *Time and Tide*, 16 October, pp.1361–4; 23 October, pp.1393–5; 30 October, pp.1428–9.
'Books for pre-adults', *New Statesman and Nation*, 4 December, pp.944, 946.
Review of Uffa Fox, *Uffa Fox's Annual*, *New Statesman and Nation*, 13 March, pp.426, 428.
Reviews of K. Adlard Coles, *Sailing and Cruising*; John Irving, *The King's Britannia*; Helen and Jacques Le Grange, *Clipper Ships of America and Great Britain*, *New Statesman and Nation*, 26 June, pp.1052–4.
Review of W. L. A. Derby, *The Tall Ships Pass*, *New Statesman and Nation*, 9 October, p.548.
Review of Glyn Jones, *The Blue Bed*, *Observer*, 7 February, p.7.

1938
'Notes on the way', *Time and Tide*, 26 November, pp.1638–9; 3 December, pp.1686–8; 10 December, pp.1787–90.
'The gentle pirate', *Listener*, 16 June, pp.1268–70.
'Tale-telling for children', *The Graphic*, 16 June, pp.222–3.

'England's green and pleasant sea', *The Star*, 29 August.
'Birth of a hurricane', *Listener*, 15 October, pp.544–55.
Review of *The Letters of T. E. Lawrence, New Statesman and Nation*, 10 December, pp.1007–8.

1939

Introduction, Fred Rebell, *Escape to the Sea* (London).
'Jamaica today', *Geographical Magazine*, December, pp.105–14.
Reviews of Uffa Fox, *The Beauty of Sail*; John Irving and Douglas Service, *The Yachtsman's Week-End Book*; Uffa Fox, *Thoughts on Yachts and Yachting*; *The Yachtsman's Annual and Who's Who, New Statesman and Nation*, 7 January, pp.26, 28.
Review of Daisy Bates, *The Passing of the Aborigines, Sunday Times*, 15 January.

1940

'Notes on the way', *Time and Tide*, 29 June, p.684; 6 July, p.708.
Letter to the *Western Mail*, 30 April, p.6.
Review of Hilaire Belloc, *On Sailing the Sea, New Statesman and Nation*, 10 February, pp.182, 184.

1945

Review of Marin-Marie, *Wind Aloft, Wind Alow, Sunday Times*, 18 November.
Review of A. L. Rowse, *West Country Stories, Times Literary Supplement*, 8 December, p.585.

1946

'Sailing', *The Saturday Book*, 24 March, pp.221–7.
'Will radio develop a literature of its own?', *World Review*, November, pp.33–6.
Review of Gwyn Jones, *The Buttercup Field and Other Stories, Times Literary Supplement*, 5 January, p.5.
Review of M. P. Fogarty, *Prospects of the Industrial Areas of Great Britain, Quarterly Review*, January.
Reviews of Evan John, *Time in the East*; Barry Sutton, *Jungle Pilot, Sunday Times*, 28 April.

1947

'The second revolution: literature and radio', *Virginia Quarterly Review*, 23 (Winter), pp.34–43.

Review of John Scott Hughes, *Sailing through Life*, *Sunday Times*, 31 August.
Review of Clifford Ashley, *The Ashley Book of Knots*, *Sunday Times*, 16 November.

1948
'The writer's duty', *Listener*, 22 July, pp.131–2.
'Polish impressions', *Spectator*, 17 September, pp.358–9.
'Star Tiger down', *Spectator*, 8 October, pp.457–8.
'Politicians are specialists', *Our Time*, 17, no.3 (October), p.338.
Review of Joshua Slocum, *Sailing Around the World*, *Time and Tide*, 17 April, p.404.
Review of G. M. Gilbert, *Nuremberg Diary*, *Sunday Times*, 1 August.

1949
Introduction, John Voss, *The Adventuresome Voyages of Captain Voss* (London).
'Dry land', *Time and Tide*, 26 November, pp.1185–6.
'Make parenthood possible', *World Review*, December, pp.48–52.

1950
'Robert Louis Stevenson: a centenary tribute', *Listener*, 16 November, pp.533–4.
Review of Thor Heyerdahl, *The Kon-Tiki Expedition*, *Observer*, 2 April.

1951
Prologue and Epilogue, Amabel and Clough Williams-Ellis, *Headlong Down the Years* (Liverpool).
'Wales through the looking-glass', *Listener*, 24 May, pp.838–9.

1953
'The Coronation in Wales', *Time and Tide*, 6 June, pp.742–3.
'Albert Schweitzer', *Picture Post*, 12 December, pp.16–17.
Review of Desmond McCarthy, *Humanities*, *Spectator*, 2 October, pp.364, 366–7.
Review of E. M. Forster, *The Hill of Devi*, *Spectator*, 16 October, pp.432–3.
Review of Joyce Cary, *Except the Lord*, *Spectator*, 18 December, pp.738–9.

Review of Virginia Woolf, *A Writer's Diary*, *Spectator*, 20 December, pp.587–8.
Review of *The Golden Horizon*, *Sunday Times*, 20 December.

1954

'George Borrow: Victorian rebel', *Radio Times*, 3 December, p.4.
Review of Charles R. Sanders, *The Strachey Family*, *Spectator*, 5 February, pp.156–7.
Review of J. K. Johnstone, *The Bloomsbury Group*, *Spectator*, 11 June, pp.716, 719.
Review of J. R. R. Tolkien, *The Fellowship of the Ring*, *Spectator*, 1 October, pp.408–9.
Review of Dylan Thomas, *Under Milk Wood*, *Sunday Times*, 7 March.
Review of Anthony Alpers, *Katherine Mansfield*, *Sunday Times*, 25 April.
Review of Louis Le Golif, *Memoirs of a Buccaneer*, *Sunday Times*, 12 May.

1955

Review of Stuart Chase, *The Power of Words*, *Sunday Times*, 15 May.
Review of Harry Hodgkinson, *Double Talk*, *Sunday Times*, 26 June.
Review of Anthony Glyn, *Elinor Glyn*, *Sunday Times*, 24 July.
Review of Lionel Trilling, *The Opposing Self*, *Sunday Times*, 7 August.
Review of Dylan Thomas, *Adventures in the Skin Trade*, *Sunday Times*, 11 September.
Review of David Garnett, *The Flowers of the Forest*, *Spectator*, 14 October, p.504.

1956

Reviews of Thomas Parry, *A History of Welsh Literature*; Gwyn Williams, *An Introduction to Welsh Poetry*, *Sunday Times*, January.

1957

'The birth of radio drama', *Atlantic*, 200 (December), pp.145–6, 148.

1961

'Augustus', *Sunday Telegraph*, 5 November, p.20.

1962

'I live where I like', *Vogue*, 140 (15 August), pp.72–3.

'I live in Merioneth', *Homes and Gardens*, March, pp.92–5.
'Liturgical language today', *Province*, 13, no.4.

1963

'Faulkner and Bennett', *Encounter*, 21 (September), pp.59–61.

1964

Introduction, William Faulkner, *Mosquitos: A Novel* (London).
'Seven mirrors for parishes', in *Six Lay Voices* (Penarth).

1965

'The young Robert Graves: a reminiscence', *Sunday Telegraph*, 9 July.
'Poet with frying pan', *Sunday Telegraph*, 25 July, p.14.

1967

'A note on the artist', in *Edward Wolfe ARA: A Retrospective
 Catalogue of Paintings and Drawings* (London), pp.7–8.
Review of Francis Chichester, *Gypsy-Moth Circles the World*, *Sunday
 Times*, 12 November.
'African authors – read your contracts!', *Nairobi Nation*, 27 February.

1968

Introduction, *Deudraeth Rural District: The Official Guide* (Penrhyn-
 deudraeth).

1970

'Not things but persons', *Times* (Saturday Review), 21 March, p.1.
'Of use and beauty', *Books*, 1, pp.21–4.
'Fiction as truth', *Proceedings of the American Academy of Arts and
 Letters and National Institute of Arts and Letters*, second series, 20,
 pp.16–20.

1971

'You should have been here yesterday', *Observer*, 17 January, p.30.
Fiction: Annual Address to the North Wales Association for the Arts
 (Bangor).
Letter to *The Times*, 10 February, p.13.

1973

Review of Hugh Thomas, *John Strachey*, *Sunday Times*, 6 May.

1975
'Eheu fugaces', *Virginia Quarterly Review*, 51 (Spring), pp.258–63.

B. Publications on Richard Hughes

B.1 Books

Hughes, Penelope, *Richard Hughes: Author, Father* (Gloucester, 1984).

Milligan, Ian, *Richard Hughes: A High Wind in Jamaica: Notes*, York Notes Series (London, 1980).

Notes on Richard Hughes's A High Wind in Jamaica, Study-aid Series (London, 1971).

Poole, Richard, *Richard Hughes: Novelist* (Bridgend, 1987).

Poole, Richard (ed.), *Fiction as Truth: Selected Literary Writings of Richard Hughes* (Bridgend, 1983).

Thomas, Peter, *Richard Hughes*, Writers of Wales (Cardiff, 1973).

B.2 Articles, book chapters, and interviews

Bakewell, Michael, 'A life sentence: memoirs of Richard Hughes', *Listener*, 10 May 1979, pp.658–9.

Bosano, R., 'Richard Hughes', *Etudes Anglaises*, 16, no.3 (1963), pp.262–9.

Bradshaw, Jon, 'Tolstoy in Wales', *Daily Telegraph Magazine*, 6 August 1971, pp.27–8.

Brown, Daniel R., '*A High Wind in Jamaica*: comedy of the absurd', Ball State University Forum, 9, no.1 (1968), pp.6–12.

'A conversation with Richard Hughes', *Listener*, 23 October 1975, pp.546–7.

De Jong, John M., 'Richard Hughes and the Cartesian world', *Critique*, 19, no.2 (1977), pp.13–22.

Dooley, D. J., 'Richard Hughes', in *An Encyclopedia of World Literature in the Twentieth Century*, general editor L. S. Klein, 2 vols. (New York, 1982), II, p.407.

'Drama by wireless waves: encouraging first results', *Evening Standard*, 16 January 1924, p.5.

Dumbleton, Susanne M., 'Animals and humans in *A High Wind in Jamaica*', *Anglo-Welsh Review*, 68 (1981), pp.51–61.

Dumbleton, Susanne M., '*The Fox in the Attic* and *The Wooden Shepherdess*: a definition of the human predicament', *Anglo-Welsh Review*, 73 (1986), pp.38–48.

Firchow, Peter (ed.), *The Writer's Place: Interviews on the Literary Situation in Contemporary Britain* (Minneapolis, 1974), pp.183–208.

Fletcher, Ifan Kyrle, 'Richard Hughes: a Welsh playwright of distinction', *South Wales Daily News*, 31 August 1927, p.6.

Gordan, John D., 'Richard Hughes', *Bulletin of the New York Public Library*, 71 (May 1967), p.303.

Henighan, T. J., 'Nature and convention in *A High Wind in Jamaica*', *Critique*, 9, no.1 (1966), pp.5–18.

Humfrey, Belinda, 'Richard Hughes', in *British Novelists 1930–1959*, 2 vols. (Detroit, 1983), I, pp.186–94.

Miller, Richard Hugh, 'History and children in Richard Hughes's *The Wooden Shepherdess*', *Antigonish Review*, 22 (1975), pp.31–5.

Milligan, Ian, 'Richard Hughes's *A High Wind in Jamaica* and Aaron Smith's *Atrocities of the Pirates*', *Notes and Queries*, August 1979, pp.336–7.

Milligan, Ian, 'Richard Hughes and Michael Scott: a further source for *A High Wind in Jamaica*', *Notes and Queries*, June 1986, pp.192–3.

'Miners in Danger', *Listener*, 17 January 1974, p.85.

Morgan, Louise, 'Richard Hughes: artist and adventurer', *Everyman*, 9 April 1931, pp.327–9.

Morgan, Paul, 'Richard Hughes and "Living in Wales"', *Anglo-Welsh Review*, 84 (1986), pp.91–103.

Morgan, Paul, '*A Moment in Time*: the short stories of Richard Hughes', *New Welsh Review*, 1, no.2 (1988), pp.57–63.

Morgan, Paul, 'Richard Hughes: an author's library', *National Library of Wales Journal*, 25, no.3 (1988), pp.341–6.

Morgan, Paul, 'Ex Libris Richard Hughes: three bookplates', *National Library of Wales Journal*, 25, no.3 (1988), pp.347–9.

Morgan, Paul, 'Richard Hughes's *A High Wind in Jamaica*: a misattributed edition', *Notes and Queries*, March 1990, p.67.

Percy, Walker, 'Hughes's solipsism malgré lui', *Sewanee Review*, 72, no.3 (1964), pp.489–95.

Poole, Richard, 'Irony in *A High Wind in Jamaica*', *Anglo-Welsh*

Review, 51 (1974), pp.41–57.

Poole, Richard, 'Morality and selfhood in the novels of Richard Hughes', *Anglo-Welsh Review*, 55 (1975), pp.10–29.

Poole, Richard, 'Fiction as truth: Richard Hughes's *The Human Predicament*', *Anglo-Welsh Review*, 57 (1976), pp.57–92.

Poole, Richard, '*In Hazard*: the theory and practice of Richard Hughes's art', *Planet*, 45/46 (1978), pp.68–77.

Poole, Richard, 'Afterword to Richard Hughes, "A Preface to His Poetry"', *Poetry Wales*, 16, no.3 (1981), pp.70–1.

'Richard Hughes: author of *The Innocent Voyage*', *Wilson Bulletin*, November 1929, p.660.

'Richard Hughes', [Interview] *New Yorker*, 28 June 1969, pp.30–1.

Roberts, Glyn, 'Richard Hughes: novelist and playwright', *Western Mail*, 29 August 1933, p.6.

Savage, D. S., 'Richard Hughes, solipsist', *Anglo-Welsh Review*, 68 (1981), pp.36–50.

'Shop talk by Richard Hughes', [Interview] *Christian Science Monitor*, 2 March 1967, p.5.

'A short story writer', *Cherwell*, 1, no.2 (1920), p.17.

Sieveking, Lance, 'Richard Hughes', in *The Eye of the Beholder* (London, 1957), pp.163–87.

Swinden, Patrick, *Unofficial Selves: Character in the Novel from Dickens to the Present* (London, 1973), pp.181–202.

Swinden, Patrick, *The English Novel of History and Society, 1940–1980: Richard Hughes, Henry Green, Anthony Powell, Angus Wilson, Kingsley Amis, V. S. Naipaul* (London, 1984), pp.24–56.

Thomas, Peter, 'Measuring the wind: the early writings of Richard Hughes', *Anglo-Welsh Review*, 45 (1971), pp.36–56.

Thomas, Peter, 'In the Abbey shadow: the fortunes of the Portmadoc Players', *Anglo-Welsh Review*, 47 (1972), pp.89–95.

Thomas, Yvonne, 'A line and a half a day: an interview with Richard Hughes', *Guardian*, 14 April 1973, p.24.

Woodward, Daniel H., 'The Delphic voice: Richard Hughes's *A High Wind in Jamaica*', *Papers on Language and Literature*, 3, no.1 (1967), pp.57–74.

B.3 Reviews

Reviews of *Gypsy–Night and Other Poems*

Nation and Athenaeum, 15 July 1922, pp.540–1.

Times Literary Supplement, 31 August 1922, p.559.
Squire, J. C., *London Mercury*, September 1922, p.544.
Williams-Ellis, Amabel, *Spectator*, 3 June 1922, pp.695–6.

Reviews of *Confessio Juvenis: Collected Poems*

Times Literary Supplement, 30 September 1926, p.646.
Read, Herbert, *Nation and Athenaeum*, 12 June 1926, p.282.
Rickword, Edgell, *Calendar of Modern Letters*, 3 (July 1926), pp.156–9.

Reviews of *The Sisters' Tragedy and Three Other Plays*

Times Literary Supplement, 5 February 1925, p.85.
Saturday Review of Literature, 3 January 1925, p.435.
Canadian Forum, 5 (September 1925), p.375.
Aldington, Richard, *Nation and Athenaeum*, 14 February 1925, p.682.
B., H. I., *Welsh Outlook*, May 1925, pp.138–9.
Bell, Lisle, *New York Herald Tribune: Books*, 14 December 1925, p.12.
Francis, J. O., *Western Mail*, 18 December 1924, p.11.
Turner, W. J., *Calendar of Modern Letters*, March 1925, pp.81–2.

Reviews of *A Moment of Time*

Times Literary Supplement, 28 January 1926, p.60.
Hartley, L. P., *Saturday Review*, 13 February 1926, pp.200–1.
Muir, Edwin, *Nation and Athenaeum*, 6 March 1926, p.782.
Rickword, Edgell, *Calendar of Modern Letters*, April 1926, p.81.

Reviews of *A High Wind in Jamaica*

Times Literary Supplement, 26 September 1929, p.742.
Booklist, 26 (October 1929), p.33.
Saturday Review of Literature, 22 March 1930, p.837.
John O'London's Weekly, 5 October 1929, p.904.
Western Mail, 3 October 1929, p.11.
Boston Evening Transcript, 15 June 1929, p.2.
Wisconsin Library Bulletin, 25 (May 1929), p.25.
Allraum, Juana, *New York Herald Tribune: Books*, 28 April 1929, p.3.
Arrowsmith, J. E. S., *London Mercury*, November 1929, pp.78–9.
Brooks, Walter R., *Outlook*, 151 (10 April 1929), pp.593, 596.
Colcord, Lincoln, *New York World*, 69 (5 May 1929), p.10.

Connolly, Cyril, *New Statesman*, 5 October 1929, p.780.

Davies, T. Huw, *Welsh Outlook*, 16, no.12 (December 1929), pp.362–3.

Davis, Lambert, *Virginia Quarterly Review*, 5 (July 1929), pp.474–80.

Galantiere, Lewis, *New Republic*, 58 (1 May 1929), p.312.

Hartley, L. P., *Saturday Review*, 148 (28 September 1929), pp.355–6.

Hey, Robin, *Bookman*, 77 (November 1929), p.137.

Irvine, Lyn, *Nation and Athenaeum*, 28 September 1929, pp.830–1.

MacDougall, Robert B., *Saturday Review of Literature*, 5 (13 April 1929), p.879.

Pritchett, V. S., *Christian Science Monitor*, 16 November 1929, p.14.

Pritchett, V. S., *Spectator*, 28 September 1929, pp.417–18.

Spain, Ruth, *New Republic*, 61 (27 November 1929), pp.25–6.

Van de Water, F., *New York Evening Post*, 13 April 1929, p.11.

Walpole, Hugh, *The Graphic*, 28 September 1929, p.352.

Reviews of *In Hazard*

Nautical Magazine, 140 (August 1938), pp.170–1.

Times Literary Supplement, 9 July 1938, p.463.

Booklist, 35 (1 November 1929), p.84.

North American Review, 246 (Winter 1938–9), p.405.

Pratt, Winter 1939, p.35.

Springfield Republican, 9 October 1938, p.7.

Time, 10 October 1938, p.65.

Western Mail, 7 July 1938, p.11.

Bates, Ralph, *New Republic*, 96 (2 November 1938), pp.368–9.

Burnham, Philip, *Commonweal*, 14 October 1938, pp.647–8.

Fadiman, Clifton, *New Yorker*, 14 (8 October 1938), pp.67–9.

Garnett, David, *New Statesman and Nation*, 9 July 1938, p.78.

Grant, James, *Queen*, 21 July 1938, p.153.

Greene, Grahame, *Spectator*, 8 July 1938, p.68.

Hartley, L.P., *Sketch*, 183 (3 August 1938), p.230.

Hicks, Granville, *Books and Bookmen*, October 1938, p.48.

Hutchison, Percy, *New York Times Book Review*, 9 October 1938, p.6.

Jones, Glyn, *Life and Letters Today*, 19, no.3 (1938), pp.127–8.

Kronenberger, Louis, *Kenyon Review*, 1 (Spring 1939), pp.203–5.

Marriott, Charles, *Manchester Guardian*, 12 July 1938, p.7.

Maxwell, William, *Saturday Review of Literature*, 8 October 1938, p.6.

Muir, Edwin, *Listener*, 21 July 1938, p.153.

Pritchett, V. S., *Christian Science Monitor*, 10 August 1938, p.11.

Rascoe, Burton, *Newsweek*, 10 October 1938, p.34.

Scott–James, Marie, *London Mercury*, August 1938, p.272.

Shackleton, Edith, *Time and Tide*, 9 July 1938, p.984.

Soskin, William, *New York Herald Tribune: Books*, 9 October 1938, p.3.

Zabel, Morton D., *Nation*, 147 (15 October 1938), pp.383–4.

Reviews of *The Human Predicament:* Volume One: *The Fox in the Attic*

Times Literary Supplement, 6 October 1961, p.657.

Booklist, 58 (1 March 1962), p.438.

Bookmark, 21 (February 1962), p.130.

Newsweek, 5 February 1962, p.85.

New Yorker, 24 March 1962, p.176.

Time, 16 February 1962, pp.87–8.

Kirkus, 29 (15 November 1961), p.1023.

Wisconsin Library Bulletin, 58 (May 1962), p.177.

Barrett, William, *Atlantic*, 209 (April 1962), pp.150, 154.

Bowen, John, *Time and Tide*, 5 October 1961, p.1660.

Butcher, Fanny, *Chicago Sunday Tribune*, 4 February 1962, p.3.

Cruttwell, Patrick, *Guardian*, 6 October 1961, p.7.

C., E., *Books Abroad*, 36 (Spring 1962), pp.205, 206.

Finch, Archer, *Book of the Month Club News*, February 1962, p.9.

Furbank, P. N., *Encounter*, 22 (April 1964), pp.85–9, 91.

Gardiner, Harold C., *America*, 106 (3 March 1962), p.722.

Gersh, Gabriel, *National Review*, 27 February 1962, pp.134–5.

Gray, James, *Saturday Review*, 45 (3 February 1962), pp.20, 37.

Guttwillig, Robert, *New York Times Book Review*, 4 February 1962, pp.1, 35.

Hicks, Granville, *Books and Bookmen*, 11 (October 1965), p.48.

Hobson, Harold, *Christian Science Monitor*, 1 February 1962, p.7.

Hogan, William, *San Francisco Chronicle*, 2 February 1962, p.41.

Hughes, Catherine, *Catholic World*, 195 (May 1962), pp.117–18.

Hutchens, J. K., *New York Herald Tribune*, 31 January 1962, p.19.

Jackson, Robert C., *Library Journal*, 1 March 1962, p.994.

Johnson, Lucy, *Progressive*, 26 (March 1962), pp.49–51.

Kennebeck, Edwin, *Commonweal*, 76 (30 March 1962), p.20.

Kermode, Frank, *Partisan Review*, 29, no.3 (1962), p.416.

Kurtz, Harold, *History Today*, December 1961, p.852.

Mayne, Richard, *New Statesman*, 6 October 1961, pp.483–4.

McDonough, James P., *Best Sellers*, 21 (15 February 1962), p.443.
M., E. M., *Christian Century*, 18 April 1962, p. 492.
Mortimer, Raymond, *New York Times Book Review*, 4 February 1962, pp.1, 35.
Pickrel, Paul, *Harper's*, 224 (February 1962), pp.107–8.
Prescott, Orville, *New York Times*, 31 January 1962, p.29.
Price, R. G. G., *Punch*, 11 October 1961, pp.551–2.
Rovit, Earl, *Nation*, 24 February 1962, pp.181–2.
Saxton, Mark, *New York Herald Tribune: Books*, 28 January 1962, p.3.
Spender, Stephen, *Encounter*, 17 (December 1961), pp.78–81.
Symons, Julian, *Twentieth Century*, 170, no.1012 (Winter 1962), pp.147–54.
Symons, Julian, *Spectator*, 6 October 1961, p.472.
Warnke, Frank J., *New Republic*, 146 (23 April 1962), pp.29–30.
Wiley, Paul, *Wisconsin Studies in Contemporary Literature*, 4, no.2 (1962), pp.229–30.

Reviews of *The Human Predicament*: Volume Two: *The Wooden Shepherdess*

Times Literary Supplement, 6 April 1973, p.369.
Booklist, 70 (15 September 1973), pp.83–4.
British Book News, July 1973, pp.484–5.
Choice, December 1973, p.1550.
Kirkus, 41 (15 June 1973), p.653.
National Observer, 25 August 1973, p.21.
Publishers' Weekly, 18 June 1973, p.63.
Allen, Walter, *Daily Telegraph*, 5 April 1973, p.8.
Bell, Pearl K., *New Leader*, 17 September 1973, pp.15–16.
Charles, John W., *Library Journal*, 98 (15 May 1973), p.1600.
Janeway, Elizabeth, *New York Times Book Review*, 19 August 1973, pp.1–3.
Jellinek, Roger, *New York Times*, 31 August 1973, p.23.
Kennedy, Eileen, *Best Sellers*, 33 (1 September 1973), pp.241–2.
Lee, Joseph, *Spectator*, 28 April 1973, pp.523–4.
Leonard, John, *New York Times Book Review*, 2 December 1973, p.2.
Manning, Olivia, *Guardian*, 14 April 1973, p.24.
May, Derwent, *Listener*, 5 April 1973, pp.451–2.
Poole, Richard, *Anglo-Welsh Review*, 50 (1973), pp.227–32.
Porterfield, Christopher, *Time*, 27 August 1973, p.64.

Prescott, Peter S., *Newsweek*, 3 September 1973, p.81.
Rees, Goronwy, *New Statesman*, 6 April 1973, pp.504–5.
Sullivan, Walter, *Sewanee Review*, 82 (Winter 1974), pp.138–47.
Symons, Julian, *Book World*, 26 August 1973, pp.8–9.
Theroux, Paul, *Times*, 5 April 1973, p.16.
Thomas, Peter, *Planet*, 18/19 (1973), pp.152–5.
Thwaite, Anthony, *Observer*, 8 April 1973, p.37.

Index